Cultural Studies

Theorizing Politics, Politicizing Theory

VOLUME 12 NUMBER 3 JULY 1998

Special issue:
Cultural Studies of Science and Technology

Edited by
Ann Balsamo

Editorial Statement

Cultural Studies continues to expand and flourish, in large part because the field keeps changing. Cultural studies scholars are addressing new questions and discourses, continuing to debate long-standing issues, and reinventing critical traditions. More and more universities have some formal cultural studies presence; the number of books and journals in the field is rapidly increasing. *Cultural Studies* welcomes these developments. We understand the expansion, reflexivity and internal critique of cultural studies to be both signs of its vitality and signature components of its status as a field. At the same time, cultural studies has been – and will no doubt continue to be – the subject of numerous attacks, launched from various perspectives and sites. These have to be taken seriously and answered, intellectually, institutionally and publicly. *Cultural Studies* hopes to provide a forum for response and strategic discussion.

 Cultural Studies assumes that the knowledge formations that make up the field are as historically and geographically contingent as are the determinations of any cultural practice or configuration and that the work produced within or at its permeable boundaries will be diverse. We hope not only to represent but to enhance this diversity. Consequently, we encourage submissions from various disciplinary, theoretical and geographical perspectives, and hope to reflect the wide-ranging articulations, both global and local, among historical, political, economic, cultural and everyday discourses. At the heart of these articulations are questions of community, identity, agency and change.

 We expect to publish work that is politically and strategically driven, empirically grounded, theoretically sophisticated, contextually defined and reflexive about its status, however critical, within the range of cultural studies. *Cultural Studies* is about theorizing politics and politicizing theory. How this is to be accomplished in any context remains, however, open to rigorous enquiry. As we look towards the future of the field and the journal, it is this enquiry that we especially hope to support.

Lawrence Grossberg
Della Pollock

January 1998

Advertising (UK):
Routledge Journals,
2 Park Square, Milton Park, Abingdon, Oxon, OX14 4RN

Advertising (USA):
Susan Dearborn, Publisher's Communication Group
875 Massachusetts Ave., Suite 81, Cambridge MA 01239, USA
Fax: (617) 354 4804 email: sdearborn@pcgpivs.com

Subscription Rates (calendar year only):
UK/EC individuals £30; institutions £108
North America: individuals $46; institutions $150
Rest of the world: individuals £30; institutions £108;
All rates include postage.
Subscriptions to:
Subscriptions Department (UK)
Routledge, Cheriton House, North Way, Andover, Hants SP10 5BE, UK.
Tel: +44 (0)1264 343062; Fax: +44 (0)1264 343005

Subscriptions Department (USA and Canada)
Routledge Journals,
29 W35th Street, New York NY 10001–2299, USA.
Tel: (212) 216 7800 x 7822; Fax: (212) 564 7854
email: journals@routledge-ny.com

Periodicals class postage paid at Rahway, NJ

Single copies available on request.

ISSN 0950–2386

Typeset by Type Study, Scarborough

Transferred to Digital Printing 2004

Contents

VOLUME 12 NUMBER 3 OCTOBER 1998

Articles

Anne Balsamo
INTRODUCTION **285**

Kavita Philip
TOWARDS A CRITICAL CULTURAL STUDIES OF COLONIAL SCIENCE **300**

Richard Grusin
REPRODUCING YOSEMITE: OLMSTED, ENVIRONMENTALISM, AND
THE NATURE OF AESTHETIC AGENCY **332**

Susan Squier
INTERSPECIES REPRODUCTION: XENOGENIC DESIRE AND THE
FEMINIST IMPLICATIONS OF HYBRIDS **360**

Ron Eglash
CYBERNETICS AND AMERICAN YOUTH SUBCULTURE **382**

J. Macgregor Wise
INTELLIGENT AGENCY **410**

Charles R. Acland
IMAX TECHNOLOGY AND THE TOURIST GAZE **429**

Notes on contributors **446**

Anne Balsamo

INTRODUCTION

T HE TOPIC FOR THIS SPECIAL ISSUE grew out of discussions I have been involved in the past few years about the structure of interdisciplinary programmes and in particular the role that cultural studies can play in rethinking humanities education for the twenty-first century. I bring to these discussions both a research interest in feminist cultural studies and a pedagogical interest in developing courses and classroom materials in the study of science, technology and culture. Since 1985, the date that marked the initial publication of Donna Haraway's essay, 'A manifesto for cyborgs', these two areas of interest have become increasingly intertwined for many cultural studies scholars as we have turned our collective attention to the critical analysis of science, technology and medicine as the dominant institutional sites for the production and circulation of contemporary global culture.

It is certainly true that this recent interest can be traced back to the clarion call that Haraway issued to socialists and other feminists in the mid-1980s. More than Haraway probably ever anticipated, the 'Manifesto' fulfilled its rhetorical objective: it served as the catalyst for an impressive range of new critical work that takes as its focus the cultural implications of new developments in science and technology. Noteworthy anthologies include *Technoculture* (1991), edited by Constance Penley and Andrew Ross, *Technoscience and Cyberculture* (1996), edited by Stanley Aronowitz, Barbara Martinsons and Michael Manser, and the work collected in *The Cyborg Handbook* (1996), edited by Chris Hables Gray. This is not to say that the works collected in these anthologies all follow in Haraway's footprints. In fact, Menser and Aronowitz take pains to assert that it is 'Haraway's *position* – but not her approach – on technology, science, and culture' that they largely share (p. 10). Their project represents what they characterize as a 'frontal assault' on the categories and concepts marked by the terms 'technology', 'science' and 'culture'. In contrast to Haraway's 'backdoor assault' (which they don't elaborate fully), Menser and Aronowitz argue for the development of a theory of complexity to describe and account for the shape of contemporary technoculture. This mild critique of Haraway notwithstanding, her work remains an important source of inspiration for cultural critics – and especially for an

entire cohort of feminist graduate students – who seek to understand not only the current technological landscape, but also the shape of things to come as we project ourselves, theoretically and politically, into the next millennium.

Naming this work

What has become evident by the mid-1990s is that the mere act of 'naming' of an area of study as 'cultural studies of science and technology' often generates controversy among those who subscribe to its intellectual objectives and theoretical commitments. As noted above, Aronowitz and Menser depart from Haraway's approach to the issue, while they steadfastly assert that cultural studies is best situated to provide a theory of complexity adequate to make sense of the contemporary organization of technoscience. Working a different section of this intellectual territory, Peter Dear takes issue with Joseph Rouse over his confusion about the influence of cultural and social history on contemporary cultural studies of scientific knowledge. Rouse's article, 'What are cultural studies of scientific knowledge?' was the lead article in the first issue of *Configurations* (the journal of the Society for Literature and Science). Here Rouse itemizes the issues that 'mark the movement beyond the terms of the disputes between internalists and social constructivists'. As he goes on to admit, it is 'for convenience' that he adopts the phrase 'cultural studies of scientific knowledge to refer to this quite heterogeneous body of scholarship in history, philosophy, sociology, anthropology, feminist theory and literary criticism' (p. 2). Rouse's objective in this piece was to introduce the readers of *Configurations* – many of whom come from a literary studies background – to a distinctive project built on the work of scholars from many fields, all of whom take a cultural approach to the study of science. Because he is concerned to elaborate the key differences between cultural studies of scientific knowledge and a social constructivist (SSK) tradition, the commitments he attributes to cultural studies are defined more in terms that belong to the discourse of SSK than to that of cultural studies. The six themes he attributes to cultural studies include:

> (1) antiessentialism about science; (2) a nonexplanatory engagement with scientific practices; (3) an emphasis upon the materiality of scientific knowledge; (4) an even greater emphasis on the openness of scientific practice; (5) subversion of, rather than opposition to, scientific realism or conceptions of science as 'value-neutral'; and (6) a commitment to epistemic and political criticism from within the culture of science.

To elaborate these themes he invokes the work of several noteworthy 'cultural practitioners' – Paula Treichler, Sharon Traweek, Donna Haraway, Evelyn Fox Keller, Bruno Latour, Leigh Star, among others. As he admits, the people he cites

do not comprise a singular school nor do they represent a common scholarly framework. Again, his point in listing the names of these diverse scholars is to draw attention to the heterogeneity of cultural studies projects that engage issues of the construction of scientific knowledge. In this, Rouse is successful; and yet his invocation of the name 'cultural studies' to identify this selection of scholars seems both familiar and odd at the same time. His choice of names works well to illustrate the claims he wants to make about the contribution that cultural studies can offer to the epistemological analysis of scientific knowledge. But the specific cultural theory that marks this work as an example of 'cultural studies' is less well elaborated. To be fair, Rouse's project (as he asserts several times in his article) is true to one of the abiding characteristics of cultural studies – that of its heterogeneity and cross-disciplinary influences. And yet there is a field of scholarship that has been *historically* identified as cultural studies that has during its history included work on issues pertaining to science and technology.

In fact, when reviewing that history, it becomes evident that the move made by Rouse – to gather a heterogeneous group of people under the umbrella term 'cultural studies' and to assemble insights from their work in the name of cultural studies – is one that has happened with some frequency during the past two decades. In the process, the identity paradox of cultural studies comes to the fore. How does one 'name' a field that is so deeply marked by heterogeneous and cross-disciplinary influences? Furthermore, in the face of this heterogeneity, upon what grounds can one assert the coherence of cultural studies? It is clear, as Richard Johnson illustrated, that cultural studies has a history and a sense of continuity and tradition in terms of the questions it addresses and the methods it employs. As I argued in a different context,[1] perhaps the best approach to take when attempting to stake out a territory for cultural studies is to do so historically: to revisit the work done over time to determine the ongoing commitments that mark the work as 'cultural studies'. To this end, the next section of this introduction attempts to recall some of those earlier attempts to apply the insights of cultural studies to questions pertaining to science and technology.

One set of influences

In that cultural studies itself builds on the work of an entire tradition of critical scholarship, especially the work of those associated with the Frankfurt School, this engagement has a long history. From Marx through Marcuse, not to mention Habermas and Polanyi, several scholars whose work is central to the development of critical theory had themselves been involved in the project of investigating the specifically cultural dimensions of science and technology. Key theoretical terms such as 'ideology', the 'public sphere', and 'capitalism' were debated and clarified in the work of these critical thinkers specifically in reference to the practices of technologists and the expropriation of a scientific worldview

in the development of both industrial and postindustrial societies. In making reference to this history, I am not suggesting that we need to return to the work of some 'mythic' fraternity of founding fathers in lieu of the inspiration of cyborgian feminism in order to continue our work on these issues. Rather I suggest that a review of some of the work done in the name of cultural studies in the 1970s and early 1980s on issues pertaining to science, technology and culture would not only ground this work historically – an important endeavour especially in the face of criticism that contests our 'right' to address such issues – but it will also illuminate nuances of the questions that continue to compel contemporary work. Although a fuller elaboration of this historical reclamation project is beyond the scope of this introduction, I'd like to begin with a consideration of two books and an educational curriculum that show the early influence of cultural studies on such questions.

Two edited collections, both published in 1980, grew out of the work of scholars who were associated with the Center for Twentieth Century Studies at the University of Wisconsin-Milwaukee (UWM) during the 1970s. These two books include some of the earliest work done in the name of cultural studies on issues pertaining to technology, art, and scientific rationality.[2] The first volume, *The Myths of Information: Technology and Postindustrial Culture*, edited by Kathleen Woodward, included contributions from Baudrillard, Huyssen, Wildon and Ellul among others, and included sections on 'technology, mass culture, and the public sphere', 'art and technology', and 'cybernetics, constraints and self-control'. The influence of the Frankfurt School's critical theory is explicit: Oskar Negt's article, titled 'Mass media: tools of domination or instruments of emancipation? Aspects of the Frankfurt School's communication analysis', elaborates the sometimes contradictory work on communications and the mass media by scholars such as Horkheimer, Adorno, Brecht and Benjamin. But others pushed beyond the insights of this group to analyse in greater detail the relationship between culture and technology. For example, in his article 'The hidden dialectic: the avant garde – technology – mass culture', Andreas Huyssen writes:

> I would go further: no other single factor ha[d] influenced the emergence of the new avant garde art as much as technology, which not only fueled the artists' imagination (dynamisim, machine cult, beauty of technics, constructivist and productivist attitudes), but penetrated to the core of the work itself. The invasion of the very fabric of the art object by technology and what one may loosely call the technological imagination can best be grasped in artistic practices such as collage, assemblage, montage, and photomontage. . . . It may actually have been a new experience of technology that sparked the avant garde rather than [as Benjamin argued] just the immanent development of the artistic forces of production.
>
> (p. 158)

Here Huyssen begins to address an issue that has become more pressing for cultural studies during the past decade – the relationship between the experience of technology and the production of culture. He goes on to offer a historical view on the meaning of the technologically saturated art created by various groups of Dadaists, not because their methods should be resurrected or imitated in the service of producing a critique of contemporary mass culture, but rather because their historically specific engagement with technology and art illuminates a critical project that persists for us today: how to make sense of the relationship between changes in the means of technological production and the contours of the realm of everyday life, especially as these technological developments are 'taken up' more broadly in art, literature and culture. Huyssen also points to a related difficulty for cultural criticism, both then and now: how to apprehend the contradictory effects of technology as it is implicated in the simultaneous creation of new possibilities and the reproduction of traditional, and often oppressive, social relations.

Several people associated with the first volume contributed to the second book as well, which takes its title from a phrase used by Huyssen in the above quotation: *The Technological Imagination: Theories and Fictions*. It is probably not surprising then to see the persistence of key questions from one volume to the next. One difference between the two books is that the second book includes several essays that focus specifically on the relationship between science, technology and literature. One section, titled 'Science fictions', includes work by Darko Suvin and Samuel Delaney, as well as by Teresa deLauretis, who writes:

> In every historical period, certain art forms (or certain literary forms . . .) have become central to the episteme or historical vision of a given society. . . . If we compare it with traditional or postmodern fiction, we see that SF might, just might, be crucial from now on. . . . The science fictional construction of a possible world . . . entails a conceptual reorganization of semantic space and therefore of material and social relations, and makes for an expanded cognitive horizon, and epic version of our present social reality.
>
> (p. 170)

Thus we see again the elaboration of a topic that has become familiar to those working in cultural studies of science and technology in the 1990s: a focus on science fiction, as a popular literary form, as a semantic field that narrativizes – and thus makes available for analysis and criticism – the arrangement of contemporary social realities.

In the 'Introduction' to the first book, Woodward describes the range of perspectives represented by the various authors in the anthology:

> Although the contributors represent many different disciplines – communications and cultural analysis, literary criticism, intellectual history, philosophy, aesthetics, art history, cybernetics, and economics – their work is best described as cultural studies. . . . Broadly speaking, the concern is with cultural politics. . . . Technology is not considered apart from culture, but rather a part of it, and one part only.
>
> (p. xviii)

Woodward's identification of the space of intellectual overlap as 'work best described as cultural studies' marks the scope of work not only in the two books described above, but also in the institutional setting that gave rise to the work collected in these two volumes. Beginning in the mid-1970s, several faculty from the Center had been teaching in an interdisciplinary programme in 'Cultural and Technological Studies' (CTS) started at UWM in 1969 as a curricular programme aimed at the University's engineering undergraduate students. The programme booklet (published at UWM in 1977) that describes the CTS curriculum states that one of the reasons for the development of the CTS programme was that 'Technology . . . is too important to be left to the technologists'. As the statement continues, it becomes clear that the faculty were beginning to stake out a new territory of intellectual inquiry:

> The basic aim [of the CTS programme] is to provide students a 'context', historical and cultural. Rather than attempt either to survey the vast and rich themes of Western culture or endeavor to provide students with a topical introduction to God, man, nature and society, our curriculum concentrates on the meaning of life and work in a technological society. Students have the opportunity to evaluate the basic value systems, to examine the limitations and opportunities which this context provides, and to question the relationship between current issues, power structures, change elements, societal needs, and ethical systems.
>
> (p. 4)

The booklet goes on to list the courses and syllabi that constitute the curriculum of the programme. Here we find courses from a wide range of disciplines: anthropology ('Cultural Systems, Energy and Technology'), zoology ('Bioethics and the Future of Man'), urban affairs ('Technology and Urban-industrial Development'), communications ('Human Communication and Technology'), comparative literature ('Literature and Ecology'), history ('Social History of American Technology to the Civil War'), philosophy ('Ethical and Legal Problems in Technology'), and political science ('Technology and Public Policy in the Courts'). Whereas the title of the UWM programme explicitly referred to the study of technology and culture, science was also considered to be an important part of

the critical purview of the programme in that several syllabi required students
to read basic scientific research, as well as historical essays on the development
of scientific rationality as a particular philosophical worldview.

The point in revisiting the details of the structure of the interdisciplinary
programme developed throughout the 1970s at Milwaukee is to illustrate the fact
that the interest in technoscience is not a new area of critical concern for cul-
tural studies. Moreover, this interest (as represented in the Milwaukee curricu-
lum) takes shape institutionally during the same time frame as did many science
studies and STS programmes in the US. Among the differences between the
UWM programme and other science studies efforts were both its focus on tech-
nology and culture and its inclusion of courses from a wide range of disciplines
into its curriculum. While the decision to include faculty and courses from across
the UWM campus may have been a thoroughly pragmatic one – apparently one
of the original aims of the programme was to provide a more coherently organ-
ized liberal arts education for UWM engineering majors – it enacts a commit-
ment that has by now become an abiding strength of cultural studies projects:
the reliance and utilization of interdisciplinary frameworks of analysis for the
study of the complex interactions among science, technology, medicine and other
domains of cultural knowledge and practice. We see also the resonance with
Rouse's invocation of heterogeneity and intellectual diversity in the name 'cul-
tural studies'.

Similar to programmes in science and technology studies, the foundation for
this early programme in the cultural studies of science and technology included
reference to the work of Jacques Ellul, Paul Goodman, Louis Mumford and
Thomas Kuhn. But it also drew on studies of literature, popular culture, science
fiction and art criticism as a way of shifting the terms of analysis from a focus on
the social characteristics of scientific practice (a typical concern of STS pro-
grammes) to a consideration of the cultural embeddedness and the cultural circu-
lation of scientific and technological knowledge. Several of the people associated
with the UWM programme in the 1970s continued to offer important insights
into the dynamic relationships among various technologies and cultural practices
explicitly in the name of 'cultural studies'. These scholars were themselves influ-
enced by the work of earlier critics, many of whom, as mentioned above, also
belong to a history of cultural studies. Thus it is possible to read in the various
syllabi the trace of the influence of Marxist theory, the social theory of the Frank-
furt School, and the aesthetic theory of Lukacs, Brecht and Benjamin.

The influence of communication and media studies

Although not as present in the work of the people at UWM, the other early influ-
ences for this focus of cultural studies rests to different degrees with Marshall
McLuhan and Raymond Williams. While both fixed their critical gaze on the

dominant media technologies of postindustrial society, they each employed dramatically different methodologies in their work. Where McLuhan contributed his 'tetrarch' as a methodological template for the analysis of a particular technology's influence and impact, Williams' focused on the study of technological forms and the complex ways in which technologies are both determining conditions and determined effects of specific cultural practices. While it is not the place here to rehearse the limitations of McLuhan's formalism, suffice it to say that his influence can still be seen in current cultural studies work, due no doubt to the resurgence of interest in him popularized by the editorial staff of magazines such as *Wired* and *Mondo 2000*, as well as the continued interest in Baudrillard's writing.[3]

Less well cited than McLuhan, but arguably more thoroughgoing, was Raymond Williams' studies of broadcasting technology, most notably his book, *Television and Cultural Form*, published in 1974. Williams, like McLuhan and Walter Ong, appreciated the centrality of communication technologies for the social and cultural integration of postindustrial life. Williams refused McLuhan's technological determinism based on what he judged to be grand abstractions on McLuhan's part in favour of a more grounded analysis of the relations among specific communication institutions. Instead, he promotes a theory of complexity (his term) to describe and explain the determining influence of various media technologies.

> Determination is a real social process, but never (as in some theological and some Marxist versions) as a wholly controlling, wholly predicting set of causes. On the contrary, the reality of determination is the setting of limits and the exertion of pressures, within which variable social practices are profoundly affected but never necessarily controlled. We have to think of determination not as a single force, or a single abstraction of forces, but as a process in which real determining factors – the distribution of power or of capital, social and physical inheritance, relations of scale and size between groups – set limits and exert pressures, but neither wholly control nor wholly predict the outcome of complex activity within or at these limits, and under or against these pressures.
>
> (p. 130)

Williams employs this theoretical foundation not only in his study of television and postindustrial culture, but also in his more historically broad-ranging analysis of historical communication systems. His essay on 'Communication technologies and social institutions' is worth rereading for the insights it offers about the so-called epochal transformations between oral, written and print cultures:[4] 'Between the invention of printing, in the 15th century, and our own day [1981], there has been a long and complex series of institutional changes and conflicts in the uses of this powerful and often decisive technology [writing]' (p. 228). His

focus here is on the complex interactions between social institutions and technological conditions whereby literacy becomes a widely adopted cultural objective and cultural battleground.

A fuller explication of Williams' study of the history of communication systems and literacy is (as are many other topics) beyond the scope of this short introduction. Although Williams is better appreciated for his attention to the study of cultural forms, of literature, of drama, and more recently of television, I suggest that his study of literacy is one of his most undervalued contributions to the developing field of cultural studies of science and technology.[5] Literacy – as an institutionalized set of educational objectives and a mass circulated set of specific knowledges – remains a contested zone of cultural authority. In describing the ways that notions of literacy are ideologically reproduced (and sometimes, though more rarely, contested) through the interactions among technological forms, scientific epistemologies, social institutions and popular cultures, he enacts a critical practice that is attendant both to the historical specificity of particular cultural arrangements and to the theoretical development of cultural studies more broadly. Literacy is a borderland where educational policy meets educational practice, cultural knowledge confronts cultural politics, and the social is reproduced in the individual. Much of the work going on in the name of cultural studies of science and technology implicitly addresses issues of literacy – either through an attention to the informal networks through which science and technology education circulate, networks such as popular science fiction, museums, or popular film, or through attention to the received histories of science and technology that serve as the guiding narratives of science education in the US today.

It is exactly on the topic of scientific and technological literacy that cultural studies faces one of its most pressing political challenges today. Our work is often interventionist in its objectives – the horizon of this interventionist aim is twofold. On the one hand we seek to describe and analyse contemporary arrangements of scientific and technological culture, arrangements that are often 'black boxed' by scientific and technological practitioners, and beyond the supposed expertise of lay critics. It is especially important for cultural studies of science and technology to investigate the way in which certain arrangements get *reproduced* over time, even as new agents, with new degrees of freedom, transform the landscape of possibilities. Because we live *with* this landscape we need to keep attentive to the way in which new possibilities are constructed while others are short-circuited and foreclosed.

An equally important horizon is to attend to the education of generations of younger students about the issues that will increasingly come to determine, if not dominate, their social worlds. Cultural studies scholars and critics need to take seriously the challenge and responsibility for transforming the educational system wherein new scientists, technologists and future citizens of the world are educated. Although the possibilities for curriculum revision are scarce, it is not

impossible. In fact, one of the ways in which cultural studies is growing is through new alliances with scientific and technological partners – in technical writing programmes, medical humanities programmes, and scientific ethics and techno-logical policy courses. Forging these new alliances represents an attempt to reap the intellectual terrain, and to stake a claim on a territory that has been previ-ously 'off-limits' to the non-scientist. As with other political struggles, this project is not without its risks and dangers.

As cultural studies scholars actively seek to contribute to debates about the structure of scientific and technological education, they find themselves in the position of having to navigate a highly charged and contested zone of cultural authority. These debates have garnered a fair share of media attention under the banner of the 'Science Wars' and have in the past two years included a number of well-publicized skirmishes between scientists and cultural critics. At issue are questions of authority and intellectual territory.[6] While some scientists contest the right of cultural scholars to critique the practices of technoscience on the basis of a (collective and individual) lack of scientific training and professional socialization, cultural critics counter that science, technology and medicine rep-resent the central institutionalized sites of ideological work in contemporary culture. As such, these technoscientific institutions and practices implicate all of us in global arrangements that we have a right, and in fact a duty, to debate, contest, modify and perhaps even to transform. These institutions and practices are therefore important areas of investigation – even for the supposedly untrained critic. Although scientific training and the related professional social-ization clearly bestow upon science 'producers' a range of intellectual privileges – including the privilege of speaking the discourse of truth – the lack of such training and socialization does not insulate anyone from the consequences of the deployment of scientific authority or technological rationality, nor does it dis-qualify a critic from understanding the intricacies of the social matrix within which technoscientific knowledge is produced and disseminated. In fact, one could argue, in the anthropological tradition, that the 'outsider' status of the cul-tural critic engenders an incisive (albeit perspectival) insight into the actions under consideration. While the debates are still ongoing among participants in the Science Wars, these skirmishes represent a significant chapter in the history of cultural studies in that they testify to the increasing influence of cultural studies within the US academy now, not just in the traditional humanities, but also in the sciences and other professional fields.

The work in this special issue

True to the influence of this history I have briefly invoked, the scope of these articles as a collection spans several traditional disciplines and implicitly argues that the study of scientific and technological formations demands a critical facility

to read across discourses and to borrow analytical insight from diverse interpretive frameworks. In contrast to the focus of SSK or STS – studies that emphasize the investigation of the social practices of scientists and technologists or of the development of scientific knowledge – this work focuses instead on how scientific and technological knowledge becomes institutionalized in specific cultural arenas such as medicine, tourism, the leisure industry, and youth culture. In this sense, the emphasis of these articles is more a shared focus on the deployment and circulation of scientific and technological knowledge – both diachronically and synchronically – than on its development and contestation.

In her article 'English mud', Kavita Philip investigates the epistemological issues at stake in the circulation of specific British colonialist 'settlement' memoirs of the late nineteenth and early twentieth century. She illuminates the concern on the part of indigenous people living in the hill country of Nilgiri – a region in the western mountains of India – about the colonialist transformation and control of the nature of the region. Her investigation of the rhetoric of colonial science shows how scientific and technological rationality, as historically specific forms of subjectivity, aided the British imperialist project in settling the region. One of the attendant consequences was that certain classes of scientists (including anthropologists as well as botanical agriculturists) became engaged in the colonialist transformation of an entire region and social system. As Philip points out, traditional SSK approaches will often investigate issues such as the social construction of nature, but not usually with an understanding of the way in which such constructions are themselves politically contested and embedded in global political economies – in short, how they are constituted in relation to the enterprise of colonialism. By combining the insights of SSK and the sociology of science with cultural studies, Philip shows how social constructions are politically and economically 'stitched into place' even as they are contested by other social actors. Thus, she contends that:

> historical scholarship in cultural studies of science is faced with a unique opportunity: that of transcending traditional boundaries between disciplines by forging a historiography which fully incorporates the insights of cultural/textual studies, to yield a genuinely integrated approach to engaging in a dialogue with the past – one that combines political engagement and cultural critique without abandoning the rigour of complex and detailed historical analysis.

Working on a similar concern, namely the way that cultural constructions of nature vary historically as well as geographically, Richard Grusin analyses the narratives embedded in a specific conservationist act: that of creating Yosemite as a US national park. His article, 'Reproducing Yosemite', discusses the expressive (signifying) practices of landscape architecture as it develops in concert with and against nascent beliefs in environmentalism in the US in the nineteenth century.

In his attention to the historical specificity of the circulation of a discourse about nature and aesthetics, he shares with Philip a concern to keep cultural studies historically grounded. His contribution, in keeping with this focus, is an illumination of the way that scientific and technological practices (specifically of Olmstead's borrowing of certain tropes of neuro-medicine) were implicated in the reproduction and dissemination of certain relations of capitalist production. In the case of Yosemite, he shows how Olmstead's invocation of the therapeutic value of natural scenery refracted the contradictions of late nineteenth-century capitalism. For Olmstead, the therapeutic benefits offered by the 'national' park simultaneously built on and elided the effects of social and psychological exchanges that constituted the capitalist marketplace in the nineteenth century. Grusin's reading of the Yosemite conservation project draws attention to the historical moment when 'environmentalism' became thinkable in America. Thus he illuminates the historical context and epistemological antecedents for the development of a particular cultural logic that persists today.

Working on a dramatically different intersection between science and nature, in her article, 'Interspecies reproduction: xenogenic desire and the feminist implications of hybrids', Susan Squier examines the meaning of the invocation of a specific experimental medical procedure: cross-species fertilization. Even as the procedure is 'outlawed' in various government reports, Squier shows how the concept, once put in circulation, has contradictory ideological effects. Her close reading of an official governmental research panel report yields a glimpse of both an underlying moral anxiety and acute curiosity with the mixing of human and non-human biological material. For Squier, this anxious obsession about hybrid embryos recalls theories of race that circulated in the seventeenth, eighteenth and nineteenth centuries. As she briefly reviews the historical development of the scientific interest in hybridity, she illuminates the trace of a racist ideology at work in contemporary scientific theories of interspecies reproduction. To show further how this ideology circulates in other cultural forms, and in more recent historical moments, Squier turns her attention to the elaboration of narratives of hybridity in more recent literary texts, first of several texts that reveal the nuances of a modernist fear of hybrids and then of those that announce a particular postmodern fascination with the promises of hybridity. Through her close analysis and reading of one through the other, Squier describes how both scientific theories and literary texts reveal broader cultural preoccupations with reproductive boundaries and transgressions. Moreover, she shows how even the most proactive texts on xenogenesis betray our limits to think outside the boundaries of 'class, race, gender, species, as well as propagative methods'. She ends – by invoking Rosi Braidotti's work – with an invitation to feminists to begin to think 'interspecies reproduction within an alternative register of non-sexual reproduction'. Squier's article shows clearly the way in which scientific debates get taken up in specific popular cultural texts. Culture and science, in her view, are not worlds separated by ontological and

epistemological differences, but are rather interlaced sites for the elaboration and circulation of a particular worldview that has material consequences for all participants.

In a way similar to Squier's invocation of the racist implications of theories of hybridity in the biomedical sciences and in the shift from modernist to post-modernist literature, Ron Eglash maps the cultural politics that emerge in the transformation between phases of cybernetic theory as they parallel changes in American youth culture. His article, 'Cybernetics and American youth sub-culture', offers a speculative account of the causal links between cybernetics and popular culture – links that he argues work in both directions – especially as they concern the non-scientific involvements of early cybernetic theorists, including Norbert Weiner, Gregory Bateson, Margaret Mead and others. Eglash notes the way in which political polarization accrued to those dichotomies central to the field of cybernetics. Of particular interest is the way in which 'recursivity' as a characteristic of self-corrective systems becomes identified with a humanistic notion of liberation. In Eglash's work we read echoes of Raymond Williams as he discusses how scientific and technological constructs are complexly, and often contradictorily, implicated in the determination of other cultural phenomena as they are also influenced by broader cultural forces. He then proceeds to trace the ways in which the *meaning* of the analogue–digital dichotomy is differently deployed in various social analyses and scientific accounts of the different phases of the historical development of the informational sciences. By his own admission, his final analysis backs away from offering a grand statement to explain the confluence between the technoscience changes he traces in the field of cyber-netics and the ones he isolates in various popular cultural practices. In doing so he reminds us that the power of cultural analysis does not result from the pro-duction of grand theoretical formulations about various cultural practices, but rather from the act of making manifest the connections between what seem to be on the surface disparate practices and knowledges.

Greg Wise takes up a topic similar to Eglash's in that he investigates the nature of agency in cybernetic systems. His article, titled 'Intelligent agency', considers the 'nature' of intelligent agents – programmes that navigate infor-mation networks as an 'agent' of a computer user. Such IAs serve as mediators between a cybernetic structure – such as the space of networks of information – and the individual user. But the nature of the agency of these programmable intelligent agents is dubious at best. They are, Wise argues, always 'double agents' – working for the user in an immediate sense, but ultimately for a cor-porate agent in some guise. The nature of the agency possessed by IAs is com-pared to the nature of agency possible for cyborg citizens. This leads Wise to a discussion of the differences between linguistic agency and technological agency as two forms of agency available to technological users. The point of his analysis is to draw our attention to the way in which technologies not only 'have agency' in a Latourian sense, but are reproducing agents that can function as social actors

and as our proxies in the information landscape of the Digital Age. As Wise argues in the end, this technological multiplication of disembodied social actors *who are empowered to act on our behalf* is not a part of some science fictional future, but a current situation that requires our immediate attention.

The final article in this special issue considers a relatively new mass-mediated technology for the circulation of scientific and technological knowledge. In his article, 'IMAX technology and the tourist gaze', Charles Acland offers an analysis of the development of IMAX cinema as it extends the filmic perspective of popular cinema into the tourist industry and museum culture. His project has significance for both cultural studies as well as film studies in that he argues that IMAX is a 'powerful example of the changing role of cinema-going in contemporary post-Fordist culture'. In describing IMAX as a 'multiple articulation of technological system, corporate entity and cinema practice', Acland employs Gramscian social theory to describe the 'meaning' of this emergent media form and shows how specifically it is reconfiguring older cultural forms and practices under new conditions of spectatorship and filmic production. In doing so, Acland comes the closest to Williams' approach to the cultural study of technological forms by focusing simultaneously on the relationships among the social institutions (cinema, tourism) that shape the development of this new technology, and on the impact of the technology on other institutional arrangements (spectatorship, the epistemological structures of museum culture). In the process, he returns to an insight suggested by Raymond Williams several years ago: that culture is taking over the integrative function of social practices. As Acland points out: 'the distinctions between the museum and the amusement park, between institutions of public education and public entertainment, between shopping and tourism, and their associated modes of presentation, are increasingly muddled.' His study – of one site of the collapse of the social into the cultural – serves as an insightful model for the construction of cultural studies of science and technology in that it offers rich details about the organization of media institutions and the development of new technologies while it educates the reader about the significance of these arrangements and the transformations we often fail to notice.

Although there is some disagreement about the most important points to emphasize in studying the cultural dimensions of scientific and technological formations, taken together the contributors to this collection offer accounts of science and technology as cultural accomplishments that are simultaneously influenced by and implicated in reproduction of broader cultural arrangements. This is the promise, following Raymond Williams, of cultural studies of science and technology – to show with historical rigour and analytical precision how science and technology are both determining conditions and determined arrangements. Whereas the broad aim of this issue is to build on the work of science and technology studies (STS) as it has been developed and disseminated in the US during the past three decades, it is specifically concerned to extend this

work into the domain of culture. The articles in this issue demonstrate the particular contribution that cultural studies can make to the exciting and sometimes cranky area of research in technoscience studies. At the very base, authors share an understanding of science and technology as immanently social practices, but they are also concerned to illuminate how such practices are themselves part of broader cultural formations. Taken together, these articles identify the range of scientific and technological issues that will be important across global cultures during the rest of this decade and into the next century.

Notes

1 Anne Balsamo, 'Feminism and cultural studies', *Journal of the Midwest Modern Language Association* (Spring, 1991): reprinted in Jeffrey Williams (ed.) *The Institutions of Literature* (SUNY, forthcoming).

2 Kathleen Woodward (ed.) *The Myths of Information: Technology and Postindustrial Culture* (Madison, WI: Coda Press, 1980) and Teresa deLauretis, Andreas Huyssen and Kathleen Woodward (eds) *The Technological Imagination: Theories and Fiction* (Madison, WI: Coda Press, 1980).

3 *Wired* magazine claims McLuhan as its 'patron saint'. *Mondo 2000* gushes McLuhanesque platitudes in every (sporadically published) issue. Baudrillard is another author who takes McLuhan a bit too literally without considering the implications of his technological determinist position. See especially his essay, 'The implosion of meaning in the media and the implosion of the social in the masses', in Kathleen Woodward (ed.) *The Myths of Information: Technology and Postindustrial Culture.*

4 In Raymond Williams (ed.) *Contact: Human Communication and its History* (New York: Thames and Hudson, 1981: 225–38).

5 For a compilation of this work, see Alan O'Connor (ed.) *Raymond Williams on Television: Selected Writings* (London: Routledge, 1989).

6 For an insightful analysis of the implications (specifically) for cultural studies of one recent skirmish in the 'Science Wars', see Jennifer Daryl Slack and M. Mehdi Semati, 'Intellectual and political hygiene: the "Sokal Affair"', forthcoming, *Critical Studies in Mass Communication* 14:3 (1997). See also the volume edited by Andrew Ross, *Science Wars* (Durham: Duke University Press, 1996).

Kavita Philip

ENGLISH MUD: TOWARDS A CRITICAL CULTURAL STUDIES OF COLONIAL SCIENCE

Abstract

In order to analyse colonial science as a form of culture, we must tell the multiple, tangled narratives of race, class, gender, nation and scientific progress together. The construction of ideas of nature in British colonies, for instance, intersects with the construction of 'primitives', the privatization of land, the scientific management of forests, their products and their inhabitants, and the political economy of global exploration. Excavating archival records of Ootacamund, a British hill station in South India, I read popular narratives of mud, flowers, forests, tribals, plantations, labour, disease and progress. These interlocking narratives must be read together if we are to understand the cultural construction of colonial science as part of a larger system in which a global political economy and a scientific epistemology were being simultaneously legitimated.

Keywords

colonial science; British India; hill station; nature; anthropology; forestry

ALTHOUGH THE HISTORY OF COLONIALISM, the processes of decolonization and the condition of postcoloniality have been widely

written about in the last two decades,[1] the question of the importance of scientific discourse in material and cultural terms to colonial administrative systems and to the colonizer–colonized relationship has been largely undeveloped theoretically.[2] The question of 'colonial science' is beginning to be raised by historians of science interested in the social and economic history of medicine, forestry, anthropology and natural history.[3] However, histories of science in the non-Western world continue to be understood by mainstream history of science in a framework which divides up historical studies according to 'areas of specialization'; rarely do we see theoretical insights from these studies brought into a sustained engagement with the study of Western science, or developed in methodological discussions on the historiography of science.[4]

The history of Western science, particularly as it developed in Britain after the Industrial Revolution, is incomplete without an account of the ways in which 'science' as an intellectual and philosophical project, and later as an institutionalized and professionalized field, was constituted in relation to the enterprise of colonialism. Thus colonialism is a central moment in the history of nineteenth-century science, and one that deserves a different kind of attention than it has received from historians of science.

The need for critical approaches to the historical and cultural studies of colonial science can be addressed most fruitfully by a framework of the sort that has in recent years been developed by scholars in the cultural studies of science, a field that is greatly indebted to, but in important ways different from, the history of science and science and technology studies.

As I see it, historical scholarship in cultural studies of science is faced with a unique opportunity: that of transcending traditional boundaries between disciplines by forging a historiography which fully incorporates the insights of cultural/ textual studies, to yield a genuinely integrated approach to engaging in a dialogue with the past – one that combines political engagement and cultural critique without abandoning the rigour of complex and detailed historical analysis.

In this article I illustrate one approach to the study of the mutual constitution of colonial science and culture in nineteenth- and early twentieth-century India. Focusing on the Nilgiri hills of south-western India, I offer an overview of the intersecting colonial narratives of 'natural' and 'cultural' progress by describing the dramatic changes in the physical and conceptual landscape of these hills after they were 'discovered' by the British. I argue that, by examining the discourses of English administrators, ethnographers, missionaries, planters, foresters and hunters, we can read their intersecting 'narratives of nature' in order to understand not only attitudes towards nature in a particular historical context, but also for the political and cultural agendas these narratives implicitly promote, the 'ways of knowing' that they legitimate, and the complex power relations within which these different narratives intersect, conflict with or complement one another.

Section I – Historicizing nature: some thoughts on methodology

Thanks to its work over the last two decades, science and technology studies (STS) has made it a commonplace that 'science' is a form of 'culture'. The British school of sociology of scientific knowledge (SSK) introduced to the sociological study of science an observational methodology borrowed from anthropology, which yielded 'laboratory-level' understandings of the sociological dynamics within and among scientific communities.[5] SSK's extension and modification of traditional sociological methodology, through 'ethnomethodology' and its corresponding relativistic epistemological stances, revealed the myriad modes of 'construction' that scientists employ, thus showing that science is a form of culture like sport or religion.[6]

However, as philosopher Joseph Rouse has pointed out, one problem with 'epistemic relativisms which place scientific communities on a par with others and with one another' through 'exposing' the 'social aspects' of scientific practice lies in their implicit assumption that 'scientific knowledge belongs to a single kind, similar or distinguishable in kind . . . from other kinds'.[7] In other words, the claim that scientific theories can be explained as being based on 'social factors' merely leaves the category 'social' unproblematized, and ignores how the construction of scientific terms, metaphors and theories is imbricated with cultural processes such as the production of meaning and identity.[8] The production of ideology is not often considered to be an interesting subject of investigation by SSK practitioners, perhaps because the normative implications of ideology critique have traditionally been taboo in Anglo-American sociology. Joseph Rouse has suggested that SSK-style relativism sets up a research paradigm in which ideology critique is difficult if not impossible.[9]

Postcolonial theorizations of marginalized epistemologies are conspicuous by their absence in the SSK literature. Where might we begin, then, in embarking on a study of indigenous responses to colonial control of nature, if we wish to adopt an analytical stance quite different from the Latourian anti-normativism or the noncommittal Anglo-American SSK relativisms?[10]

The insight (usually credited to Thomas Kuhn, and thence taken up by SSK) that scientific theories are socially constructed must be complemented with the recognition (now most developed in literary and cultural theory) that social categories themselves are historically and politically contingent. An account of the social construction of a scientific theory or a technological artefact is incomplete if social categories themselves are reified and history narrowed to a primary focus on scientific communities and their interests. If science is really to be analysed as a cultural formation, it is necessary that political, scientific and cultural categories be simulateously problematized.

The expansion of the cultural studies rubric to the study of science and technology over the last five years suggests, I think, that we have effectively begun to

transform the terms of the post-Kuhnian debates, which were structured by opposing pairs: constructivism vs. positivist realism, sociological vs. 'internal' justifications of theory, the 'ethnographic insider' vs. the 'interpretive scholar' approach to observation.[11] While these debates have been useful in that they have served the important historical function of pushing enquiry into the nature of scientific knowledge beyond the Mertonian and Kuhnian paradigms, they run the danger of settling into an oscillation between irreconcilable opposites if they are not made the basis for still more radically interdisciplinary, boundary-crossing theoretical and empirical work. What we need is a detailed analysis of the ways in which ideas of nature embed themselves in human sociality: an analysis of 'nature' that is flexible enough to incorporate historically contextualized understandings of ideology, culture and global political economies.[12] The analysis of hegemonic cultural formations, of resistance from marginal subject positions, and of the global and historical developments that create conditions of possibility for certain forms of knowledge and reason to marginalize others, are issues to which critical cultural studies, in many guises, have developed sophisticated analytical approaches over the last decade or more.

In the next section I combine questions about the social construction of 'nature' (an issue at the heart of Latourian sociology of science, SSK, and feminist studies of science) with questions about the ideological construction of colonial modernity. This historical exploration is intended to be an introduction to the kinds of questions one might ask within the critical framework of 'cultural studies of colonial science', and does not attempt exhaustively to address all of the issues such a research programme might encompass. I choose to unravel colonial narratives of nature because 'nature' has been (and continues to be) the site on to which constructions of 'primitives' are projected. The dichotomy between nature and culture has been recast countless times in the history of the West; each time its specific configurations inevitably reveal the deep structure of race, gender and property relations. The analysis of some of these recastings, then, will be our route into the belly of the progress-narratives that sustained the civilizing missions.

Section II

In this section I move to a historically and regionally specific investigation of nature narratives. The Nilgiri district of Madras Presidency, where the British colonial government located its summer capital in order to escape the heat of the plains, was the object not of those common constructions of the colonized landscape as hostile and barren, so familiar to us from *Passage to India* or *Heat and Dust*, but of constructions so cloying and rosy that they might seem, on a first reading, to assimilate India to the English self, rather than figuring it as radically other. The first part of this section will interrogate these constructions, moving from

representations of 'nature' in descriptions of climate, vegetation, landscape and so on to representations of power and authority in the management of nature and from there to the interwoven management narratives of nature and natives.

The second part of this section takes up the possibility of counter-narratives. Any investigation of hegemonic constructions cannot help but reveal the ways in which these are rendered unstable even in the act of construction. The complete exploration of narratives of resistance is outside the scope of this article;[13] however, this short section will identify some of the unstable moments in colonial constructions of the Nilgiri inhabitants, suggesting where the fractures lie in what might otherwise come across as a seamless and closed narrative. Section III, finally, surveys the diverse array of narratives that come under our scrutiny as we refine and expand our analytical lens.

Section IIa – Colonial nature-narratives: environmental progress in the Nilgiris, India, 1830–1930

Lord Lytton[14] wrote to his wife while staying at the Government House at Ootacamund, in the Nilgiri hills of the Western Ghats, describing the summer capital of Madras Presidency thus: 'I affirm it to be a paradise. The afternoon was rainy and the road muddy but such beautiful *English* rain, such delicious *English* mud.'[15] He went on to describe Ooty as a combination of 'Hertfordshire lanes, Devonshire towns, Westmoreland lakes, Scottish trout streams and Lusitanian views'.

Thomas Macaulay, after a visit to Ooty in June 1834, wrote that it had 'very much the look of a rising English watering place'. He reported to his sister that the scenery looked like 'the vegetation of Windsor forest or Blenheim spread over the mountains of Cumberland'.[16]

Lytton and Macaulay were only two of the most eminent of the hundreds of English residents of India who in letters, magazines, guidebooks and histories extolled the 'English' virtues of Ootacamund.[17] Was this narrative of the Englishness of the landscape a consequence of the 'naturally English' landscape of the Nilgiri hills? I will argue, rather, that it was a culturally and politically significant construction of the environment, and that in examining such 'narratives of the environment' we might arrive at a method by which to study the intersecting mechanisms that constitute environmental politics in specific periods. I will describe several parallel narratives of the Nilgiri hills, examine the function of each and ask whether the contradictions and inconsistencies of these various discourses tell us something about the ideological basis of English presence in the hills.

The first record of European interest in the Nilgiris is in 1602, when Francisco Roy, the first Roman Catholic Bishop of the Syrian Christians, despatched a priest and a deacon to investigate stories of a lost tribe of Christians 'in a country called Todamala', with the aim 'that priests and preachers should be sent

thither immediately to redeem them to the Catholic faith, baptise them, etc.'
(Price, 1908). They found the Todas, whom they believed to be degenerated
from 'the ancient Christians of St. Thomas'.[18] However, there was almost no
European interest in the region for the next two hundred years. From 1799
onwards, the Nilgiri mountains were included in the revenue area of Coimbat-
ore, and Price reports that a Chetty would periodically collect revenue. In 1819,
two Europeans in pursuit of a Poligar accused of robbing Coimbatore peasants
followed him through a mountain pass and 'discovered' what was later to become
the town of Ootacamund, then a Toda settlement. Sullivan, Collector of Coim-
batore, was greatly excited by the find, and in two years had built his own resi-
dence there, at which, later documents report, he spent increasing amounts of
time, reluctant to leave a land which he envisioned as a home away from Home,
a promised land where Europeans would multiply and thrive on English produce.
One of the first things he did was to import a gardener from England, to make
this vision into a reality. One commentator records:

> [G]ardening . . . was a passion with Mr. Sullivan. He sent for a gardener
> from England, a Mr. Johnson, who was left in charge of building operations
> when the Collector had to tear himself reluctantly away to attend to the
> affairs of his district. With Johnson, in 1821, arrived the first English apple
> and peach trees and strawberries, the first seeds of flowers and vegeta-
> bles. . . . Potatoes were introduced, and flourished. . . . A few years after
> Mr. Sullivan's arrival, gargantuan wonders were being compared as proudly
> as though their owners were competing in a village show at home. A beet
> is recorded as being nearly three feet round, a radish three feet long, and
> a cabbage plant eight feet high. Geraniums grew in hedges, and somebody's
> verbena forgot its place and shot up to the sky on a trunk like that of a
> robust tree. English oaks and firs were planted . . . in 1829 there were wild
> white strawberries, wild Ayrshire roses, and small, deep damask roses
> growing in Ooty. . . . A convalescent young officer . . . [described Ooty as]
> 'presenting to the eye a wildered paradise.'[19]

The specially imported Johnson and a host of enthusiastic fellow-gardeners
rapidly transformed Ooty into an English vision of paradise, refracted through
colonialist tropes of gigantic tropical wonderlands, thus ending up with an image
of 'Home' enlarged into fantastic proportions. (I will discuss other, grander-scale
visions of transformations through planting later.)

Ooty, like other English settlements in the hills, grew around state govern-
ment official activities and the stationing of troops in a climate conducive to
'English' patterns of life. As Anthony King has noted:

> [The hill station] provided, in its physical, social, psychological and 'aes-
> thetic' climate, the closest approximation to conditions of life 'at Home.'

Of all areas of settlement, it was the hill station which most easily permitted the reproduction of metropolitan institutions, activity patterns and environments.[20]

Although the attraction of the hills came initially from what seemed to be their astonishing 'natural' similarity (climatically and topographically speaking) to England, King goes on to note, they came increasingly to be cherished as sites of the elimination of two factors which 'restricted social life' in the plains. First, because of their relative isolation, the hills could not be monitored as easily by British officials, whether in India or in London. Thus an individual English officer's authority was practically unlimited in the hills. Second, English officers and their families could retreat from the large urban Indian populations of the plains to the sparsely populated hills, in which indigenous natives could be seen as quaint rather than threatening.[21]

The overcoming of these three major constraints of the plains (oppressive climate, restricted authority and ubiquitous natives) is the basis of much narrative-building by Europeans in the Nilgiris from the founding of Ootacamund in 1821 up through the twentieth century (and indeed, in interesting ways, continues today). I explore some of these narratives below.

Climate

Consider the following extract from an early twentieth-century verse entitled 'Nilgiri sunshine', penned by a Civil Service officer in Ooty:

The Nilgiri sunshine!
Sheer gold out of blue,
Heart-winning, heart-warming,
Heart-waking anew;
The flowers for its fairies,
The birds for its friends,
And its message — 'Life's excellent;
Life never ends.'

The sunshine of England
It shows in its way
That winter's not summer,
That night isn't day;
But it can't call the colours,

It hasn't the art
Of the Nilgiri sunshine
That kindles the heart.

.

.

There's a breath in the wattle,
A stir in the gums;
Down his bright stairway
The sun-god comes –
Down to his Nilgiris,
Azure and gold,
Where nobody ever
Need fear growing old.[22]

Here we are told: not only is the Nilgiri climate a relief from that of the Indian plains, but it surpasses even that of England. As we saw in the earlier description of flowers and vegetables, the Nilgiris are represented as paradise: as England on a grander scale, a land blessed to excess by the nature gods. Those who reside there are blessed with immortality. The first two stanzas make it clear who these immortal residents are: it describes 'the old fellows' – they are, most likely, planters or foresters – sitting outside 'the Clubhouse' – a mandatory component of every British settlement, it was a crucial cultural site for the reproduction of ruling-class ideologies – or playing cricket, their advanced age belied by the vigour with which they drive the ball. The poet would have us believe that they are uncannily fit for their age, somehow having escaped from natural ageing processes such as might occur in less enchanted spaces, like England. English nature, the second stanza suggests, is far more prosaic, dull, decidedly unmagical, if functional and predictable. What gives Nilgiri Nature its superior power? How can we understand this apparent inversion of hierarchies?

English nature, this stanza suggests, is part of a timetable that regulates the day and the year, dividing them into predictable elements, and producing temporal progression ('the seasons change, the years pass, men grow old'). In the Nilgiris, however, the Englishman escapes from the tyranny of regulated, ordered temporality into a space that stands outside time. (Nilgiri sunshine has 'the art' that English sunshine doesn't – this appeals to a view of art as outside of sociality and temporality, eternal, unspoilt by the griminess of production relations.) Like 'pure' art, then, Nilgiri nature is unburdened by social functions; its manifestations are 'fairy'-like, full of flowers and birds. The status of paradise thus accrues to the Nilgiris by virtue of the asociality of its nature. 'Naturally', then, when one escapes sociality and temporal progression, one attains immortality. However, this pure uncorrupted nature and therefore this immortality are not available to everyone. There are at least two moments in the poem that allow us to unpack the self-understanding of this poem. Consider the flowers, fairy-like, putatively sprung from a divine nature: it was no secret, either to the planters in the poem or to the author himself, how the flowers came to be there. The

sweetpeas and daffodils that adorned the landscape were cultivated by professional and amateur English gardeners, as we have already seen. The jolly celebration of nature in the first stanza is rendered unstable by the sociality that lies close to the surface of its 'purely natural' elements – one only needs to tweak this strand of sociality, so to speak, to have a whole mess of power relations disrupt the happy surface of this nature celebration.

Why do I claim that planting daffodils exposes messy power relations? Both metaphorically and materially, gardens were significant ideological spaces in British India. They were seen as bringing order and refinement to an alien and inhospitable land. In material terms, private and public gardens created spaces into which only certain types of citizens could legitimately enter: the civilized, genteel sophisticate with the capacity to contemplate nature in its pristine purity. Consider the word 'nobody' in the penultimate line: who does this exclude? By comparing narratives of Englishness with narratives of the 'native' and 'his' relation to nature, it becomes clear that this particular timeless construction of 'nature' is available only to the highly 'cultured' (that is, to truly appreciate nature in all its purity, one had first to possess the requisite cultural training, or sophistication). This reification of a pure or elevated nature, along with its pair, an elevated cultural sophistication, was accomplished through the 'othering' of a corresponding nature–culture pair, namely 'low' or debased nature and low or primitive culture.

One of the reasons indigenous worldviews occupied this position (defined by low nature/low culture) was because they failed to separate the natural and the cultural; as indeed they had failed to distinguish between work and leisure, between the sacred and the secular. They had failed to make the transitions that modernity and industrial production required, whereby they ought to have separated themselves, as self-acting autonomous subjects, from their surroundings, in order to truly act upon 'nature'. Instead, they confused nature and culture, ascribing subjectivity to natural objects (often naming hillocks, groves and other features of the landscape) and refraining from that genuine productive activity which results from an 'acting upon' and a transforming of the landscape.

The ascription of subjectivity to natural objects is contrasted with the creation of a new and progressive society, in the following description of the earliest European settlement in Ooty:

> Lord Elphinstone, then Governor of Madras, fancied [a] spot for the erection of a dwelling house, but met with great difficulty in effecting the purchase of the ground, on account of the objections raised by the Badagas, who had from time immemorial sacrificed a buffalo calf every year to a deity supposed to be present in an old decayed tree growing in that locality.[23]

The narrator describes how the Governor was able to persuade the Badagas,

through gifts and drinks, to give up their rights to the land for a nominal fee. He continues:

> No sooner was the transfer concluded than his Lordship began to enlarge the old building, and in course of time converted the property into one well worthy of a nobleman's residence. The house was magnificently furnished . . . the grounds were tastefully laid out, and the whole assumed the appearance of a beautiful English Manor House – full of enchantment and attraction to the exiled Europeans, a perfect oasis in the surrounding waste.[24]

Note the contrast, then, between the impulse to acquire property, and, through labouring, to transform it into a 'civilized' land, and the pre-modern deification of space that leaves the land static and inhospitable. (This contrast is sustained, in the quotes above, by the contrast between the 'decayed' trees of the natives and the 'enchanted' oasis of the Europeans.)

Despite the implication in this passage that indigenous ties to the land were easily swept aside, it was not the case that all Nilgiri tribes acquiesced passively to either the appropriation of their land or the succeeding 'upliftment' programmes of the state and the church. In a later section I touch briefly on the complex issue of indigenous resistance and the competing narratives of nature offered to the English settlers.

Power and authority

Why did the colonizing group see itself as somehow more fit to take charge of the land? The form a justification of this takes is identical to arguments made for the displacement of almost every indigenous group displaced by European colonists between the fifteenth and nineteenth centuries. Elizabeth Povinelli reminds us that:

> Early political-economic theory [Locke] postulated that laboring subjects created proprietary interests in things and that the mode of production determined the level of those proprietary interests. And colonial law settled Australia as *terra nullius* based on this assumption.[25]

In other words, since Australian aboriginals did not *labour* over their land, they were not entitled to own the land they inhabited.[26]

The British could never claim the *terra nullius* argument in India as a whole, since pre-colonial Indian society was already constituted by complex and interconnecting modes of production and had its own elaborate land tenure systems. However, in tribal areas, most often in hilly forested regions such as the Nilgiris, an argument very close to this was implicitly made. Categorizing vast tracts of

hill land (long used by tribal populations) as 'wasteland' or unused land, the government initiated forest management programmes and encouraged coffee and tea planters to bring the land under modern productive systems.

There is a considerable body of historical scholarship on land tenure in pre-colonial and British India, which I do not attempt to synthesize here.[27] Once again, however, popular narratives are invaluable windows into the manner in which ideological constructs of the economy found their way into 'common-sense' thinking. Consider the following extract from an anecdotal memoir of an Englishman who had lived in tribal hill regions for most of his professional life. The author is an avid hunter and nature lover of the contemplative kind found in the verses quoted above. He has been part of a half-century of hill 'development', and comments here on the requirements of civilizational progress and the inca-pacity of the native hillman to fathom them. After extolling the simplicity and honesty of the hill dwellers, he goes on to explain:

> [A]nimals have no money and no need for it; and it is much the same with the villagers of the Agency whose lives have been set by a kind and merci-ful Providence very nearly upon the animal level . . . the characteristic which most distinguishes the Agency man from his fellows is a hopeless and absolute apathy. He does not want to do anything, he does not care about anything, he does not value or seek or aspire to anything – which is a shade trying when your ostensible object is the reformation of him and his country. He does not much mind whether he lives or dies. [I] ha[ve] seen an Agency coolie go down with heart failure after carrying a heavy load of mangoes up a ghat, and the man crawled to a pool of water and lay down and died aimlessly in the most disinterested and casual way.
>
> . . . With this example in view you will not expect to hear that the Agency peoples show a quick interest in clearing jungle for cultivation, building roads or setting up sanitary houses for themselves or others; and indeed they do not. . . . How it is that [they do] not starve or die of sheer inertia is a problem science has yet to solve.[28]

What are the assumptions about the nature of environmental progress that enable this narrative to claim, without making any explicit argument, the impossibility of 'progress' for the 'native'? These are precisely the Lockean assumptions regarding the constitutive link between personhood and private property.

The author of this narrative also gives us a glimpse into the significance of hill-station life for the colonial administrator who chafed under the bureaucratic restrictions of life in the plains, where he was more directly responsible to government scrutiny (British administration was known for its complicated bureaucratic procedures). Thinking back to the poem about Nilgiri sunshine, one can see now that the *frisson* of immortality experienced by the happy cricket-players came not merely from the effects of a particularly sunny Ooty afternoon

– it was, in fact, a consequence of the increased power and authority[29] wielded by a colonial official in the hills, as compared to the plains. Take this account of official duties in the hills:

> [W]hat a godsend and relief it is to get a little elbow-room, a little broad freehand work, a chance of action not absolutely determined by Codes and Manuals. . . . Oh, the relief of getting away [from the Plains;] from niggling and pottering over Section X Subsection Z to a wider world where one lays out roads and reservoirs, plans for reserves and areas for cultivation, settles questions of rights and tenures, has, in a word, a chance of getting something done that shows.[30]

Officials in the hills could easily see themselves as invested with god-like qualities: a sense of omnipotence emerges, in this account, from the language of laying out, settling, and planning the lives and landscapes of the hills. Hill-stations were relatively isolated from the state bureaucracy, and hence individual administrators were less accountable to higher officials. This increased personal power allowed hill administrators to feel like lords of their own kingdoms.

In progressing from discussing climate and vegetation to discussing power and authority, we have not really moved outside of 'environmental' narrative. Thus deconstructing constructions of nature are, as I suggested earlier, powerful routes into political analysis. Our notion of environment ought to encompass social and political dynamics as well as the physical landscape, since the two continually constitute each other.

This brings us, of course, to the question which has been in the background since the beginning of this discussion: whose rights and tenures were being thus authoritatively determined? Who inhabited this land of Eden before it was 'discovered' to be a paradise? The answer is no secret; the Nilgiris, in addition to being heaven on earth for British officials and their families, was an ethnographer's paradise, and scores of anthropologists, amateur and professional, flocked there throughout the century to record what they considered valuable data on the origins of man, studying various aspects of the five tribal groups of the Nilgiris.[31] The narratives generated by European encounters with these groups will offer us another perspective on colonial constructions of the environment, and on the constitution of the 'hill tribes' as anthropological objects.

Natives

In his account of the early European settlement in Ooty, the German missionary Friedrich Metz describes the disenfranchisement of the Badagas from their land, in a passage quoted above. He describes how the land was obtained at a nominal price from the Badagas:

It used to be the boast of the old headman that the Government once came in person to ask for the site, and that he maintained his rights against him. It is said that what His Lordship did not accomplish, was afterwards secured by his Lordship's steward, who feted the Badaga chiefs and when he had got them into good humour, persuaded them to give up the land on condition of receiving an annual fee of 35 Rupees. The objections of those who had a prescriptive right to the soil being thus removed, his Lordship obtained the land on a lease for 99 years.[32]

Here we see the same land of enchantment invoked, but this time at the end of a narrative that exposes the other side of the bargain. Nor were the new inhabitants content with having gained control of the land; they had grander plans in mind: environmental and social progress through systematic planting, efficient production and a pedagogy of scientific progress.

Pedagogical efforts to uplift the natives were regularly made by missionaries, planters and forest officials. In 1845 Elphinstone's house was bought by Mr Casamajor of the Indian Civil Service, who established a school for Badaga children. Metz comments: 'but so little were the hill tribes able to appreciate the value of mental culture that it was necessary to offer them a douceur of one anna per diem for every child sent to the school.'[33] Metz himself spent several years trying to 'uplift' the Todas. Sullivan and administrators who succeeded him appointed 'chiefs' of the Todas to oversee the communication and authorize agreements between them and the Europeans. These appointments resulted, over time, in the undermining of traditional forms of authority. The Toda economy revolved around buffaloes and milk; their religious authority was known as the Pálaul, the person who oversaw the care and worship of the buffaloes. Metz comments:

> Prior to the period when Europeans began to resort to the Neilgherries, the authority of the Pálaul must have been very great, but of late years it has much diminished; and as the light of civilization has penetrated into the dark corners of the Hills, superstition has quailed under its influence; and even the self-righteous ascetic in his secluded retreat has gradually relaxed in those rigorous austerities which the religious notions of more primitive times had imposed upon him.[34]

Several ethnographers noted that the Toda birth rate began to decrease following European settlement of the Nilgiris; some noted a rising incidence of venereal disease and sterility. Many ethnographers expressed the concern that the extinction of the Todas would mean the loss of valuable data. In Metz's view,

one thing alone can ward off this result [extinction], and that is a hearty

reception of the Gospel with all its purifying and elevating effects upon the life and habits of those who embrace it in its fullness. [35]

Christian missionaries, in fact, were moderately successful in gaining Toda and Badaga converts; in most cases the converted communities lost ties with their original kin- and social groups. However, it was not the case that all Nilgiri tribes acquiesced passively to missionaries' and revenue officials' schemes of progress. Through lies, threats, and the possibility of flight, they carried on what were ultimately unsuccessful but often vigorous efforts at resistance.

Section IIb – Reading narratives of resistance

Implicit in the historiographical act of rereading colonial romanticist narratives of the land as discourses of power is the assumption that one can read hegemonic narratives against the grain, in order to study the forces, both dominant and subordinated, that formed the agonistic domain in which these narratives were forged. Reconstructing a subordinated narrative so as to restore historical agency to the marginalized is often seen as the next step in this counter-hegemonic historiography. Such a process was pioneered by the Subaltern Studies collective, whose many successes have nevertheless been accompanied by vigorous debate over the precise nature of their liberatory effects. [36]

The critical framework of a cultural studies of colonial science can, I believe, offer rich insights into the first stages of such a project. Bracketing for the moment the highly contested terrain of re-narrating histories through reconstructed subaltern subjectivities, we can surely offer up what cultural studies does best: we can unravel narratives of scientific progress so that the constructedness of a seemingly seemless scientific rationality is revealed. I suggest, tentatively, that the excavating of subordinated narratives of science will be far more fraught with difficulties than the historiography of, say, agrarian protest, simply because the hegemony of scientific ideologies has historically been more insidious, and therefore less contested, than the politics of land revenue or labour laws. [37] As Gayatri Spivak has argued, literary and historiographical skills must be actively intertwined when we read colonial histories against the grain. While the historian 'unravels the text to assign a new position to the subaltern', the literary scholar 'unravels the text to make visible the assignment of subject positions', she claims. [38] I defer, for now, the question of how we might reinscribe new subject positions in the agonistic domain of postcolonial science, while noting that this must be a central programmatic issue in any attempt to formulate a cultural studies of colonial science. For now, I will explore the points at which the colonial narratives of nature in the Nilgiris reveal fissures through which the agency of the indigenous inhabitants clearly asserts itself.

1 Lies and evasion

Friedrich Metz, the anthropologist-missionary who sought to save the souls of the indigenous Nilgiri tribes, offers us narrative histories that clearly reveal the difficulties of assigning them passive, backward, non-rational subject positions. While Metz anxiously asserts his own readings, the historian is offered generous glimpses into the contested terrain in which such assertions had to be made.

Metz tells us, for instance, directly and rather indignantly, that Toda 'informants' have long been lying to European enquirers:

> A familiar acquaintance . . . with their language . . . ha[s] led me to discover that much dissimulation is practised by these men towards Europeans, and that they soon detect what information the latter desire to obtain and make their replies accordingly. The custom of paying the Todas for every insignificant item of information has naturally brought about this result, and it is now a matter of difficulty to obtain from them any account of their previous history, upon the truth of which implicit reliance can be placed.

It is evident from Metz's accout that the Todas were by no means conveniently stable objects of scientific investigation. Processes of construction were evidently happening on both sides of the colonial encounter: the Todas, gauging that these strangers who tramped with increasing regularity across their pastures would pay sums of money for information about Toda history and customs, obligingly invented stories according to the context in which the question was asked. Far from being evidence of their fundamental irrationality, or incapacity to think historically, as was invariably postulated by frustrated enquirers such as Metz (who was one of the few who had, in fact, spent enough time with the Todas to notice such discrepancies), this was probably due to the fact that anthropologists' questions were invariably couched in terms of their theories of progression or degeneration of races, and not necessarily sensitive to the context in which they were asked, or the ways in which they themselves were perceived as interlocutors. Toda responses, then, were rational responses to a situation in which they were presented with questions whose formulations did not pay attention to the interlinking of their histories, landscapes and social practices; and, moreover, they appeared to be attached to a reward which they might avail of by satisfying the questioner with any combination of narratives.

In one of the Toda funeral songs recorded by Metz, different forms of sin are enumerated. Among these are killing a snake, lizard or frog, drinking water at a stream without first worshipping it, destroying a water reservoir, and making a complaint to the government. We might note the 'environmental utility' of these practices – respecting sources of water, protecting useful wildlife and evading government supervision are accorded equal value. The inclusion of the last into

a funeral[39] song indicates that the strategic value of lying to colonial officials was a tactic that was being written into the society's normative code of ethical conduct.

2 Hostility and threatened flight

Metz relates that although he was initially seen as nothing but a harmless story-teller, when his intent to convert became known, there was open hostility. Badagas refused him admittance into a village; in a Toda village they refused to give him milk, saying that the buffaloes would be destroyed by offended deities.

When the government issued orders restricting Toda buffalo sacrifices, Metz records the following:[40]

> When this prohibitory order was issued the Todas charged me with having been the cause of it, and vented their maledictions upon me . . . [they] threatened to flee from the hills, but I declared myself prepared to follow them wherever they might go; and in course of time they have become reconciled to the restrictions placed upon the mode of observing their ancestral customs.

Metz also refers to the 'hill brahmins' or Haruvaru, who would walk on coals. Metz scoffs at 'so palpable an imposture'. He suggests that 'they remained only a few seconds on the coal' so that there was no possibility of burning.

> I used often however to be taunted by them and challenged to perform a similar miracle in the name of my God: to which I replied that a much greater wonder than that was that I should not cease to love such squalid fellows as they were; and that too in spite of all the abuse they daily heaped on me.
>
> When a recent order was issued prohibiting the practice . . . I had to submit to the most dreadful execrations, showered upon me as the origi-nator of the order.

It is thus evident from Metz's own narrative that there was vigorous resistance to the imposition of a Christian narrative of the environment and people's place in it. The Todas, represented in anthropological treatises as a passive, peace-loving tribe, lethargic to the point of eternal indolence, were not incapable of causing the intruding missionary to flee when he became too offensive.

3 Other narratives?

It is possible to guess at a narrative of the Nilgiri environment that is quite differ-ent from the English promised-land narratives I have described so far. From the

reports of anthropologists and missionaries, a picture emerges of a landscape invested with social and religious significance by the different groups that inhabited and used it. Metz reports (in his tirade against idolatry) that there were at least 338 Toda idols in the surrounding area, placed on hills, in trees or by streams. Each natural feature of the landscape had a deity associated with it: *Gangamma* was present in every stream; *Bété Swamy*, the god of sport, had a particularly large tree as his resort, and *Mukurty* Peak was named after a piece of a demon's nose. Metz complains, 'a host of nameless gods . . . live in the heart of the lofty mountains, and in dense impenetrable forests'. Landscape narratives clearly conflicted here: the colonial narratives, while steeped in romanticism, saw themselves as securely anchored in a rational, resource-oriented scientific and technological paradigm. The indigenous narratives, which combined the conceptualization of nature-as-resource with that of nature-as-socio-religious-formation, were accordingly constructed as the 'other' of rational scientific discourse.

Interestingly, a later missionary, Catherine Ling, who spent forty-five years in the Nilgiris and became a trusted member of Christian Toda communities, was also written into the landscape, or had the landscape written into her:

> She has become with her steps this way on the way.
> She has become with her nose this way on the path.
> Moss has risen on the branches. A hump (lit. mushroom) has risen on the back.
> She has become like the sun setting on the hilltops.
> She has become like a tree yielding ripe fruit on the high branches.[41]

Thus we can see that the Todas commonly exercised a discriminatory taste when assessing the intentions of visiting colonialists; it seems they were far less likely than the colonizers to indulge in the creation of monolithic discourses of the other.

While amateur Nilgiri poets and popular writers might use religious metaphors of the sun-god or bountiful nature to extol the beauties of Ootacamund, their narrative of the land sits firmly within a post-Enlightenment secular worldview, by which a romantic contemplation of the landscape coexisted with a model of utilizing it through systematic and productive 'improvement'. In the next section, I examine this narrative of 'improvement' by expanding our archival exploration a little further than the confines of the 'English' town of Ootacamund. Narratives of nature were not, of course, confined to concerns about hedgerows and daffodils in Ooty lanes and fields. As examples of the routes by which the examination of nature narratives rapidly takes us through a number of different discursive fields, I will briefly touch on the discourses of hunting, planting, forestry and health.

Section III – The scope of nature narratives

1 Hunting

The narratives of hunting, or *shikar*, offer the historian a host of insights into this romantic yet masculinist and progressivist construction of nature. Here I will illustrate this with just one such '*shikar* narrative'.[42]

> It is a mistake to think that people are fond of shikar because they are fond of killing beasts. . . . [My] idea of shikar is to go out into the shikar country and meditate. [I have] . . . sometimes thought that if one can absolutely overcome one's body so that it becomes a mere block of substance, absolutely silent and absolutely still, one's spirit can get away from it and come into tune and touch with the place around one as do, no doubt, the spirits of animals . . . the inducing of a certain peacefulness of mind and a tantalizing sense of getting nearer to the heart of things.[43]

Here we have the narrative of a romantic communion with nature that all *shikar* stories include. Noting the language of metaphysics, one might ask what it is that distinguishes the romantic-religious narrative of nature here from the spirit-imbued Toda narratives decried by Metz. We begin to understand how this line is drawn when we note that what is so far left out in the *shikar* narrative above is the indigenous expertise and manpower that provides the material basis of this metaphysical experience. But we do not have to look far, for the British *shikari* always mentions his native assistants:

> Always, of course, one has one or more native shikaris; these are to be distinguished from their fellows by their extreme hideousness and by a skinniness which approaches towards hallucination. . . . Yet it takes a man in the very pink of condition and training to keep up with them on a long day's hunt. . . . Their capacity for work seems to increase slightly the more hideous and emaciated they are. . . . For all this, however, it is these wretches, armed with a condemned Police carbine or an old double-barrel or a country musket of a type unknown to modern makers, who kill off the game and spoil the Indian shikar.[44]

This narrative suggests that the practice of killing animals with guns is not quite the same when practised by emaciated natives as by serious English hunters in khaki shorts and solar topis. We are being led to believe here that the romantic appreciation of the wilderness is accessible only to a culture that has transcended the brute materiality of hunger and labour. This transcendence, of course, occurs via scientific forms of 'improvement'.

To show how the *shikari's* romanticist view of nature went hand-in-hand with

a pragmatic, scientistic approach to 'improving' nature, let us look at some narratives of systematic planting and of productivism as it applied to forests.

2 Planting

To address the ideas of planting and production, I will examine the narratives of afforestation, deforestation and forest labour that were generated around the Nilgiris.[45] By 1856, when military barracks were being built just outside Ooty, H. R. Morgan, Deputy Conservator of Forests, noted that there were no long logs to be had in Ootacamund. The Forest Department thus obtained 'a rented forest adjoining the Wynad teak Belt and by 1860 delivered 200,000 cubic feet of timber to the barracks at a cost of only 1 rupee/cubic foot, after all charges had been paid'.[46] The labour he employed for this job was recruited from among the Kurumbas; here we can detect conflicting narratives of the environment:

> In working this forest . . . the Coorumbers [sic] had to be trained to fell only the largest and best trees, as they were in the habit of felling a tree that would just measure about 12 cubic feet, as they were paid by the log. I introduced the system of payment by the cubic foot . . . At one time they gave much trouble, every large tree was 'Swami Tree' and could not be cut; even this difficulty was surmounted.[47]

Here the native is represented as a good source of labour, if firmly supervised. The trouble here is caused by the natives' *refusal to cut* trees; later we shall see that trouble also arises when natives do cut trees. At any rate, for timber operations, Morgan soon developed a typology of labour:

> In Wynaad the axemen are Corumbers. . . . They are also very useful for Teak plantations, many are intelligent, and the great advantage of employing them is that they live in the forest all year round, they fell and square timber with great precision, they can also be trusted in planting out operations; for cartmen, road labor, &c., Canarese are employed. Sawyers are obtained from Mysore and other parts. On the Anamallies, men from Palghaut are employed as axemen, they were very expert in dividing by means of wedges very large trees into planks suitable for dockyard purposes. The Kadirs, a jungle tribe, are useful for building huts, the Mahouts there and in Wynaad are generally musselmen, whereas in Nellumbore and those parts, they are almost invariably Punniars, and as the Nellumbore elephants are used without harness, dragging by their teeth, the equipment of a Punniar and his elephant may be said to amount to *nil*. These Punniars obtain an extraordinary influence over their elephants, and especially the males by a peculiar process. The local labor at Nellumbore is made up of

Malayalums and some Moplahs, and there are many trained men amongst them who understand planting and pruning.[48]

We note here that the forester must build a detailed ethnographic understanding of the 'inherent' capacities of various tribes. The responsibility of a Forest Officer, ran the dominant narrative of the forest department, was to conserve the forest against wasteful use and to harvest the forest for progressive and profitable use. We can see this in Morgan's textbook:

> It has always appeared to me that if the Forest Officer had an efficient establishment, his duty was to carry his timber to the best market.[49]

And, further:

> [T]he ryot should be saved from his own destructive habits and taught that to destroy forests is not the way to benefit himself, and that by a little timely forethought, he might procure forage for his cattle without having recourse to the reckless system pursued by him for ages.[50]

In order to fulfil his duties competently, a Forest Officer had to have multiple talents:

> [A] Forest Officer to be really useful should know first and foremost the language of the people, without this he is useless, or at best, at the mercy of intriguing interpreters. In addition to the language, the habits and customs of the people, then Arboriculture in all its branches, next Engineering and Surveying – how to build houses and bridges, survey roads, and blocks of forest, &c., run boundaries by a pickaxe trench, as mounds of earth, stones are useless. Physic his people when ill, treat them with tact, attend to the health of his bullocks and elephants, and last but not least, keep his own health. The life of a Forest Officer is not cast on a bed of roses, but rather a bed of thorns, an iron constitution and a good conscience may enable him to surmount all his difficulties.[51]

Here we are told that the Forest Officer had to be an expert in all sciences – engineering, ethnography, and most importantly, medicine. This knowledge would confer on him the power to be nurse and protector to both nature and human. The narrative of expert knowledge leads us to the narrative of paternal protection:

> In vain does the Forest Department try to save the ryots from themselves, their improvident habits too surely destroy the jungles which ought to last them for centuries. . . .It is not of the slightest use attempting to raise the

status of the ryot, so long as we leave the main points of his position untouched; and until he is educated up to a certain point, he is quite incapable of appreciating any efforts made in his favour. *It may be urged that this has nothing to do with forestry, I maintain it has,* for we have to consider communal rights and to teach the ryot not to encroach on reserved Government forests. . . . It is to be borne in mind that the ryot has for ages been brought up under a reckless system of mismanagement, and new habits are not learnt in a day especially by a people who are the most conservative that the world has seen. From sire to son for ages, the same habits, trades, occupations have been the hard and fast rule . . . the eternal laziness of the ryot prevents him from ever attempting to work for his descendants. (Emphasis added.)[52]

Here Morgan clearly lays out the paternal role of the forester: he must not only manage the chaotic tropical forest, but also drag the resisting forest cultivators (ryots) into the modern economy. The narrative of paternal instruction in the care of the environment found an ideal candidate for the villain of the piece in *kumri* cultivation (otherwise referred to as 'slash and burn' agriculture). Morgan decries it: 'Of all the varieties of cultivation carried on in the world, this is the most pernicious.' He lays out plans for its curtailment:

The aboriginal tribes must be found some other means of employment. They must be civilised. . . . *They must be encouraged to plant fruit trees and grow other crops than those they have been accustomed to.* They must be taught trades. . . . Congenial employment must be found for them by the Forest Department, such as timber squaring, the collection of forest produce, &c., and deserving men should be employed as watchers, elephant-drivers and maistries. They can be made of the greatest service to the Forest Department or the reverse; as they happen to be treated. . . . How can the Curumber be expected to rise in the scale of civilization when *he dare not possess property?* (Emphases added.)[53]

We return full circle, then, to where we started: the route to abundance is through the planting of 'fruit trees' and crops other than those indigenous to the area; progress can only occur if respect for private property obtains. In Ooty, we had another group of people formulating property rules and planting English fruits and flowers.

I have suggested that one can read these narratives not only for the narrators' attitudes towards the land, but also for the political values they advocate and the complex power relations within which they are located.

At this stage it is important to add that the story of interlocking environmental narratives is by no means completed with the parts described above. It was not only the government that cleared and planted forests, but also private

entrepreneurs who cultivated the plantation crops (rubber, tea, coffee and cin-
chona) for export to European markets. I will complicate my present narrative
by briefly pointing to a few more strands: the medical discourse, the private
planter's discourse, and the international political economy of transplantation.

3 Health, labour and planting

In the 1860s, there was an anxious medical debate over the possible correlation
between *kumri* and malaria. Reports from the Madras Government Medical
Department, and letters between the government, the District Collector and
tahsildars reveal several different lines of speculation about the nature of this cor-
relation. One of the most interesting was expressed by Cole, the Inspector
General, Medical Department, in 1865:

> I quite agree with those gentlemen who think that the soil of the Kumari
> [*sic*] cultivation is much more likely to be a source of fever than when
> covered by its original jungle. Whatever the ultimate essence of malaria
> may be, we know that it is largely contained in the soil, and that the first
> disturbance of the surface soil, whether for cultivation or other purposes,
> is often followed by outbursts of fever.

He thus suggests that the clearing of the forest that is carried out by tribals such
as the Kurumbas is an unhealthy practice, and might breed malaria. However, he
thinks that it is a good idea in general to clear the tropical jungle:

> As to the general question of permanently clearing and cultivating spaces
> in the dense forests of the Western Ghats, there can be no question but that
> such operations here, as in every other portion of the world, must ulti-
> mately result in sanitary benefit to the population. Excess of vegetation is,
> and probably will always be, in any part of the world, incompatible with
> the numerical increase of the human race.

What, then, is the significance and importance of clearing the forest? In the
private planting discourse, clearing the forest for cultivation is seen as a positively
valued activity, one that aids the progress of civilization. However, an anxiously
repeated if not always coherent distinction is constantly made regarding the
difference between European cultivation of the land and unscientific native forest
clearance. We are told that there is a difference between indigenous or traditional
clearing, and progressive, scientific clearing:

> The feeble races of N. Canara can make no headway against the jungle. If
> the latter is to be in part reclaimed, it will have to be done by other than
> indigenous labour. There can be no question, in a sanitary point of view, of

the benefit to these wild districts of encouraging Europeans of means and ability to take up and permanently clear patches of these vast forests, such as may be suitable for coffee, tea, or cinchona.

In fact, until very considerable portions of the Ghauts are cleared, it is very doubtful whether the climate will ever permit of the districts being inhabited by a healthy and industrious people.

The argument here suggests that forest clearing must be done under the supervision of Europeans, and must be for the purpose of planting crops other than the *kumri* crops, paddy and millet. It is only the plantation crops that truly bear the potential for the liberation of the land from its unhealthy state and of the population from its parochial agricultural practices. In an 1864 handbook for coffee planting, we learn that

> Everything on a plantation should be carried out scientifically, order and regularity being studied in all cases, no matter how trifling they may appear. The beauty of the plantation should be looked to as well as the productiveness . . . straight lines . . . render the plantation regular.[54]

We learn from another planting memoir that planting in the Nilgiris has many advantages: the local tribal labour is cheap, and extra labour can easily be shipped in from neighbouring districts in which unemployment is high. Further, the planters in this district have successfully lobbied the government to build public roads connecting them to markets and to urban machinery- and supply-centres.[55]

However, we are reminded that planting is a serious business, and not one that is available to any ignorant agriculturist:

> The natives . . . are daily opening their eyes to the profits derived from coffee cultivation, and it is not uncommon to see their threshing floors for rice filled with coffee. . . . Little, however, can be said in favor of these consumers of betel mixture – whether it is that the mildness of the climate and fertility of the soil render active exertion unnecessary, but these people seem to regard *sloth* as the chief luxury. Jungles have risen to an enormous price. . . . Some . . . Natives are insane enough to suppose that if they put in seed coffee on the ground, regardless of the wood or underwood being cut, that they will be in such a case entitled equally with the European planter to hold their jungles as coffee plantations; but surely Government won't be taken in by such a silly trick. Almost daily, exceedingly fine offers for jungles are made by Europeans to these [natives], but they will accept nothing in reason. . . . It is altogether a dog in the manger case.[56]

The argument being made here, evidently, is that the natives are perhaps subject to a form of climatically determined activity disorder that makes it impossible

for them to be true planters; to plant meant that one proceeded in an orderly fashion; one hired labour to clear the jungle and to plant in straight lines; further, one had to avail of roads, communications and the economic infrastructure that connected producers to markets. The natives, clearly, did not, *could not*, qualify for this position.

4 Local and global nature narratives

We can, it seems to me, employ neither the whiggish strategy of explaining the victory of one kind of theorization of nature over another as a result of its supposedly inherent superiority or correspondence with reality; nor the strong constructivist position that juxtaposes descriptions of self-supporting, internally coherent and incommensurable but equivalent belief systems while declining to comment on the historical/ideological matrix that frames them. I see the task of the cultural studies of science as different from both of these in that we must simultaneously assess and critique the construction of both scientific and cultural categories within a historical context whose norms, in turn, cannot be assumed to be unproblematically fixed.

Thus my own narrative is incomplete if it ends with yet another local discourse of the Nilgiri hills. This space in south India was itself never purely 'local'; although I have been piling on the local detail here, it should be obvious that my categories of analysis are in fact globally significant in this historical period. I have tried to show how British colonial notions of scientific progress were rooted in a system of thought that was neither universal nor transhistorical. It employed sets of oppositions between nature and culture, work and leisure, labour and sloth, active and passive, 'high' and 'low' culture, that were specific to the political and economic context of postindustrial revolution England. E. P. Thompson and Raymond Williams have shown us how these oppositions were ideologically employed in similar ways with respect to the transformation of the English peasantry and the creation of a working class.[57]

To understand the political economy of such a narrative, finally, one must move even further out from the Nilgiris, to examine the global botanical networks that linked colonial peripheries together through the centre of botanic expertise, Kew Gardens.

In the mid-nineteenth century, the British government launched an ambitious project, centred at Kew, to manufacture a cheap drug against malaria, which was claiming thousands of English lives and posing a danger to military strength and public health. The production of quinine (the anti-malarial drug extracted from cinchona bark) through the domestication of the cinchona tree in the Nilgiris resulted in the establishment of an enormous global network of exploration, collection and systematization of botanical knowledge, a centralized array of botanical gardens, and a colonial science of natural resource management. Thus we must move back and forth between local nature narratives to

global ones; between the interrogation of rhetorical constructions of daffodil-planting and the political economy of global trade.

Interrogating environmental rhetoric and practice as narrative, I have suggested in this article, offers a method by which to examine the rhetoric of colonial science in conjunction with its economic and political functions. In doing so, we might better understand how ideologies of progress and modernity constitute and are constituted by historically specific constructions of nature.

Notes

1 Said, 1979; Guha, 1982–94; Mohanty *et al.*, 1991; Amin, 1989.
2 However, excellent archival work on specific colonial sciences has been carried out in the last few years, and plenty of material is available for a new interdisciplinary research programme to engage with. See, for example, MacLeod, 1975; MacKenzie, 1990; Gadgil and Guha, 1992; Harrison, 1994; Godlewska and Smith, 1994; Haraway, 1989; Adas, 1989; Worboys, 1990; Baber, 1995. For a debate over the relevance of colonial science studies to the history of science, see Pyenson, 1993, and Worboys and Palladino (1993) in *Isis*, 84 (1993).
3 See Asad, 1973; Arnold, 1993; Grove, 1995; Headrick, 1981. While most work so far focuses on British colonialism, some studies indicate that a programmatic discussion of the cultural studies of colonial science ought to include other European imperialisms. See Adas, 1989; Osborne, 1994.
4 Eric Wolf's pathbreaking study, *Europe and the People Without History*, radically critiques this division. He argues that the history of the non-Western world, at least since 1400, is part of the same 'manifold' as the history of the Western world, and that relegating the former to sub-disciplines of area specialization effectively implies that it is 'ethnohistory', not 'real' history. Wolf argues that the history of Europe's 'others' can be 'suppressed or omitted' from histories of Europe 'only for economic, political, or ideological reasons' (Wolf, 1982, pp. 18–19).
5 See Barnes and Shapin, 1979; Knorr-Cetina and Mulkay, 1983.
6 In a recent review article, Peter Dear sums up the central argument of SSK-inspired historical studies of 'the cultures of science' as follows: 'Technical achievement, such as well-entrenched, and hence reliable, units of electrical resistance, are shown to be the same as the achievements of architects or theologians: made by social groups as characteristic cultural attainments' (Dear, 1995, p. 158).
7 Rouse, 1992.
8 For example, the meanings of categories such as labour, productivity and progress are produced culturally as well as scientifically; so are the relational identities of self and other, colonizer and colonized; and, of course, gendered, caste and tribal identities.

9 The value of 'critique' in studies of science was debated by philosopher Joseph Rouse (an advocate of the new 'cultural studies of science') and historian Peter Dear (a supporter of SSK-inspired social and cultural history of science). See Rouse, 1992; Dear, 1995. Rouse suggests that social constructivists such as Harry Collins, Trevor Pinch, Bruno Latour, Karin Knorr-Cetina and Steve Woolgar predominantly share an anti-normative stance 'which forecloses the possibility of criticizing scientific practices and beliefs' (p. 5). Dear cites Steven Shapin's work in defence of social history of science, arguing that Shapin self-consciously sets his studies in the context of sociological theory in order to 'coordinate his findings with issues relating to present-day science and the concerns that arise with respect to it'. Shapin, Dear argues, is not 'uncritical of scientific practices', as 'he wishes for a much greater public awareness of, and hence potential to address and shape, what scientists do' (p. 159). In my own work I take the position that our 'wishes' for different social or scientific systems ought to play an explicit role in organizing our research and writing. In this respect I find feminist sociology and philosophy of science the most enabling aspect of science and technology studies in general, because the wish for a better world is explicitly stated in the best feminist critiques of science. See Harding, 1991; Haraway, 1991.

10 SSK is in fact normative about the position that science should take (that is, SSK holds it should occupy a position no more privileged than other forms of culture); however, it is anti-normative and relativist about the content, practices and truth-claims of science. The latter restricts its ability to carry out critiques of ideology. See Lynch, 1994; Sismondo, 1993; Mohanty, 1989.

11 See Collins and Pinch, 1982; Pickering, 1992; Knorr-Cetina and Mulkay, 1983.

12 Cultural studies guru Raymond Williams has, in fact, done much of the groundwork for the formulation of such a framework. In his 1980 essay, 'Ideas of nature', he comes to the analysis of nature through a route very different from Latour's, but offers an outline for the analysis of the mutual constitution of nature and culture. He points out that the history of ideas of nature is the history of changing social relations: 'Out of the ways in which we have interacted with the physical world we have made not only human nature and an altered human order; we have also made societies.' One of the tasks of a cultural analysis of science is, then, to understand how ideas of nature have shaped and been shaped by social, political and economic relationships (Williams, 1980).

 While Williams' essay outlines a possible analytical stance from which to begin such research, I have found the literature in environmental history and social geography invaluable in exploring concrete instances of these processes. See, for example, Cronon (1991), which is a historical study on the analytical model of Williams' study of the city and the country (Williams, 1973), Wolf, 1982; Pred and Watts, 1992.

13 Reading resistance 'through' the fissures in colonial texts is a well-known

historiographical exercise. This is an important part of retelling hegemonic narratives of nature, although the excavation of these stories is an exercise fraught with historiographical difficulties. See Scott, 1985; Spivak, 1988; Comaroff and Comaroff, 1991; Guha, 1982–94; O'Hanlon, 1988; Haggis et al., 1986.

14 Viceroy of India from 1876 to 1880.

15 Quoted in Panter-Downes, 1967.

16 Ibid.

17 Nor is Ootacamund unique in this respect – most hill-stations (for example, Simla, Mussoorie, Darjeeling and Mahableshwar) were valued for their 'Englishness'.

18 From 'The Mission of Todramala', a Portuguese manuscript by Finicio (1602), translated by W. H. R. Rivers. This is the record of a Portuguese priest's two-day encounter with the Todas. See Rivers, 1906.

19 Panter-Downes, 1967.

20 Anthony King, *Colonial Urban Development* (1976, pp. 165–7). The importance of reproducing, through gardening, a 'Home' environment can be found in much colonial literature by women. For example, Sarah Jeannette Duncan, in her 1893 novel *Simple Adventures of a Memsahib* (Ottawa: Tecumseh Press, 1986) has her protagonist, Helen, nurture a flower garden. Helen Browne's flower garden is suggestive of all the delicacy and refinement of English life, all the purity and freshness that an English wife recreates for her family in a far-flung outpost of the Empire. She 'could always go down and talk of home to her friends in the flower beds, who were so steadfastly gay, and tell them . . . how brave and true it was of them to come so far from England. . . . And in the evening the smoke of the hubble-bubble was lost in the fragrance of the garden.' In contrast to this gentle private garden, the India outside was desolate. It was 'empty as if it had just been made'; stony, its vegetation dry or twisted, its only inhabitants 'straggling . . . bands' of 'brown people . . . appearing from nowhere and disappearing in vague and crooked directions', and crows and vultures – altogether a primitive and barren landscape. Outside the bungalow was 'India as it was before ever the Sahibs came to rule over it'.

21 Ibid.

22 Charles Hilton Brown (1936), quoted in Hockings, 1989. Brown was an officer of the Indian Civil Service from 1913 to 1934, and served in several administrative positions in South India.

23 Metz, 1864.

24 Ibid.

25 Povinelli, 1993.

26 It was only in the mid-twentieth century, in fact, that Australia amended the '*terra nullius*' clause in its Constitution.

27 See Ludden, 1989. Economic and agrarian histories of colonialism offer valuable information on the material conditions of colonial societies, and should be an important component of cultural studies of colonial science.

28 Anon., 1921.

29 In progressing from discussing climate and vegetation to discussing power and
 authority, I do not see myself as moving outside of a 'narrative of environ-
 ment'; rather, I would argue that our notion of environment ought to encom-
 pass social and political dynamics as well as the physical landscape since the
 two continually constitute each other. This mutual constitution should become
 clear in the case that is being made here.

30 Anon., 1921.

31 These were the Todas, Badagas, Kurumbas, Irulas and Kotas. The Todas, whom
 some of the earliest studies constructed as a lost Roman tribe, must be one of
 the most studied groups in the subcontinent.

32 Metz, 1864.

33 Ibid.

34 Ibid.

35 Ibid.

36 See O'Hanlon and Washbrook, 1992; Prakash, 1992; Spivak, 1988.

37 However, as I have argued here, narratives of labour and agriculture are ideo-
 logically part and parcel of scientific ideologies of progress.

38 Spivak (1987, p. 91).

39 The funeral was one of the occasions for the production of rituals that repro-
 duced social and religious norms and reinforced social cohesion.

40 The following quotes are from Metz (1884).

41 Translated by and cited in Emeneau (1971).

42 I have used hunting briefly in this section to illustrate the significance of cul-
 tural constructions of nature. Much interpretive work remains to be done on
 representations and practices around colonial shikar. I have not touched on one
 of its most interesting aspects, namely its gendered tropes and practices.

43 Anon., 1921.

44 Ibid.

45 To do this we must move to the northern part of the Nilgiri district (the Nilgiri
 Wynad), more densely forested than the region around Ooty, and thus the
 focus of attention for the Forest Department. Some of the material here was
 generated in relation to Wynad proper, part of Malabar district. I include this,
 and some comments on other parts of the Western Ghats, as these were con-
 tinguous forest belts and part of the same mountain range (the Western Ghats)
 and also of the same forest management system (under the Forest Department
 of Madras Presidency).

46 Morgan, 1884.

47 Ibid.

48 Ibid.

49 Ibid.

50 Ibid.

51 Ibid.

52 Ibid.

53 Ibid.

54 Shortt, 1864.

55 Ouchterlony, 1847.
56 Ibid.
57 See Thompson, 1966; Williams, 1973, 1980.

References

Archival material (all from Tamil Nadu Archives, Madras)

Anonymous (1921) *Civilian's South India: Some Places and People in Madras*, London.
Cole (1865) 'Medical debate over Malaria', in *Selections from Madras Government Papers Relating to Forest Conservancy in India*.
Emeneau (1971) *Toda Songs*, Oxford: Clarendon Press.
Metz, F. (1864) *The Tribes Inhabiting The Neigherry Hills; Their Social Customs and Religious Rites*, from the rough notes of a German missionary edited by a friend, Mangalore: Basel Mission Press (2nd edn).
Morgan, H. R. (1884) Late Deputy Conservator of Forests, Madras, ed. by J. Shortt, Retd. Deputy Surgeon General, Madras, *Forestry in Southern India*, TNA.
Ouchterlony, Captain (1847) *Memoir to the Madras Government*.
Price, Frederick (1908) *A History of Ootacamund*, Madras.
Rivers, W. H. R. (1906) *The Todas*, London: Macmillan and Co.
Shortt, J. (1864) *Handbook to Coffee Planting*.

Secondary sources

Adas, Michael (1989) *Machines as the Measure of Men: Science, Technology and Ideologies of Western Dominance*, Ithaca, NY: Cornell University Press.
—— (1992) 'From avoidance to confrontation: peasant protest in precolonial and colonial Southeast Asia', in Nicholas Dirks (ed.) *Colonialism and Culture*, CSSH Book Series, Ann Arbor: The University of Michigan Press.
Amin, Samir (1989) *Eurocentrism*, trans. Russell Moore, New York: Monthly Review Press.
Arnold, David (1993) *Colonizing the Body: State Medicine and Epidemic Disease in Nineteenth-century India*, Berkeley: University of California Press.
Asad, Talal (ed.) (1973) *Anthropology and the Colonial Encounter*, London: Ithaca Press.
Baber, Zaheer (1995) *The Science of Empire: Scientific Knowledge, Civilization, and Colonial Rule in India*, SUNY Press.
Barnes, Barry (1974) *Scientific Knowledge and Sociological Theory*, London: Routledge & Kegan Paul.
—— (1977) *Interests and the Growth of Knowledge*, London: Routledge & Kegan Paul.
Barnes, Barry and Shapin, Steven (ed.) (1979) *Natural Order: Historical Studies of Scientific Culture*, San Francisco, CA: Sage.
Collins, Harry. M. and Pinch, T.J. (1982) *Frames of Meaning: The Social Construction of Extraordinary Science*, Boston, MA: Routledge & Kegan Paul.

Comaroff, Jean and Comaroff, John (1991) *Of Revelation and Revolution: Christianity, Colonialism, and Consciousness in South Africa*, Chicago, Ill: University of Chicago Press.

Cronon, William (1991) *Nature's Metropolis: Chicago and the Great West*, New York: Norton.

Dear, Peter (1995) 'Cultural history of science: an overview with reflections', *Science, Technology and Human Values*, 20(2).

Duncan, Sarah Jeannette (1986) *Simple Adventures of a Memsahib*, Ottawa: Tecumseh Press.

Gadgil, Madhav and Guha, Ramachandra (1992) *This Fissured Land: An Ecological History of India*, Delhi: Oxford University Press.

Godlewska, Anne and Smith, Neil (eds) (1994) *Geography and Empire*, Cambridge, MA: Blackwell.

Grove, Richard (1995) *Green Imperialism: Colonial Expansion, Tropical Island Edens and the Origins of Environmentalism, 1600–1860*, New York: Cambridge University Press.

Guha, Ramachandra and Gadgil, Madhav (1989) 'State forestry and social conflict in British India', *Past and Present*, 123.

Guha, Ranajit (ed.) (1982–94) *Subaltern Studies: Writings on South Asian History and Society*, New York: Oxford University Press.

Haggis, Jane, Jarrett, Stephanie, Taylor, Dave and Mayer, Peter (1986) 'By the teeth: a critical examination of James Scott's *The Moral Economy of the Peasant*', *World Development*, 14(12): 1435–55.

Haraway, Donna Jeanne (1989) *Primate Visions: Gender, Race, and Nature in the World of Modern Science*, New York: Routledge.

—— (1991) 'Situated knowledges', in *Simians, Cyborgs, and Women: The Reinvention of Nature*, New York: Routledge.

Harding, Sandra (1991) *Whose Science? Whose Knowledge? Thinking From Women's Lives*, Ithaca, NY: Cornell University Press.

—— (1995) 'Science and multiculturalism', public lecture, Ithaca, NY: Ithaca College.

Harrison, Mark (1994) *Public Health in British India: Anglo-Indian Preventive Medicine 1859–1914*, New York: Cambridge University Press.

Headrick, Daniel R. (1981) *The Tools of Empire: Technology and European Imperialism in the Nineteenth century*, New York: Oxford University Press.

Hockings, Paul (ed.) (1989) *The Blue Mountains*, Delhi: Oxford University Press.

Kennedy, Dane (1996) *Magic Mountains: Hill Stations and the British Raj*, New Delhi: Oxford University Press.

King, Anthony D. (1976) *Colonial Urban Development*, London: Routledge & Kegan Paul.

Knorr-Cetina, Karin D. and Mulkay, Michael (eds) (1983) *Science Observed: Perspectives on the Social Study of Science*, Beverly Hills, CA: Sage.

Latour, Bruno (1993) *We Have Never Been Modern*, trans. Catherine Porter, Cambridge, MA: Harvard University Press.

Ludden, David (1989) *Peasant History in South India*, Delhi: Oxford University Press.

Lynch, William T. (1994) 'Ideology and social construction,' *Social Studies of Science*, 24: 197–227.

MacKenzie, John (1990) *Imperialism and the Natural World*, Manchester: Manchester University Press.

MacLeod, Roy (1975) 'Scientific advice for British India: imperial perceptions and admininstrative goals, 1898–1923', *Modern Asian Studies*, 9(3): March.

MacLeod, Roy and Collins, Peter (eds) (1981) *The Parliament of Science: The British Association for the Advancement of Science 1831–1981*, London: Science Reviews.

Mohanty, Chandra Talpade, Russo, Ann and Torres, Lourdes (eds) (1991) *Third World Women and the Politics of Feminism*, Bloomington: Indiana University Press.

Mohanty, Satya (1993) 'The epistemic status of cultural identity: on beloved and the postcolonial condition', *Cultural Critique*, Spring.

Nelson, Cary and Grossberg, Lawrence (1988) *Marxism and the Interpretation of Culture*, Urbana: University of Illinois Press.

O' Hanlon, Rosalind (1988) 'Recovering the subject: subaltern studies and histories of resistance in colonial South Asia', *Modern Asian Studies*, 22(1): 189–224.

O'Hanlon, Rosalind and Washbrook, David (1992) 'After Orientalism: culture, criticism and politics in the Third World', *Comparative Studies in Society and History*, January.

Osborne, Michael (1994) *Nature, the Exotic and the Science of French Colonialism*, Bloomington: Indiana University Press.

Panter-Downes, Molly (1967) *Ooty Preserved*, London.

Pickering, Andrew (ed.) (1992) *Science as Practice and Culture*, Chicago, Ill: University of Chicago Press.

Povinelli, Elizabeth A. (1993) *Labor's Lot: The Power, History and Culture of Aboriginal Action*, Chicago, Ill: University of Chicago Press.

Prakash, Gyan (1992) 'Can the subaltern ride? A reply to O'Hanlon and Washbrook', *Comparative Studies in Society and History*, January.

Pred, Allan Richard and Watts, Michael John (1992) *Reworking Modernity: Capitalisms and Symbolic Discontent*, New Brunswick, NJ: Rutgers University Press.

Pyenson, Lewis (1993) 'Science and imperialism', *Isis*, 84(1).

Rouse, Joseph (1992) 'What are cultural studies of scientific knowledge?', *Configurations*, 1(1): 1–22.

Said, Edward W. (1979) *Orientalism*, New York: Vintage Books.

Scott, James C. (1985) *Weapons of the Weak: Everyday Forms of Peasant Resistance*, New Haven, CN: Yale University Press.

Sismondo, Sergio (1993) 'Some social constructions', *Social Studies of Science*, 23(3): 515–54.

Spivak, Gayatri (1987) 'A literary representation of the subaltern', *Subaltern Studies*, V: 91.

—— (1988) 'Can the subaltern speak?', in Nelson and Grossberg (eds) *Marxism and the Interpretation of Culture*, Urbana: University of Illinois Press.

Thompson, Edward P. (1966) *The Making of the English Working Class*, New York: Vintage.

Williams, Raymond (1973) *The Country and The City*, New York: Oxford University Press.

—— (1980) *Problems in Materialism and Culture: Selected Essays*, London: Verso.

Wolf, Eric R. (1982) *Europe and the People Without History*, Berkeley: University of California Press.

Worboys, Michael (1981) 'The British Association and Empire', in MacLeod and Collins (eds) *The Parliament of Science: The British Association for the Advancement of Science 1831–1981*, London: Science Reviews.

—— (1990) 'The Imperial Institute: the state and the development of the natural resources of the colonial Empire, 1887–1923', in John MacKenzie (ed.) *Imperialism and the Natural World*, Manchester: Manchester University Press.

Worboys, Michael and Palladino, Paolo (1993) 'Science and imperialism – comment/reply [to Pyenson]', *Isis*, 84(1).

Richard Grusin

REPRODUCING YOSEMITE: OLMSTED, ENVIRONMENTALISM, AND THE NATURE OF AESTHETIC AGENCY

Abstract

In this article I address the origins of America's national parks, particularly as they figure in the environmentalist discourse surrounding the institution of Yosemite Valley as a public park. Although technically speaking Yosemite did not become a national park until 1890, its cession to the State of California in 1864 provides an important cultural site for the emergence of environmentalism as part of a broader concern with the relations between aesthetic, social and natural agency. In mapping out these relations in Frederick Law Olmsted's 1865 report on the management of Yosemite, I claim that the preservation of Yosemite reproduces nature as a public park in which human agency can be simultaneously produced and elided by means of the aesthetic agency of nature. I read Olmsted's report as a discursive site on which we can trace the structural parallels between the preservation of Yosemite and several related cultural practices in which the origins of American environmentalism are embedded. I also read it as sketching out the configurations of human and natural agency within which these parallel practices are articulated.

My study operates from the assumption that science and technology need to be understood not simply by explaining how they are socially or culturally constructed, but also by looking at how certain fundamental ideas of metaphors (like natural agency or the reproduction of nature) are worked out at the same historical moment in different discursive practices. In taking up the idea of America as it both defines and is defined by the network of relations among science, technology and culture, I outline certain myths of American environmentalist origins as played out across a number of diverse and heterogeneous discourses and technologies of representation and reproduction. I hope also to illuminate the way in which

© Routledge 1998

American cultural origins are simultaneously constructed and destabilized through the act of reproducing nature.

Keywords

environmentalism; national parks; aesthetic agency; nature; Yosemite; Olmsted

I

A T THE 1995 biennial meeting of the American Society for Environmental History in Las Vegas, Susan Flader delivered the response to a session entitled 'Nature objectified/nature commodified: the defense of scenery', noting that environmental historians now generally agree that nature is a cultural construction – that despite what nineteenth- and twentieth-century preservationist ideology might claim, the preservation of natural scenery works to further, not oppose, the values of the dominant culture. Two days later, in the first half of the conference's two-part headliner session, 'Reinventing nature', William Cronon echoed Flader's point, arguing that the concept of wilderness does not escape the categories of culture – that there is 'nothing natural about the concept of wilderness'.[1] For Cronon as for Flader, wilderness reproduces the cultural values its advocates seek to escape. Of course Cronon and Flader are by no means alone in their indictment of 'romantic nature as an instrument of imperial conquest'; as Lawrence Buell has noted, citing (among other examples) 'The West as America', the 1991 exhibit at the Smithsonian Museum of American Art, it has become almost a truism that the 'nineteenth-century American romantic representation of the West was built on an ideology of conquest'.[2] For each of these scholars, as for environmental history more generally, the ideology of nature or wilderness preservation has been demystified, has been revealed to harbour within it the very will to power it would set out to escape.

In countering a less critical body of scholarship that often took at face value the claims of early preservationists (that nature offered an escape from the cultural ideologies of progress and development which fuelled American expansion in the nineteenth and early twentieth centuries), recent work in environmental history has set the stage for a revaluation of the cultural meanings of the origins of environmentalism in America. Motivated largely by the widespread acceptance of arguments for the social or cultural construction of knowledge, environmental historians have begun to rewrite the history of American environmentalism not as the story of an increasing recognition of the intrinsic value of

nature or wilderness, but rather as the story of the increasing use of the ideology of nature's intrinsic value to further the social, cultural or political interests of a dominant race, class, gender or institutional formation. As powerful as these revisionist narratives are, however, they run the risk of stripping nature of any agency whatsoever – of transforming nature so completely into culture that the preservation of nature as a national park, for example, becomes indistinguishable from its transformation into a ranch or a mine or a private resort.

In making this claim about the agency of nature, I do not propose that we undo the hard-earned insights of the cultural construction of knowledge, but that we undertake the more difficult task of pursuing these insights more fully. Granted that nature is culturally constructed, we need to ask how the cultural construction of nature differs from (and intersects with) other culturally constructed entities. Further, we need to ask how the cultural construction of nature varies historically and how it remains constant both through time and across different geographical locations. In other words, we need to pursue locally the more global insights of the cultural construction of nature if we are to understand the way in which natural agency differs from other forms of cultural agency. Or, to put it yet another way, we need a truly ecological criticism, one which understands that the cultural construction of nature circulates within what we could call a discursive ecosystem. The task of such a criticism would be to trace the connections and interrelations both within the discursive practices of environmentalism and among the scientific, technological and cultural networks through which environmentalism emerges.[3]

Stephen Greenblatt points to such a critical practice in 'Towards a poetics of culture', an essay on the new historicism in literary studies, in which he relates an 'exemplary fable of capitalist aesthetics' concerning an excursion taken on the Nevada Falls Trail in Yosemite National Park.[4] For Greenblatt the trail offers more than the expected 'pleasure of the mountain air and the waterfall and the great boulders and the deep forest of Lodgepole and Jeffrey pine'; it also offers an 'unusually candid glimpse of the process of circulation that shapes the whole experience of the park', a process in which 'the wilderness is at once secured and obliterated by the official gestures that establish its boundaries', and in which 'the natural is set over against the artificial through means that render such an opposition meaningless' (p. 9). The occasion for this glimpse is provided in the middle of a bridge on which 'a splendid view of Nevada Falls' is juxtaposed against an aluminum plaque 'inscribed' both with 'inspirational, vaguely Wordsworthian sentiments by the California environmentalist John Muir' and with 'a photograph of Nevada Falls taken from the very spot' (p. 9). The lesson Greenblatt draws from this juxtaposition is that 'the distinct power of capitalism' is constituted by its production of 'a powerful and effective oscillation between the establishment of distinct discursive domains and the collapse of these domains into one another' (p. 8). Both securing and effacing the distinction between nature and artifice, the plaque on the Nevada Falls bridge 'conveniently calls attention to the interpen-

etration of nature and artifice that makes the distinction possible' (p. 9). As exemplary of capitalist aesthetics as this fable proves to be, however, it cannot, Greenblatt contends, account for 'the question of property relations, since the National Parks exist precisely to suspend or marginalize that question through the ideology of protected public space' (p. 10).

In recounting this fable of capitalist aesthetics, Greenblatt reveals his aware-ness of the cultural capital that environmentalism has acquired on the eve of the twenty-first century. But in objecting that America's national parks suspend or marginalize the question of property relations, he reveals equally his lack of awareness of the cultural history of environmentalism. Identifying the aesthetics of nature with the aesthetics of film or literature, Greenblatt fails to recognize what is distinctive about the environmentalist aesthetics of nature embodied in the cultural logic of America's national parks. More specifically, his understand-ing of Yosemite is insufficiently cultural and historical. First, he fails to distin-guish America's national parks from, say, England's, where the question of property relations is not marginalized but rather central to the ideology of Great Britain's national parks, thus overlooking the cultural specificity in the ideology of America's parks. Second, he fails to consider the American 'ideology of pro-tected public space' in the context of the creation of the parks, thus overlooking the historical specificity of Yosemite or the American parks more generally.

In this article I set out to supplement Greenblatt's account, tracing this fable of capitalist aesthetics back to the emergence of environmentalism in mid-nineteenth-century America, at about which time, Carolyn Merchant explains, 'the capitalist ecological revolution' ('characterized by the efficient organization of land, labor, and capital, competition in the marketplace, and the emergence of large-scale control over resources') was 'structurally complete'.[5] In so doing I address the question of the origins of the national parks, particularly as it figures in the preservationist discourse surrounding Yosemite's institution as a public park. Although, technically speaking, Yosemite did not become a *national* park until 1890 (before which it was administered by the State of California), its preservation in 1864 provides an important cultural site for the emergence of environmentalism as part of a broader mid-nineteenth-century American concern with the relations between aesthetic, social and natural agency. In mapping out these relations as they manifest themselves in Frederick Law Olmsted's 1865 report on the management of Yosemite, I claim that the preser-vation of Yosemite reproduces nature as a public park in which individual human agency can be simultaneously produced and elided by means of the aesthetic agency of nature.

II

On 28 March 1864, Senator John Conness of California introduced the bill that

would grant Yosemite Valley and the Mariposa Big Tree Grove to the State of California 'for public use, resort, and recreation', to be 'held inalienable for all time'.[6] Referred without discussion to the Committee on Public Lands, the bill was returned to the Senate on 17 May with a recommendation that it be passed.[7] After a brief debate the bill was passed and sent on to President Lincoln, who signed it into law on 30 June 1864.[8] On 28 September, exactly six months after the bill was introduced, California Governor Frederick F. Low issued a proclamation accepting the grant on behalf of the state. The following day Low appointed Frederick Law Olmsted (who had come to California in 1863 as superintendent of the Mariposa Mining Estate) as chairman of the commission.[9] Although Olmsted had only visited Yosemite Valley for the first time the previous month, his experience as architect-in-chief of Central Park and Secretary of the US Sanitary Commission made him an ideal choice as the commission's head. He quickly took charge, arranging for Clarence King and J. T. Gardner to survey Yosemite before the Sierra winter set in, and advancing payment for the survey out of his own pocket. Thus it was that on 8 August 1865, at a meeting of the commission in the valley, Olmsted, survey in hand, presented his report to the California legislature on the future administration of the park.

What kind of action was the preservation of Yosemite? And why does the preservation of nature become institutionalized at this particular moment and in this particular cultural form? Environmental historians have generally agreed that, whatever its significance, the preservation of Yosemite was not an expression of genuine environmentalist concern because it was not founded upon the recognition of an intrinsic value in nature. Thus, despite arguing that 'the legal preservation of part of the public domain for scenic and recreational values created a significant precedent in American history', Roderick Nash minimizes its significance for the origins of the American environmentalist movement because it was motivated not by biocentric ideas of wilderness but by the anthropocentric values of tourism.[10] Similarly, although Alfred Runte has characterized 'the park act of 1864' as 'a model piece of legislation',[11] he, too, faults Congress for failing to measure up to late twentieth-century environmentalism: 'Monumentalism, not environmentalism, was the driving impetus behind the 1864 Yosemite Act'.[12] Despite the fact that 'the term *ecology* was not even known' in mid-nineteenth-century America, Runte credits such farsighted advocates of Yosemite as Olmsted and John Muir with training themselves 'to look beyond the spectacular in nature' to the ecological commonplace; as prophetic as such men were, however, Runte laments that it would not be until 'well into the twentieth century' that 'an age receptive to the life-giving properties and esthetic beauty of all ecosystems' would be convinced of what Olmsted and Muir had earlier understood: 'that the commonplace in nature was as worthy of protection as the spectacular.'[13]

Writing as if the idea of natural value was culturally and temporally stable, traditional environmental historians like Nash and Runte are unable to come

to terms with the way in which ideas like environmentalism or actions like wilderness preservation did in fact obtain in the early years of the national parks movement, even if these earlier ideas and actions do not measure up to current standards. One reason for this shortcoming is that environmental history has often failed to situate the origins of environmentalism in relation to other cultural discourses of the time, a practice which results in conflicting and overstated interpretations of complex discursive formulations like that set forth in Olmsted's report to the Yosemite commission.[14] Consequently, in this article I read Olmsted's Yosemite report as a discursive site on which we can trace the structural parallels between the preservation of Yosemite and several of the related cultural practices in which the origins of American environmentalism are embedded. In addition, I read his report as sketching out the cultural configurations of human and natural agency within which these parallel practices are articulated. I operate throughout from the assumption that science and technology need to be understood not simply by explaining how they are socially or culturally constructed, but also by looking at how certain fundamental ideas or metaphors (like natural agency or the reproduction of nature) are worked out at the same historical moment in different discursive practices. In taking up the idea of America as it both defines and is defined by the network of relations among science, technology and culture, I sketch out certain myths of American environmentalist origins as played out across a number of diverse and heterogeneous discourses and technologies of representation and reproduction. In so doing, I hope to illuminate the way in which American cultural origins are simultaneously constructed and destabilized through the act of reproducing nature.

III

Although the suppression of Olmsted's Yosemite report by several of his fellow commissioners prevented its exerting an extensive influence on the development of a coherent national park policy,[15] the report is indispensable for making sense of what it means to think about the preservation of nature in mid-nineteenth-century America. Building on his experience with Central Park, Olmsted approaches the question of Yosemite's preservation from the perspective of landscape architecture.[16] Careful throughout his career to distinguish landscape architecture from painting, Olmsted's work as a landscape architect participates in the desire of mid-nineteenth-century aesthetic theory and practice to elide the landscape's frame by erasing the signs of the artist's agency in creating his picture, thereby eliminating the separation between a work of art and its viewer. This landscape aesthetic also reproduces the double logic of photography, in which the artist must relinquish agency to nature in order to realize his artistic intention. Photography's double logic is concisely set forth in an essay published in the March 1865 issue of *The Philadelphia Photographer*, less than six months before

Olmsted would present his Yosemite report to his fellow commissioners. In this essay, photographer John Moran takes up the question of 'The relation of photography to the fine arts', contending that because photography 'speaks the same language, and addresses itself to the same sentiments' as they do, it should be considered as one of the fine arts.[17] Like the painter, Moran contends, the photographer must '"know what is most beautiful"': 'the value and importance of any work, whether canvas or negative', depends upon the artist's 'power of seeing and deciding what shall be done'. Because 'any given scene offers so many different points of view', what 'gives value and importance to the works of certain photographers over all others' is the ability to occupy more than one perceptual position at a time: 'if there is not the perceiving mind to note and feel the relative degrees of importance in the various aspects which nature presents, nothing worthy the name of pictures can be produced.' But no matter how refined the photographer's 'art of seeing', photography itself 'can never claim the homage of the higher forms of art'. The photographer cannot exercise the same control over his creation as can the painter. Although like the painter the photographer must frame his picture, 'in the actual production of the [photographic] work, the artist ceases, and the laws of nature take his place'.[18]

Moran was by no means the first to notice this double logic of photography. From its inception, photography has been distinguished from painting precisely because the mechanism of the camera requires that at the moment of exposure the photographer must relinquish control to what Moran describes as 'the laws of nature'.[19] Nor is photography the only form of art in which the human agent relinquishes the task of reproduction to nature. Indeed I invoke Moran's formulation of the relation between natural and human agency in photography precisely for its pertinence to Olmsted's theory of landscape architecture. At first glance the two would seem to have little in common. Whereas photography works in two dimensions, landscape architecture works in three. Where photography depends upon the mechanical reproduction of the camera, landscape architecture depends largely upon the organic reproduction of nature. And while the photographer reproduces pictorially the image of whatever scene is in front of the camera at the time of exposure, the landscape architect reproduces the scene itself according to the pictures of it that he has imagined. Despite these dissimilarities, however, photography and landscape architecture alike operate under a similar logic: that in order to realize their intentions, both the photographer and the landscape architect must relinquish their artistic control to nature.

To emphasize the affinities between the structure of aesthetic agency in photography and landscape architecture is not to minimize the affinities between landscape architecture and landscape painting. For despite Moran's employment of the conventional opposition between painting and photography, by mid-century the elimination of all signs of artistic agency was, for the painter, an equally well-established goal.[20] But even while Olmsted sees both landscape architect and painter as striving to draw viewers into their scenes by concealing

their agency, he also clearly distinguishes between the two forms of representation. Even while thinking about landscape architecture on the model of painting, he is compelled to think about producing his landscapes not with paint, brush and canvas but with rocks, shrubs and trees. An 'artist dealing with trees and plants', as he describes himself, must use the very natural objects he would represent as his means of reproduction. In other words, when painting a landscape an artist uses the materials of painting (pigments, brushes, canvas) to compose a scene. Whether real or imagined, natural objects are among what landscape paintings represent. When Olmsted constructs a landscape, however, natural objects are his means as well as his objects of representation. Trees and plants, in representing trees and plants, are both real and imagined, both are and are not trees and plants. For Olmsted, this production of internal difference between nature and itself is what distinguishes landscape architecture from landscape painting. Insofar as the landscape architect, like the landscape painter, aims to sink the artist and the spectator alike in the scene by concealing the signs of his agency in the park, he is concerned not with the concealment of pigments but with the concealment of plants and trees.

During his two years in California, Olmsted spent a good deal of time thinking about the structure of aesthetic agency in landscape architecture – partly because of his involvement with a number of landscape design projects in northern California (including Mountain View Cemetery in Oakland, the campus of the College of California in Berkeley, and an urban park for San Francisco), and partly because of his epistolary deliberations with Calvert Vaux over the nature and desirability of their continued partnership as landscape architects after Olmsted's return to New York.[21] In a passage written not long after arriving in Mariposa in 1863, Olmsted provides a telling description of the way in which landscape architecture requires the artist to conceal the signs of his agency as evidence of his exertion of agency on the landscape.

> Landscape Architecture is the application or picturesque relation of various objects within a certain space, so that each may increase the effect of the whole as a landscape composition. It thus covers more than landscape gardening. It includes gardening and architecture and extends both arts, carrying them into the province of the landscape painter. In all landscape architecture there must not only be art, but art must be apparent. The art to conceal art is applicable to the manipulation of the materials, the method by which the grand result is obtained, but not to the result which should not be merely fictitious nature, but obviously a work of art – cultivated beauty.[22]

Although granting that landscape architecture 'includes gardening and architecture', Olmsted maintains that it 'extends both arts' into 'the province of the land-

scape painter' because it requires the landscape architect to fashion the picturesque relation of various natural objects into a landscape composition.[23] Like the landscape photographer, the landscape architect must see nature from two perspectives at once; unlike landscape painting, however, 'the grand result' of landscape architecture is both a landscape and a representation of a landscape. Consequently the landscape architect, like the painter, must apply 'the art to conceal art' even while making sure that the art of landscape architecture is 'apparent'. That is, even while concealing the signs of his agency in 'the manipulation of the materials' with which he constructs the landscape, the landscape architect must make evident his agency in composing the landscape. In describing the result of this double gesture not as 'merely fictitious nature' but as 'obviously a work of art', Olmsted means on the one hand to distinguish his practice of landscape architecture from the 'fictitious nature' 'of the great English landscape gardeners such as William Gilpin, Uvedale Price, Humphrey Repton, John Claudius Loudon, and their American disciple, Andrew Jackson Downing', while on the other hand distinguishing his practice from nature itself.[24] In other words, the 'cultivated beauty' that constitutes 'the grand result' of the landscape architect makes his landscape an obvious 'work of art' rather than 'fictitious nature' precisely because the 'art to conceal art' has obfuscated the method by which nature has been made into art.

Olmsted's thinking about landscape architecture as an extension of landscape gardening and architecture into 'the province of the landscape painter' can itself be seen as an extension of Kant's thinking about landscape gardening and painting in a discussion of the division of the beautiful arts near the end of the *Critique of Judgment*'s 'Analytic of the sublime'.[25] I introduce Kant here neither because his understanding of landscape gardening is identical to Olmsted's understanding of landscape architecture nor because Olmsted is explicitly interested in the sublime (it is not an aesthetic concept he spends much time discussing, concerning himself more directly with the picturesque), but rather because many of the aesthetic issues with which Olmsted is concerned are precisely those which are at stake in the Kantian sublime. Indeed, in transforming conventional notions of landscape gardening into the new art of landscape architecture, Olmsted relies upon Kant's treatment of the relation between natural and artistic beauty in his analytic of the sublime. For Kant, natural beauty is superior to artificial beauty because it arouses a more immediate, formal interest in the beholder (p. 141). In explaining this claim, Kant furnishes as an example the 'lover of the beautiful', who 'regards the beautiful figure of a wild flower, a bird, an insect, etc., with admiration and love; who would not willingly miss it in nature although it may bring him some damage; who still less wants any advantage from it – he takes an immediate and also an intellectual interest in the beauty of nature' (p. 141). Kant takes the source of this immediate interest to be the fact 'that nature has produced' the beautiful forms, that they are not, as Olmsted might say, 'merely fictitious nature': 'if we secretly deceived this lover of the beautiful by planting

in the ground artificial flowers . . . or by placing artificially carved birds on the boughs of trees, and he discovered the deceit, the immediate interest that he previously took in them would disappear at once' (pp. 141–2).

Kant concludes his discussion of the intellectual interest in the beautiful by noting that 'the interest which we here take in beauty has only to do with the beauty of nature; it vanishes altogether as soon as we notice that we are deceived and that it is only art – vanishes so completely that taste can no longer find the thing beautiful or sight find it charming' (p. 145). Like Olmsted's landscape effect, the beautiful 'must be nature or be regarded as nature if we are to take an immediate interest in [it] as such, and still more is this the case if we can require that others should take an interest in it too' (p. 145). Like the beautiful in nature, 'Beautiful art is an art in so far as it seems like nature', as Kant titles section 45 of his discussion of beautiful art. 'In a product of beautiful art, we must become conscious that it is art and not nature. . . . Nature is beautiful because it looks like art, and art can only be called beautiful if we are conscious of it as art while yet it looks like nature. . . . Hence the purposiveness in the product of beautiful art, although it is designed, must not seem to be designed, i.e., beautiful art must *look* like nature, although we are conscious of it as art' (p. 149). As with any beautiful art, landscape architecture must 'look like nature, although we are conscious of it as art'. The purposiveness of an Olmsted landscape must not seem designed, but must be concealed by 'the art to conceal art'.

IV

In conceiving of Yosemite's preservation as an aesthetic act no different in kind from the creation of an urban park, Olmsted did not ignore the social and political consequences of these parks. Indeed, his report describes the benefits offered by Yosemite's preservation in terms of the philosophy of recreation that lay at the heart of his professional involvement with landscape architecture.[26] One of the fullest expressions of this philosophy is set forth in the report for Prospect Park that he and Calvert Vaux presented to the Brooklyn Park Commission in January 1866.[27] According to this report, an urban park provides the community with real economic benefits – as certain 'an increase of material wealth as good harvests or active commerce'.[28] These economic benefits are framed in terms of Olmsted's classical economic understanding of labour value: 'all wealth is the result of labor, and every man's individual wealth is, on the whole, increased by the labor of every other in the community, supposing it to be wisely and honestly applied' (p. 100). Because all labour involves 'the expenditure of force', Olmsted continues, 'it follows that, without recuperation and recreation of force, the power of each individual to labor wisely and honestly is soon lost, and that, without the recuperation of force, the power of each individual to add to the wealth of the community is, as a necessary consequence, also soon lost' (p. 100).

Recuperation and recreation participate in a twofold economy – the fiscal economy of the community and the 'physical economy' of the individual, described in the Yosemite report as 'the action and reaction which constantly occur between bodily and mental conditions' (p. 503). In defining as expenditures of force 'the slightest use of the will, of choice between two actions or two words, [or] the slightest exercise of skill of any kind' (p. 100), Olmsted means to define force not in terms of physical exertion but in terms of purposeful action. Thus, to recuperate expended force one must refrain not from physical activity but from the expression of purpose. By redefining force as purpose Olmsted suggests that the only way for an individual to recuperate force is through non-purposeful activity, what the Prospect Park report refers to as 'the unbending of the faculties which have been tasked' – an 'unbending', he suggests, that is 'impossible, except by the occupation of the imagination with objects and reflections of a quite different character from those which are associated with their bent condition' (pp. 100–1).

In explaining how the preservation of nature can add to the wealth of the nation by allowing American citizens to 'unbend' their faculties, Olmsted's Yosemite report provides a detailed account of the function of natural scenery in the psychological economy of recreation. This account begins with what he characterizes as the 'scientific fact' 'that the occasional contemplation of natural scenes of an impressive character, particularly if this contemplation occurs in connection with relief from ordinary cares, change of air and change of habits, is favorable to the health and vigor of men and especially to the health and vigor of their intellect beyond any conditions which can be offered them' (p. 502). Olmsted does not cite the source of this 'scientific fact', but his explanation of the consequences that befall those denied opportunities to contemplate impressive natural scenes clearly derives from the emerging discourse of neurology: 'The want of such occasional recreation often results in a class of disorders the characteristic quality of which is mental disability, sometimes taking the severe forms of softening of the brain, paralysis, palsy, monomania, or insanity, but more frequently of mental and nervous excitability, moroseness, melancholy or irascibility, incapacitating the subject for the proper exercise of the intellectual and moral forces' (p. 502).[29]

Although this diagnosis of the dangers of lack of recreation cannot help but seem hyperbolic today, it is not out of line with the received wisdom of mid-nineteenth-century neurological science. Neurology did not reach its popular zenith until the last quarter of the century, but 'had its beginnings as a specialty in the United States at the time of the Civil War', in the work of Silas Weir Mitchell and William Alexander Hammond, 'the fathers of American neurology'.[30] Olmsted's involvement with mid-century medical science, both as a patient and as an agent of the medical profession, was (it would be fair to say) 'overdetermined'. His own lifelong health problems were exacerbated by the war. By the end of August 1862 'he was jaundiced (possibly from hepatitis), had

developed a severe skin disorder which itched incessantly, and was on the verge of nervous collapse' (*FLO*, 4: 33). At the same time his position as Secretary of the US Sanitary Commission provided him with both the responsibility of administering what was essentially a collection of mobile military hospitals and the opportunity of working with Mitchell, Hammond and other physicians.[31]

Regardless of the precise extent of his involvement with the emerging scientific discourse of neurology, what is distinctive about Olmsted's insistence on the therapeutic value of natural scenery is his translation of conventional physiological arguments about the benefits of recreation into psychological and finally aesthetic terms.[32] For Olmsted, the physiological and psychological benefits of natural scenery depend upon its aesthetic qualities: 'If we analyze the operation of scenes of beauty upon the mind, and consider the intimate relation of the mind upon the nervous system and the whole physical economy, the action and reaction which constantly occur between bodily and mental conditions, the reinvigoration which results from such scenes is readily comprehended' (p. 503).

In Olmsted's philosophy of recreation the demands of the marketplace in mid-nineteenth-century America produce precisely the kind of mental exertion for which 'the reinvigoration of those parts which are stirred into conscious activity by natural scenery is more effective . . . than that of any other' (p. 503). His account of the physical and psychological stress of urban commercialism participates in the diagnosis of 'American nervousness' offered by Hammond, Mitchell, and especially George Miller Beard, whose analysis of neurasthenia made him one of the most popular (as well as the most controversial) of late nineteenth-century neurologists.[33] Indeed, the following passage from Olmsted's Yosemite report anticipates one of the central features of Beard's aetiology of American nervousness, the 'habit of forethought'.[34]

> The severe and excessive exercise of the mind which leads to the greatest fatigue and is the most wearing upon the whole constitution is almost entirely caused by application to the removal of something to be apprehended in the future, or to interests beyond those of the moment, or of the individual; to the laying up of wealth, to the preparation of something, to accomplishing something in the mind of another, and especially to small and petty details which are uninteresting in themselves and which engage the attention at all only because of the bearing they have on some general end of more importance which is seen ahead.
>
> (pp. 503–4)

In claiming that this passage anticipates what would become a neurological truism, I am interested not in making a case for Olmsted's historical priority but in calling attention to the way in which his Yosemite report dramatizes an aesthetic structure of natural agency that recurs almost obsessively in a number of diverse and seemingly unrelated cultural discourses.[35] Indeed, the sanative

influence of nature functions as an axiom of antebellum romanticism, epitomized by Emerson's claim in *Nature* that 'To the body and mind which have been cramped by noxious work or company, nature is medicinal and restores their tone. The tradesman, the attorney comes out of the din and craft of the street, and sees the sky and the woods, and is a man again'.[36] But where for Emerson the 'medicinal' quality of nature is primarily spiritual, moral and metaphorical, for Olmsted it is clearly physiological, scientific and quite literal.[37] In a paper presented in 1870 to the American Social Science Association, for example, he quotes the following testimony from an older physician about the health benefits of Central Park:

> Where I formerly ordered patients of a certain class to give up their business altogether and go out of town, I now often advise simply moderation, and prescribe a ride in the Park before going to their offices, and again a drive with their families before dinner. By simply adopting this course as a habit, men who have been breaking down frequently recover tone rapidly, and are able to retain an active and controlling influence in an important business, from which they would have otherwise been forced to retire.
>
> (p. 32)[38]

As this anonymous physician's prescriptions attest, both Olmsted's parks and his discursive practices provide sites for the medicalization of the antebellum axiom of the sanative influence of natural scenery. Where occupying the mind on some future purpose produces mental fatigue and nervous exhaustion, the Yosemite report explains, 'in the interest which natural scenery inspires, there is the strongest contrast to this. It is for itself and at the moment it is enjoyed. The attention is aroused and the mind occupied without purpose, without a continuation of the common process of relating the present action, thought or perception to some future end' (p. 504). In ascribing the therapeutic value of natural scenery to its ability to occupy the mind without purpose, Olmsted invokes the Kantian definition of the feeling of aesthetic beauty as disinterested even while appropriating this disinterestedness for social or therapeutic purposes. In so doing he reproduces the double logic of agency at work in photography and landscape architecture. Only by relinquishing purpose, by discontinuing 'the common process of relating the present action, thought or perception to some future end' can individuals realize their intention of recuperating expended force, of unbending their faculties. Similarly, in prescribing the appreciation of natural scenery as a cure for nervous exhaustion, either Olmsted or his physician informant must relinquish control to nature. In the actual production of a cure as of a photograph, the physician ceases and the laws of nature take his place.

The idea that a physician could heal his patient by relinquishing control to nature constitutes what Oliver Wendell Holmes (who published three important articles on photography in the *Atlantic Monthly* in 1859, 1861 and 1863)[39] chris-

tened the 'nature-trusting heresy' in 1860.[40] In trusting many diseases to the 'healing power of nature', Holmes and other mid-nineteenth-century American physicians were responding to the active intervention of the bold or heroic therapies that constituted the normative practice of American physicians in the first decades of the nineteenth century.[41] The most influential advocate of heroic medicine was Benjamin Rush, who 'accorded bloodletting and purgative mercurials like calomel the dominant positions in his armamentarium, suggesting that "when the physician step[s] into the sick room, nature should be politely asked to step out"'.[42] Reacting against the abuses of heroic therapeutic practice, doctors like Jacob Bigelow argued that the medical profession 'must come to recognize both the role of nature in healing disease and the limits of medical art'. For Bigelow, 'the physician is but the minister and servant of nature,' who can 'do little more than follow in the train of disease, and endeavor to aid nature in her salutary intentions, or remove obstacles out of her path.'[43] Other physicians concurred. Elisha Bartlett argued that 'the courses of many diseases could not be altered favorably by the intervention of medical art; the physician should trust the "recuperative energies of the system" to provide a cure in such cases'.[44] Similarly, Holmes criticized the practice of homeopathy as a delusion, contending that 90 per cent of all homeopathic patients 'would recover, sooner or later, with more or less difficulty, provided nothing were done to interfere seriously with the efforts of nature'.[45] For these physicians as for others, the art of medicine, like the art of photography or landscape architecture, can only realize its intentions when the artist relinquishes his control to the laws of nature. Not unlike Central Park or Yosemite, the mid-nineteenth-century medical body provides a discursive site on which aesthetic agency can be simultaneously produced, elided and reproduced by the therapeutics of nature.[46]

V

Although Olmsted's prominence as social reformer and landscape architect has been unchallenged since his 'rediscovery' in the 1950s, scholars remain divided over his politics.[47] Like the environmental implications of Yosemite's preservation, the political implications of his landscape designs have often been obscured by the insistence on evaluating his politics according to contemporary categories of liberalism and conservatism that would have made little sense either to him or to his contemporaries.[48] One attempt to avoid this dilemma has been offered by Alan Trachtenberg, whose critique of culture and society in the Gilded Age portrays the urban parks movement in general and Olmsted's landscape designs in particular as reproducing the contradictions of late nineteenth-century capitalism.[49] In characterizing Olmsted's employment of scenic recreation for social control as embodying a 'contradiction of ends and means', however, Trachtenberg still fails to account for the structure of aesthetic agency at

the heart of Olmsted's reformist project.[50] For Trachtenberg, capitalist incorporation works to eliminate difference by converting nature into 'the means and ends of industrial production'.[51] For Olmsted, the recreational benefits offered by the urban park operate according to a double logic of aesthetic agency which simultaneously produces and elides difference through the network of social and psychological exchanges that constitutes the capitalist marketplace.[52]

Thus the challenge of designing an urban park, Olmsted explains in the Prospect Park report, is to devise a way to provide it with two incompatible qualities: 'scenery offering the most agreeable contrast to that of the rest of the town; and opportunity for people to come together for the single purpose of enjoyment, unembarrassed by the limitations with which they are surrounded at home, or in the pursuit of their daily avocations' (p. 101). In designing a park that allows for irreducibly private aesthetic experiences to take place within a system of social circulation and exchange, Olmsted finds himself faced with a number of problems, not the least of which is that 'scenery which would afford the most marked contrast with the streets of a town, would be of a kind characterized in nature by the absence, or, at least, the marked subordination of human influences, [while] in a park, the largest provision is required for the human presence' (p. 101). Not only must he create scenery in which the signs of human agency (including his own) are concealed by the signs of natural agency, but he must at the same time provide for the accommodation of humans in the park.[53]

In devising a strategy for managing the Yosemite grant, Olmsted sees the State of California faced with a similar dual obligation for the preservation and use of natural scenery. Accordingly, his Yosemite report suggests that 'the main duty with which the Commissioners should be charged should be to give every advantage practicable to the mass of the people to benefit by that which is peculiar to this ground and which has caused Congress to treat it differently from other parts of the public domain' (p. 506). Because 'this peculiarity consists wholly in its natural scenery', Olmsted contends, 'The first point to be kept in mind then is the preservation and maintenance as exactly as is possible of the natural scenery' (p. 506). Although Runte takes such points of emphasis as evidence of Olmsted's uncompromising environmentalism, Olmsted himself consistently refuses to separate aesthetic preservation from social use. Olmsted's interest is not in the environment or the ecosystem or the biotic community but in a structure of aesthetic agency in which natural objects are simultaneously themselves and the media through which scenic landscapes are represented. Even when he cautions that 'without care many of the species of plants now flourishing [in Yosemite and Mariposa] will be lost and many interesting objects be defaced or obscured if not destroyed', his concern is not with the ecological impact but with the aesthetic effect which such destruction would have on the scenery: 'not only have trees been cut, hacked, barked and fired in prominent positions, but rocks in the midst of the most picturesque natural scenery have been broken, painted, and discolored, by fires built against them' (pp. 506–7).

In arguing that the value of preservation must be measured in terms of the wants of future generations, Olmsted computes the value of preservation according to a calculus of use, 'because the millions who are hereafter to benefit by the Act have the largest interest in it, and the largest interest should be first and most strenuously guarded' (p. 508).

For people to benefit from the preservation of Yosemite's scenery, the park must be made accessible to the public; it must be both set aside from and incorporated into a national network of circulation and exchange. Because in 1865, Olmsted argues, only the rich can afford to make the journey to Yosemite, 'the first necessity is a road from the termination of the present roads leading towards the district' (p. 509). Similarly, the valley itself should be provided with a system of traffic circulation. 'Within the Yosemite the Commissioners propose to cause to be constructed a double trail, which, on the completion of our approach road, may be easily made suitable for the passage of a single vehicle, and which shall enable visitors to make a complete circuit of all the broader parts of the valley and to cross the meadows at certain points, reaching all the finer points of view to which it can be carried without great expense' (p. 509).[54] As in Central or Prospect Park, Olmsted designs Yosemite's roads to prescribe a particular sequence of scenes and events for its visitors. Although the appreciation of Yosemite's scenery allows the mind to be occupied without purpose, Olmsted designs the roads and trails that take the visitors through that scenery with very specific scenic purposes in mind. 'When carriages are introduced' into Yosemite, he proposes, 'they shall be driven for the most part up one side and down the other of the valley, suitable resting places and turnouts for passing being provided at frequent intervals. The object of this arrangement is to reduce the necessity for artificial construction within the narrowest practicable limits, destroying as it must the natural conditions of the ground and presenting an unpleasant object to the eye in the midst of the scenery' (p. 509).[55] In designing a circuit through the park, Olmsted would both make Yosemite accessible and preserve 'the natural conditions of the ground'. But for Olmsted, designing a circuit of roads and trails that will not destroy 'the natural conditions of the ground' does not mean preserving the valley in its natural state. Rather, it means reproducing the valley as nature by creating and effacing the difference between natural and aesthetic agency. Inscribing a boundary between artifice and nature, the Olmsted circuit simultaneously produces Yosemite as a series of aesthetic experiences, elides the agency that constitutes Yosemite as a park, and reproduces Yosemite as nature for others to use again.

In light of this understanding of preservation's double logic of aesthetic and natural agency, it becomes impossible to accept Runte's characterization of Olmsted's report as advocating 'preservation of the park for its own sake'. In his Yosemite report, as in his many discussions of urban parks, Olmsted consistently argues that natural scenery should be provided for the recreational benefit of park goers. Preservation of scenery and the accommodation of visitors constitute the

double imperative of Olmsted's principles of park design. But Olmsted's persistent interest in eliding and reproducing the difference between human and natural agency – in Central Park as in Yosemite, in landscape architecture as in recreation – makes it equally difficult to accept Trachtenberg's characterization of his park designs as participating in industrial capitalism's transformation of the raw materials of nature into cultural commodities. It would perhaps make more sense to characterize his landscape designs as embodying a structure of aesthetic agency by which nature tranforms the raw materials of the human into cultural commodities – whether by transforming the designs of the landscape architect into parks or the neurasthenic patients of the physician into effective labourers.

In offering this formulation, however, I do not simply want to reverse the valence of Trachtenberg's account of Olmsted's parks as reproducing the contradictions of industrial capitalism's incorporation of nature. Rather, following Greenblatt's lead, I would argue that insofar as Olmsted's parks can be seen as participating either in the transformation of the raw materials of nature into the means and ends of industrial production or in the transformation of the raw materials of the human into cultural commodities, they must be seen as doing so according to a logic that calls into question the distinctions between human, cultural and natural agency on which such a formulation depends. Indeed, as I have been arguing implicitly throughout this article, environmentalism became possible in mid-nineteenth-century America only by thinking of nature as art, an aestheticization of nature that operates according to the double logic of aesthetic agency exemplified in Olmsted's report. Beginning at least with Yosemite in 1864, the preservation of nature in America has operated according to a structure of aesthetic agency that works by setting aside tracts of land in which human purpose must be relinquished to the laws of nature in order to realize the purposes entailed in setting aside these tracts of land. And not only does the aesthetic act of ascribing value to nature at the same time that this ascription is effaced constitute what environmentalism meant in nineteenth-century America, but as Greenblatt's 'exemplary fable of capitalist aesthetics' compels us to recognize, something not very different from this double logic of aesthetic agency might constitute what environmentalism and the national parks mean for America today.

Notes

I wish to thank Anne Balsamo, Sandra Corse, Hugh Crawford, Stuart Culver, Michael Fried, Blake Leland, Kavita Philip, and the Cultural Studies Reading Group at Georgia Tech for their helpful comments and suggestions on earlier versions of this article.

1 Cronon's paper was drawn from the essay 'The trouble with wilderness; or,

getting back to the wrong nature', in William Cronon (ed.) *Uncommon Ground: Toward Reinventing Nature* (New York: W. W. Norton & Co., 1995): 69–90.

2 Lawrence Buell, *The Environmental Imagination: Thoreau, Nature Writing, and the Formation of American Culture* (Cambridge, MA: the Belknap Press of Harvard University Press, 1995): 35.

3 Elsewhere I have described such a criticism as 'cultural historicism'; see 'Introduction', *Configurations*, 3 (1995): 349–51.

4 Stephen Greenblatt, 'Towards a poetics of culture', in H. Aram Veeser (ed.) *The New Historicism* (New York: Routledge, 1989): 10.

5 Carolyn Merchant, *Ecological Revolutions: Nature, Gender, and Science in New England* (Chapel Hill: University of North Carolina Press, 1989): 198.

6 US, *Statutes at Large*, 13 (1864): 325.

7 *Congressional Globe*, 38th Congress, 1st session, p. 1310. All subsequent citations from the *Globe* will be noted in the text.

8 Senator Conness assured his colleagues that although the lands 'constitute, perhaps, some of the greatest wonders of the world', they were 'for all public purposes worthless' and 'of no value to the Government' (pp. 2300–1). Senator Foster of Connecticut commented that because it was 'a rather singular grant, unprecedented as far as my recollection goes', it was important to know if the State of California had requested the grant (p. 2301). Assuring Senator Foster that the measure had originated with some Californian gentlemen 'of fortune, of taste and of refinement', Senator Conness agreed that 'There is no parallel, and can be no parallel for this measure, for there is not, as I stated before, on earth just such a condition of things. The Mariposa Big Tree Grove is really the wonder of the world, containing those magnificent monarchs of the forest that are from thirty to forty feet in diameter' (p. 2301).

9 In the letter appointing Olmsted, Law also announced the other members of the Board of Commissioners: Josiah Dwight Whitney, William Ashburner, I. W. Raymond, E. S. Holden, Alexander Deering, George Coulter and Galen Clark. The identity of the commissioners was hardly a surprise. Whitney, Olmsted, Coulter and Raymond had already been mentioned as prospective commissioners in correspondence between Raymond and Senator Conness. And Olmsted's former superior in the US Sanitary Commission, Dr Henry Bellows, had already written to him in early August to congratulate him on being named to the commission. In a letter dated 29 September Low wrote to Olmsted, telling him: 'By today's mail I send you the Yosemite Commission.'

10 Roderick Nash, *Wilderness and the American Mind* (3rd edn; New Haven, CN: Yale University Press. 1982): 106; Nash, *The Rights of Nature: A History of Environmental Ethics* (Madison: University of Wisconsin Press, 1989): 35.

11 Alfred Runte, *Yosemite: The Embattled Wilderness* (Lincoln: University of Nebraska Press, 1990): 21.

12 'The purpose of the park, as indicated by the placement of its boundaries, was strictly scenic. Only Yosemite Valley and its encircling peaks, an area of

approximately forty square miles, comprised the northern unit. . . .
Obviously such limitations ignored the ecological framework of the region,
especially its watersheds; indeed, the term *ecology* was not even known' (Alfred
Runte, *National Parks: The American Experience* (2nd edn; Lincoln: University of
Nebraska Press, 1987): 29).

13 Runte, *National Parks*: 29, 31.

14 Albert Fein credits the report with the articulation of 'a philosophy and a set
of working principles for the creation of state and national parks' (*Frederick Law
Olmsted and the American Environmental Tradition* (New York: G. Braziller, 1972):
40). The editors of the Olmsted papers call his report 'the first comprehen-
sive statement on the preservation of natural scenery in America' (*FLO*, 5: 3).
Laura Wood Roper makes a similar claim for Olmsted's Yosemite report,
arguing that 'With this single report, in short, Olmsted formulated a philo-
sophic base for the creation of state and national parks'; 'The Yosemite Valley
and the Mariposa Big Trees, a preliminary report (1865)', *Landscape Architec-
ture* 43 (1952): 13. Roper elaborates this claim in her biography of Olmsted,
contending that 'Olmsted's report was the first systematic exposition of the
right and duty of a democracy to take the action that Congress had taken in
reserving the Yosemite Valley and the Mariposa Big Tree Grove from private
preemption for the enjoyment of all the people' (*FLO: A Biography of Frederick
Law Olmsted* (Baltimore, MD: The Johns Hopkins University Press, 1973):
283). And in her biography Stevenson concurs, asserting that 'it was Olmsted
who honorably instigated the movement of preservation to be followed, aban-
doned, and then re-adopted here and elsewhere in the national park system
and later in the wilderness system' (p. 271).

Among the more extreme interpretations is David Brower's mythological
description of Olmsted as 'the grandfather' of 'the national park idea': 'Moun-
tains, unable to vote or protect themselves, need a voice, and Olmsted was
one of the first to try to speak for them' (David Brower, 'Foreword', *The
Yosemite* (San Francisco: Sierra, 1988; rpt. of 1914 edn): xiii). A more
measured view is offered by Runte's characterization of the report as 'a classic,
a statement that literally anticipated the ideals of national park management'
(Runte, *Yosemite*: 28). Like Brower, Runte sees Olmsted as possessing an early
environmental consciousness lacking both in Congress and throughout the
history of Yosemite's management, calling his report an uncompromising
demand for 'preservation of the park for its own sake' (Runte, *Yosemite*: 31).
John Sears, however, who considers Yosemite to be 'a turning point in the
history of American tourism and in the search for an adequate cultural monu-
ment', reads Olmsted's report quite differently as articulating the 'view that
Yosemite should be developed as a public park, that roads and railroads be built
to it and facilities constructed for the accommodation of tourists' (Sears, pp.
123, 133). For Runte, too, monumentalism goes hand-in-hand with cultural
nationalism, both of which motives he ascribes to Congress, contending that
it 'had acted with the national interest in mind' (*National Parks*: 30). Although
Sears places Olmsted's report in a broader cultural context, he, too, fails to

provide a reading of the report that accounts for the differences between Olmsted's understanding of the opposition between preservation and use and our own. *The Papers of Frederick Law Olmsted, Volume V: The California Frontier, 1863–1865* (Baltimore, MD: The Johns Hopkins University Press. Future citations will be '*FLO, 5*'. 1990): 22–3. For the history of the report's reconstruction, see Roper, 'The Yosemite Valley', pp. 12–13.

15 In her biography of Olmsted, Roper has suggested that his Yosemite report was sabotaged by two of his fellow commissioners, Ashburner (who attended the meeting in the valley) and Whitney (who did not). As members of the California Geological Survey the two men apparently felt that the funds which Olmsted had requested for managing the park would come out of the state's appropriations for the Survey (*FLO: A Biography*: 287). For whatever reason, Olmsted's report was lost from sight until Roper resurrected it for publication in 1952. For further discussion of the report's suppression, see Runte (*Yosemite*: 28–31, and 'Introduction', in Victoria Post Ranney (ed.).

16 For an interesting and informative discussion of Olmsted's Yosemite report in the context of his work as a professional landscape architect, see Anne Whitson Spirn, 'Constructing nature: the legacy of Frederick Law Olmsted', in *Uncommon Ground*, op cit.

17 'The relation of photography to the fine arts', *The Philadelphia Photographer*, 2 (1865): 3. John Moran was the younger brother of Thomas 'Yellowstone' Moran, whose paintings and lithographs of the Yellowstone region were (with William Henry Jackson's photographs) like Bierstadt's paintings and Watkins' photographs in the case of Yosemite, influential in persuading Congress to pass the legislation establishing the nation's first official national park.

18 Ibid.: 3.

19 Stanley Cavell describes this relinquishment of agency as satisfying 'the human wish, intensifying in the West since the Reformation, to escape subjectivity and metaphysical isolation': 'Photography overcame subjectivity in a way undreamed of by painting, a way that could not satisfy painting, one which does not so much defeat the act of painting as escape it altogether: by *automatism*, by removing the human agent from the task of reproduction' (*The World Viewed: Reflections on the Ontology of Film* (enlarged edition; Cambridge, MA: Harvard University Press, 1979): 21, 23). What twentieth-century commentators ascribed to mechanism or automatism, nineteenth-century commentators ascribed to the laws of nature. Thus in *The Pencil of Nature* (London, 1844–6), the first published book of photographs, H. Fox Talbot assured his readers that his photographs were 'impressed by Nature's hand' 'without any aid whatever from the artist's pencil': 'and what they want as yet of delicacy and finish of execution arises chiefly from our want of sufficient knowledge of [Nature's] laws'. For Fox Talbot as for Moran, photography is distinguished from painting precisely because in order to realize his intention the photographer must, at the moment of exposure, a 'moment' which in the early days of photography could sometimes take over an hour, relinquish artistic control to 'Nature's hand'. My understanding of the double logic of photography is influenced here

and elsewhere by Walter Michaels' discussions in *The Gold Standard and the Logic of Naturalism*.

20 In his 1855 'Letters on landscape painting', for example, Asher Durand characterizes truly great paintings as marked by 'the concealment of pigments and not the parade of them'. Thus it is unsurprising that he urges his hypothetical student to pay particular attention to 'the study of the influence of atmosphere', which he describes as 'an intangible agent . . . that which above all other agencies, carries us into the picture, instead of allowing us to be detained in front of it'. James Jackson Jarves sets forth a similar aesthetic in *The Art-Idea*, first published in 1864. Jarves finds the panoramic landscapes of Church and Bierstadt to be wanting in comparison with the landscapes of Inness precisely because the former paintings 'always keep the spectator at a distance. He never can forget his point of view, and that he is looking at a painting. Nor is the painter himself ever out of mind. The evidences of scenic dexterity and signs of his labor-trail are too obvious for that'. The effect of 'high art' like Inness', however, 'is to sink the artist and spectator alike into the scene': 'The spectator is no longer a looker-on, as in the other style, but an inhabitant of the landscape. . . . He enjoys it with the right of ownership'. Olmsted's theory of landscape architecture fuses the logic of photographic action set forth by Moran with the absorptive aesthetics of Durand and Jarves.

21 Although Mountain View Cemetery was laid out along the lines of Olmsted's design, neither of Olmsted's other two designs were ever implemented – in fact it was a number of years before Olmsted even received payment for his design for the Berkeley campus. Olmsted's correspondence with Vaux was quite involved and often bitter, focusing not only on the continuation of the partnership but on who should receive what kind of credit and how much for their work on Central Park (*FLO*, 5: 358–445).

22 Olmsted Papers; quoted in Fisher, *Frederick Law Olmsted and the City Planning Movement* (Ann Arbor, MI: UMI Research Press, 1986): 29.

23 Olmsted offered a more vexed definition of landscape architecture in a letter written to Calvert Vaux from Bear Valley, California, the town in which Olmsted lived while managing the Mariposa Mining Company. Dated 1 August 1865, the letter is largely concerned with the problems Olmsted has with the name 'landscape architecture'. 'I am all the time bothered with the miserable nomenclature of L.A. *Landscape* is not a good word, *Architecture* is not; the combination is not. *Gardening* is worse. I want English names for ferme and *village* orne'e – street &c orne'e – but orne'e or decorated is not the idea – it is artified & rural artified – which is not decorated merely. The art is not gardening nor is it architecture. What I am doing here in Cal[ifornia] especially, is neither. It is the sylvan art, *fine-art* in distinction from Horticulture, Agriculture or Sylvan *useful* art. We want a distinction between a nurseryman and a market gardener & an orchardist, and an artist. And the planting of a street or road – the arrangement of village streets – is neither *Landscape* Art, nor *Architectural* Art, nor is it both together, in my mind – of course it is not, & it will never be in the popular mind. Then neither park nor garden, nor

street, road, avenue or drive, nor boulevard, apply to a sylvan bordered and artistically arranged system of roads, sidewalks and public places, – playgrounds, parades etc. There is nothing of park, garden or architecture, or landscape in a parade ground – not necessarily, though there may be a little of any or each and all. If you are bound to establish this new art – you don't want an old name for it. And for clearness, for convenience, for distinctness you do need half a dozen new technical words at least' (*FLO*, 5: 422–3). Despite Olmsted's unhappiness with calling this new art 'landscape architecture', the name stuck. And his concern that 'the popular mind' would not accept the name proved ultimately to be unfounded.

24 Fisher, *Frederick Law Olmsted and the City Planning Movement*, p. 27.

25 Kant decrees that there are 'only three kinds of beautiful arts: the arts of *speech*, the *formative arts*, and the art of the *play of sensations*' (pp. 164–5). Kant divides the 'formative arts', 'those by which expression is found for ideas in *sensible intuition*', into two kinds: 'arts of *sensible truth*', by which he means the '*plastic*' arts of sculpture and architecture; and arts of '*sensible illusion*', by which he means painting (p. 166). Painting, too, Kant divides into two kinds: 'the art of the beautiful *depicting of nature*', by which he means '*painting proper*'; and the art 'of the beautiful *arrangement of [nature's] products*', by which he means 'the art of landscape gardening' (p. 167). Like 'painting proper', landscape gardening 'presents a *sensible illusion* artificially combined with ideas': it 'is nothing else than the ornamentation of the soil with a variety of those things (grasses, flowers, shrubs, trees, even ponds, hillocks, and dells) which nature presents to an observer, only arranged differently and in conformity with certain ideas. But, again, the beautiful arrangement of corporeal things is only apparent to the eye, like painting; the sense of touch cannot supply any intuitive presentation of such a form' (p. 167).

For Olmsted, landscape architecture is best seen as combining Kant's two kinds of painting. Like 'painting proper', Olmsted's landscapes provide beautiful depictions of nature; like 'landscape gardening', Olmsted's landscapes provide beautiful arrangements of nature's products. Kant comes closest to Olmsted's understanding of landscape architecture in a footnote acknowledging the strangeness of his classification of landscape gardening 'as a species of the art of painting'. Although landscape gardening 'presents its forms corporeally', Kant explains, 'it actually takes its forms from nature (trees, shrubs, grasses, and flowers from forest and field – at least in the first instance) and so far is not an art like plastic, and since it also has no concept of the object and its purpose (as in architecture) conditioning its arrangements, but involves merely the free play of the imagination in contemplation, it so far agrees with mere aesthetical painting which has no definite theme (which arranges sky, land, and water so as to entertain us by means of light and shade only)' (p. 167, n49).

In distinguishing landscape gardening from 'painting proper', Kant redefines landscape gardening as 'painting in the wide sense' (p. 167). 'Under painting in the wide sense I would reckon the decoration of rooms by the aid of tapestry,

bric-a-brac, and all beautiful furniture which is merely available to be *looked* at; and the same may be said for the art of tasteful dressing (with rings, snuffboxes, etc.). For a bed of various flowers, a room filled with various ornaments (including under this head even ladies' finery), make at a fete a kind of picture which, like pictures properly so called (that are not intended to *teach* either history or natural science), has in view merely the entertainment of the imagination in free play with ideas and the occupation of the aesthetical judgment without any definite purpose' (pp. 167–8). For Kant, landscape gardening, as the type of 'painting in the wide sense', operates according to the Derridean logic of the parergon as a kind of frame or border for the body of the earth, 'the ornamentation of the soil', that which is on the one hand ruled out of, and on the other hand paradigmatic of, the realm of aesthetic judgement.

26 Olmsted's report makes both an aesthetic and a political point about Congress' motivation for ceding Yosemite to California. The report sets forth 'two classes of considerations [that] may be assumed to have influenced the action of Congress', dismissing as 'less important' 'the direct and obvious pecuniary advantage which comes to a commonwealth from the fact that it possesses objects which cannot be taken out of its domain that are attractive to travellers and the enjoyment of which is open to all' (pp. 500–1). For Olmsted, the 'more important class of considerations' motivating 'the action of Congress' is its obligation to provide the benefits of recreation to American citizens: 'It is the main duty of government, if it is not the sole duty of government, to provide means of protection for all its citizens in the pursuit of happiness against the obstacles, otherwise insurmountable, which the selfishness of individuals or combinations of individuals is liable to interpose to that pursuit' (pp. 501–2).

27 Olmsted's Prospect Park report, like many of his reports (including the original 'Greensward' proposal for Central Park), was co-authored with Calvert Vaux. It is generally accepted by Olmsted scholars, however, that there was a division of labour between them in which Olmsted did the writing and Vaux (a professionally trained architect) did the maps and designs. That the philosophy of recreation set forth in the Prospect Park report was primarily Olmsted's is confirmed by its fundamental agreement with the philosophy of recreation that Olmsted set forth in the landscape reports he wrote on his own in California.

28 *Landscape into Cityscape*, p. 100. All further citations from the Prospect Park report are cited in the text from this edition.

29 For an interesting and informative cultural history of neurology, see George Frederick Drinka, *The Birth of Neurosis: Myth, Malady, and the Victorians* (New York: S. & S. Trade, 1984). For a more conventional medical history, see Russell DeJong, *A History of American Neurology* (New York: Raven, 1982).

30 DeJong, *History of American Neurology*, pp. 4, 14.

31 Shortly before he resigned from the Commission, Olmsted supported Mitchell's attempt to improve the conditions at the Fort Delaware prison depot (*FLO*, 4: 684–5). His involvement with Hammond was more extensive.

Not only did Olmsted lobby for Hammond's appointment as Surgeon General of the United States Sanitary Commission but 'the two men worked together in August 1862 planning a campaign to secure an independent ambulance corps', and Olmsted consulted with and received pledges of support from Hammond regarding the weekly journal that Olmsted and Edwin Godkin were planning to edit (*FLO*, 4: 96–9). Although his relationship with Hammond has been characterized as 'cordial though never particularly intimate', it seems likely that the two men would have had more than one occasion to share medical and other opinions (*FLO*, 4: 98).

32 For a good discussion of Olmsted's positioning amidst the physiological and hygienic arguments for recreation and urban parks, see David Schuyler, *The New Urban Landscape: The Redefinition of City Form in Nineteenth-Century America* (Baltimore, MD: The Johns Hopkins University Press, 1986).

33 DeJong finds that although Beard 'was actually more closely allied to psychiatry than neurology', his works on electrotherapy, including his establishment of the short-lived *Archives of Electrology and Neurology*, were influential both in the United States and in Europe (p. 49). In addition, he 'made many important contributions to our understanding of the functional disorders of the nervous system' (p. 39). And despite the fact that the paper he delivered at the second meeting of the American Neurological Association in 1876 prompted Hammond to accuse Beard of 'humbuggery', contending that 'if Beard's doctrine [of the emotional basis of disease] was accepted, he "should feel like throwing his diploma away and joining the theologians"', Beard remained an active member of the Association until his death in 1883 at the age of 46 (pp. 38–9). For a more extended and engaging discussion of Beard's theories, see Drinka, *The Birth of Neurosis*, pp. 20–2, 182–97.

34 That Beard considered the habit of forethought central to his account of the causes of neurasthenia as a particularly American disease is underscored by the fact that when Herbert Spencer made a similar claim in 'The gospel of recreation', a 'farewell address to his American friends', published in the January 1883 issue of *Popular Science Monthly*, Beard was moved to defend his priority in 'his own article, entitled "A Scientific Coincidence"' (Drinka, *The Birth of Neurosis*, pp. 191–2). In advocating the gospel of recreation, Spencer had accused Americans of being too civilized, contrasting civilization with savagery on the basis of the habit of forethought. 'The savage thinks only of present satisfactions, and leaves future satisfactions uncared for. Contrariwise, the American, eagerly pursuing a future good, almost ignores what good the passing day offers him; and when the future good is gained, he neglects that while striving for some still remoter good' (Herbert Spencer, 'The gospel of recreation', *Popular Science Monthly* (1883): 355–6). In *American Nervousness* (New York, 1881), Beard had set forth a similar contrast, noting that 'This forecasting, this forethinking, discounting the future, bearing constantly with us not only the real but imagined or possible sorrows and distresses, and not only of our own lives but those of our families and of our descendants, which is the very essence

of civilization as distinguished from barbarism, involves a constant and
exhausting expenditure of force' (pp. 128–33).

35 Although uninterested in the structure of agency that I have been discussing
here, T. Jackson Lears treats the emergence of neurology in post-Civil War
America as participating in the creation of the 'therapeutic world view' charac-
teristic of what he calls 'antimodernism', a resistance to the industrialization
and modernization endemic in late capitalist culture (*No Place of Grace: Anti-
modernism and the Transformation of American Culture, 1880–1920* (New York:
Pantheon Press, 1981): 47–58).

36 *The Collected Works of Ralph Waldo Emerson* (Cambridge, MA, 1871), Vol. 1: 13.
Emerson makes a similar claim in 'The young American', where in conjunc-
tion with calling for the creation of public parks and gardens, he contends that
'we must regard the *land* as a commanding and increasing power on the Ameri-
can citizen, the sanative and Americanizing influence, which promises to dis-
close new virtues for ages to come' (p. 229).

37 In making this distinction between Olmsted and Emerson I do not mean to
reinstate the traditional reading of the disembodied Emerson. Indeed, as I have
argued elsewhere, Emerson's transcendentalism is not so much a rejection of
the body as it is a sustained meditation on questions of embodiment (Richard
A. Grusin, *Transcendentalist Hermeneutics: Institutional Authority and the Higher
Criticism of the Bible* (Durham, NC: Duke University Press, 1991)). Rather, I
mean mainly to emphasize that Olmsted's understanding of the therapeutic
value of natural scenery is more explicitly involved with the discourse of nine-
teenth-century medical science than is Emerson's.

38 Frederick Law Olmsted, *Public Parks and the Enlargement of Towns* (New York,
1870; reprinted 1970): 32.

39 The three articles Holmes wrote on photography were 'The stereoscope and
the stereograph' (*Atlantic Monthly*, 3 (1859): 738–48); 'Sun-painting and sun-
sculpture, with a stereoscopic trip across the Atlantic' (*Atlantic Monthly*, 8
(1861): 13–29); and 'Doings of the sunbeam' (*Atlantic Monthly*, 12 (1863):
1–15). As the titles of the last two articles make clear, Holmes participated in
the mid-century discourse of photography as a form of representation in which
the laws of nature (through the artistry of the sun) are seen as the agents of
artistic reproduction. Although I have not found any indication that Holmes
himself ever drew a connection between the logic of photography and the
'nature-trusting heresy', his own participation in both discourses seems to be
from our vantage point (at the least) logically consistent.

40 For an excellent discussion of Holmes and the 'nature-trusting heresy', see J.
H. Warner, '"The nature-trusting heresy": American physicians and the
concept of the healing power of nature in the 1850's and 1860's' (*Perspectives
in American History*, 11 (1977–78): 291–324).

41 Two important cultural histories of nineteenth-century therapeutics are
Charles E. Rosenberg, 'The therapeutic revolution: medicine, meaning, and
social change in nineteenth-century America', in Morris J. Vogel and Charles
E. Rosenberg (eds) *The Therapeutic Revolution: Essays in the Social History of*

American Medicine (Philadelphia: University of Pennsylvania Press, 1979): 3–25; and Martin Pernick, *The Calculus of Suffering: Pain, Professionalism, and Anesthesia in Nineteenth-Century America* (New York: Columbia University Press, 1985).

42 Rush's remark is quoted in John W. Jones, 'Vis medicatrix naturae and antistasis', *Atlanta Medical and Surgical Journal*, 1 (1855): 69; quoted in Warner, 'Nature-trusting heresy': 294.

43 Ibid.: 295–6.

44 Elisha Bartlett, *An Essay on the Philosophy of Medical Science* (Philadelphia, 1844): 288–9; quoted in Warner, 'Nature-trusting heresy', p. 298.

45 Holmes, *Homeopathy and Its Kindred Delusions; Two Lectures Delivered Before the Boston Society for the Diffusion of Useful Knowledge* (Boston, 1842): 50–4; quoted in Warner, 'Nature-trusting heresy', p. 299.

46 Although Olmsted's understanding of the therapeutic value of natural scenery parallels the 'nature-trusting heresy', in treating his own illnesses he followed the not uncommon practices of using quinine as a prophylactic and of relying on alcohol as a tonic. On the rail trip across the Isthmus of Panama on his way to Mariposa, for example, Olmsted prescribed as a nightly prophylactic against malaria three grams of quinine to each member of his travelling party and reminded his wife Mary not to 'despise the prophylactic' when she came to join him the following year (*FLO*, 5: 82–4). Similarly, he described a course of medical treatment in a letter to Vaux from Bear Valley, dated 28 September 1865: 'We have an epidemic of fevers here, typhoid in the highlands, congestive remittent below. One of our clerks has died, and several of us have been threatened, but by timely care & quinine & brandy have escaped any severe attack. I was the last & kept my bed yesterday, am living on port wine today' (*FLO*, 5: 443). Insofar as these passages represent a discrepancy between his theory and his practice (and it is not entirely certain that they do), Olmsted's therapy is none the less consistent with the behaviour of even the most heretical 'nature-trusting' physicians. As Charles Rosenberg has argued, 'Practice changed a good deal less than the rhetoric surrounding it would suggest . . . older modes of therapeutics did not die, but, as we have suggested, were employed less routinely, and drugs were used in generally smaller doses' ('Therapeutic revolution' pp. 17–18). Interestingly, Rosenberg also notes that 'the decades between 1850 and 1870' saw 'a vogue for the use of alcoholic beverages as stimulants' (p. 17).

47 In 'The Olmsted Renaissance: a search for national purpose', in Bruce Kelly (ed.) *Art of the Olmsted Landscape* (New York: New York City Landmark Preservation Commission – Arts Publisher, 1981): 99–110, Albert Fein provides an account of Olmsted's popularity since the 1950s and the reasons for it. With few exceptions Olmsted scholarship has portrayed him as a liberal agrarian reformer. Arguably the staunchest advocacy of Olmsted's liberalism can be found in the work of Fein, who places Olmsted variously in the heart of the environmental tradition, Fourierist reform and Jeffersonian agrarianism. See, for example, *Frederick Law Olmsted and the American Environmental Tradition*; the

Introduction to *Landscape into Cityscape*; and 'The Olmsted Renaissance'. The portrayal of Olmsted as a liberal was challenged first by Geoffrey Blodgett, 'Frederick Law Olmsted: landscape architecture as conservative reform' (*Journal of American History*, 62 (1975–6)), closely followed by Robert Lewis, 'Frontier and civilization in the thought of Frederick Law Olmsted' (*American Quarterly*, 29 (1977): 385–403). More recently this view has (in a modified form) been given credence by Thomas Bender, *Towards an Urban Vision* (Lexington, Ky: University of Kentucky Press, 1975); James L. Machor, *Pastoral Cities: Urban Ideals and the Symbolic Landscape of America* (Madison: University of Wisconsin Press, 1987); and Schuyler, *New Urban Landscape*. For a perceptive treatment of the implications of revisionist readings of Olmsted's politics, see the Introduction to Schuyler's *New Urban Landscape*.

48 Even in a recent article by Susanna Zetzel, 'The garden in the machine: the construction of nature in Olmsted's Central Park' (*Prospects* (1989): 291–319), in which the author argues that Olmsted occupies a middle ground between conservative genteel reform and liberal Jeffersonian agrarianism, the categories of liberalism and conservatism are clearly those of the late twentieth century. The author's commitments to liberalism are evident, however; despite trying to find a compromise between the two positions, she engages in special pleading in her attempt to free Olmsted from the conventional racism of his day.

49 According to Trachtenberg, the Olmsted park exerts 'a benign coercion': 'Behind pastoral harmony, its Jeffersonian hope for a public space free of class distinction and division, lay the ordering hand of corporate civilization and hierarchy. . . . Set in a planned landscape detached from time, a zone free of the temporal demands of commerce (though governed by strict opening and closing hours), the vision of harmony now implied not a reformed social order but a therapy. A city upon a hill within the city of destruction, a celestial palace amid Vanity Fair, the park implied a scenario of recovered inner balance on one hand, and firm, elite supervision through corporate forms on the other' (*The Incorporation of America*: 111–12).

50 Ibid.: 112.

51 Trachtenberg, *Incorporation*, p. 22. Trachtenberg's description of capitalism's logic of incorporation closely resembles Greenblatt's description of Fredric Jameson's account of capitalism as a unifying totalizing system in *The Political Unconscious: Narrative as a Socially Symbolic Act* (Ithaca, New York: Cornell University Press, 1981). As I explain in my introduction, Greenblatt attributes the success of capitalism neither to its unifying nor its differentiating power, but to its production of 'a powerful and effective oscillation between the establishment of distinct discursive domains and the collapse of those domains into one another' ('Towards a poetics of culture', p. 8).

52 This is not to deny that the urban park movement participates in an ideology of Jeffersonian agrarianism. Rather, it is to insist with Philip Fisher 'that modern capitalism, however much Jefferson feared it, turned out to be the very means to a Jeffersonian America' ('Democratic social space: Whitman,

Melville, and the promise of American transparency', *Representations*, 24 (1988): 65). Insofar as Olmsted seeks to extend Jefferson's agrarian vision to the late nineteenth-century city, he seeks to design parks not as pastoral sanctuaries in which agrarian virtues can reside as in a drawer or cabinet but as aesthetic systems of circulation and exchange that serve both to reproduce and elide the difference between urban and agrarian ideals. In imagining the aim of the Olmsted park as creating 'a planned landscape detached from time, a zone free of the temporal demands of commerce', Trachtenberg is unable to recognize the way in which Olmsted's landscape designs neither escape nor reproduce the contradictory ideology of corporate capitalism, but operate according to a structure of aesthetic agency that refigures the relationship between agrarianism and urbanization within which that ideology unfolds.

53 Olmsted approaches this design problem in Prospect Park not by striving for 'a perfect compromise at all points' but by seeing that each design objective 'should be carried out at certain points in high degree' (p. 101). Unlike providing therapeutic recreation through the creation of natural scenery (which, by concealing the signs of art, allows the mind to occupy itself without purpose), in providing opportunities for people to see each other, Olmsted must attract attention away from the scenery by employing such purposeful signs of 'the application of art to inanimate nature' as 'architectural objects' or 'festive decorations' (p. 104). In obeying the double imperative of urban park design – providing natural scenery while also accommodating the movements of the public through the park – Olmsted must devise a system of traffic circulation in which both his own agency as artist and the park goer's agency as viewer can be successively produced and elided.

54 The phrasing of this passage is indicative of the persistence in Olmsted's habit of mind of the logical structure of agency that I have been outlining here. In saying that 'the Commissioners *propose to cause to be constructed* a double trail', Olmsted reveals the way in which he sees being a commissioner, like being a doctor or a photographer or a landscape architect, to involve relinquishing agency or control to others for one's intentions to be realized.

55 Olmsted's concern that artificial constructions work as parts of an overall scenic composition is evident in the plan he drew up for the design of the neighbourhood surrounding the Berkeley campus, a plan that (though never implemented) provides a good indication of his design principles around the time of the Yosemite report. In describing 'the view from the window or balcony' of a Berkeley house, he writes that it should 'be artistically divisible into the three parts of; first, the home view or immediate foreground; second, the neighborhood view or middle distance, and third, the far outlook or background. Each one of these points should be so related to each other one as to enhance its distinctive beauty, and it will be fortunate if the whole should form a symmetrical, harmonious and complete landscape composition' (*FLO*, 5: 556). In designing individual homes, Olmsted insists that their participation as elements of the 'middle distance' of others' views be always kept in mind.

Susan Squier

INTERSPECIES REPRODUCTION: XENOGENIC DESIRE AND THE FEMINIST IMPLICATIONS OF HYBRIDS

Abstract

This article explores the image of interspecies reproduction, arguably the most disturbing of the range of contemporary images of reproductive technology, as both a metaphor of some historical standing and as a new, and troubling, medical/scientific capability. Moving from the 1994 report of the Human Embryo Research Panel of the NIH, also known as the Muller Panel, through a range of sites – natural history, popular science writing, social critique, fiction, feminist theory and science studies – the article explores the context in which our current scientific perspective on interspecies reproduction is constructed. The study demonstrates the value of contextualizing – both in terms of history and literature – even the most seemingly transparent scientific or medical intervention, in order to achieve the fullest understanding of its implications. A concluding consideration of the philosophical/theoretical construction of interspecies reproduction in the present (postmodern) moment explores its implications for our understanding of the feminist critique of science.

Keywords

xenogenesis; hybridity; reproduction; embryo; modernity; postmodernity

Reproduction has become the prime strategic question, a privileged trope for logics of investment and expansion in late capitalism, and the site of dis-courses about the limits and promises of the self as individual.

(Haraway, 1989)

I N 1984, the British Government's *Warnock Report on Human Fertilization and Embryology*, while observing that 'trans-species fertilisation' was a routine part of infertility treatment, acknowledged that 'the hamster tests and the possibility of other trans-species fertilisations, carried out either diagnostically or as part of a research project, have caused public concern about the prospect of developing hybrid half-human creatures'.[1] Therefore, the Warnock Committee proposed regulations that would prevent such an interspecies embryo from being gestated or brought to term.

> We recommend that where trans-species fertilisation is used as part of a recognized program for alleviating infertility or in the assessment or dia-gnosis of subfertility it should be subject to license and that a condition of granting any such license should be that the development of any resultant hybrid should be terminated at the two cell stage.

(p. 71)

Ten years later, in September 1994, the United States government's NIH report of the Human Embryo Research Panel recommended a similar act of prohibi-tion, deeming as 'research considered unacceptable for federal funding' the 'development of human-nonhuman . . . chimeras with or without transfer', the 'cross-species fertilization except for clinical texts of the ability of sperm to pen-etrate eggs', and the 'attempted transfer of human embryos in nonhuman animals for gestation'.[2]

Something very interesting is going on here. In two government documents, hand-picked committees comprised of scientists and members of the educated lay community are agreeing on a position that seems contradictory: first, that interspecies fertilization exists and indeed is sanctioned as a crucial part of con-temporary reproductive technology and infertility treatment, and second, that interspecies reproduction is unacceptable and unworthy of federal funding, and that it should be against the law to bring interspecies hybrids to term. How do we explain this double move to approve or sanction, and then to prohibit? It seems more than merely a scientific qualification or a manoeuvre designed to calm public concerns. Rather, it brings to mind Freud's 1925 essay, 'Negation', in which he observes that 'the subject-matter of a repressed image or thought can make its way into consciousness on condition that it is denied'.[3] The parallel to Freud's analysis of the function of negation suggests that these government panels are doing cultural and psychic, as well as governmental and scientific work. Invoking interspecies pregnancy in order to deny (outlaw) it, the Warnock

Committee and the NIH Human Embryo Research Panel may be seen as satisfy-
ing a desire: putting into circulation the very same (repressed) cultural image
that they propose to legislate against.

This article will explore the image of interspecies reproduction, arguably the
most disturbing of the range of contemporary images of reproductive tech-
nology, as both a metaphor of some historical standing and as a new, and to many,
troubling, medical/scientific fact. I begin with the Muller Panel's position on
interspecies reproduction, because it can suggest some of the cultural formations
within which the panel came into being, and to which it is inevitably responding
in its treatment of interspecies reproduction. I will trace some of the embedded
meanings of the image through a range of sites – natural history, popular science
writing, social critique, fiction, feminist theory, and science studies – in order to
provide a sense of the context within which our current scientific perspective on
interspecies reproduction is constructed. In so doing, I hope to demonstrate the
value of contextualizing – both in terms of history and literature – even the most
seemingly transparent scientific or medical intervention, in order to achieve the
fullest understanding of its implications. Then, having moved from the scientific
and governmental to the cultural and more specifically literary, I will consider
one final site: the philosophical/theoretical construction of interspecies repro-
duction in the present (postmodern) moment, which has important implications
for our understanding of the feminist critique of science.

Cross-species fertilization in contemporary government reports

The Human Embryo Research Panel, also known as the Muller Panel after its
chair, Stephen Muller, devoted nearly five single-spaced pages to the question of
cross-species fertilization as part of human embryo research. The panel begins –
as did the Warnock Committee – by acknowledging the routine acceptance of
one sort of cross-species fertilization:

> Fertilization of hamster eggs with human sperm is widely used in infertil-
> ity clinics as a test for the fertilization competence of sperm. These eggs
> are used to test the competence of a particular patient's sperm to penetrate
> an egg. However, the fertilized eggs are not permitted to develop, nor is it
> likely that they would do so, due to the wide evolutionary distance between
> the two species. Thus the process has a clearly defined end point.
>
> (p. 42)

While the human–hamster embryo has a reassuring end point produced by the
very different morphologies of the two species, the Muller Panel observes that
other kinds of chimeric embryos would have no such automatic conclusion:

because of the close evolutionary relationship between humans and some primates, for example chimpanzees, it is theoretically possible that human eggs fertilized with chimpanzee sperm might develop, at least to 14 days. Such cross-species fertilization would be unacceptable.

(p. 42)

The Muller Panel elaborates on why such xenogenetic – or interspecies – activities are not recommended for federal funding:

It is theoretically possible to make chimeras between human embryos and closely related primates, such as chimpanzees but . . . the fetus would have cells derived from both species in all tissues. In other words, it might be possible for the chimeric fetus to have large parts of the brain and/or gonads derived mostly from primate cells and other parts of the body derived mostly from human cells, a situation that would, from both a medical and ethical standpoint, be totally unacceptable.

(p. 43)

A later paragraph, from a section on 'Development of human–nonhuman and human–human chimeras with or without transfer', elaborates on the panel's reason for 'unanimously oppos[ing], on ethical and scientific grounds, the creation of heterologous, or human–nonhuman chimeras, with or without transfer': 'any resulting chimera would be a mixture of both cell types in all tissues, including the brain and the gonads' (p. 95).

In its overdetermined attention to the brain and/or gonads as a site that must be protected from hybridity and kept pure from any intermixture of cell types, the Muller Panel's argument seems to reveal a concern that is less scientific than cultural. Language in a later section of the Muller report, concerning 'Attempted transfer of human embryos in nonhuman animals for gestation', confirms that suspicion (p. 96). Discussing the possibility of gestating human foetuses in nonhuman animals, a possibility that received serious and extended treatment in a 1929 text and which I will discuss in a later section, the Muller Panel 'overwhelmingly concluded to prohibit such research on the basis of scientific invalidity and moral opposition' (p. 96). Not only does the passage reveal an attention (uncharacteristic for governmental or scientific writings) to maternal–foetal interactions and the mother–infant bond (experiences often discounted when reproductive technology is being discussed), but the language is surcharged with intensity, unusual for both government and scientific discourse.

There is every reason to believe that a human embryo would be immunologically rejected after transfer into another species, or, at least, that maternal–fetal placental interactions would be profoundly affected. . . . Studies of human gestation confirm the importance of maternal–fetal interactions

during pregnancy. These are crucial not only for physiological develop-
ment, but they also represent the beginnings of mother–child bonding and
of human relationship. *The Panel finds it repugnant to experiment with such relat-
ing between a human fetus and a nonhuman gestational mother.*

(p. 96; my emphasis)

As these passages reveal, the scientific image of interspecies reproduction cata-
lyses complex emotions. The two acts which the Muller Panel advised prohibit-
ing – the creation and transfer of chimeric embryos and the gestation of human
foetuses in non-human animals – are both aspects of interspecies reproduction.
As such, they are also shadowed by the mixture of overdetermined cultural
meanings elicited by this (potential) scientific practice, which forms the con-
scious or unconscious context for any discussion of interspecies reproduction.
The first act – the creation of chimeric or hybrid embryos – recalls the discourse
of race from the seventeenth through to the nineteenth century, while the second
issue – the gestation of human foetuses in non-human animals – revisits a power-
ful site of modernist controversy over race and gender.

Hybridity and the anxiety of race and species

What is the context for the Muller Panel's anxiety about the creation and trans-
fer of chimeric embryos? In particular, what might be the origins of its curious
obsession with the notion of gonads and brains in which both human and non-
human cells were mixed? We can look to racial theories of the seventeenth, eight-
eenth and nineteenth centuries for an answer: such theories inevitably mingled
race and species because of the preoccupation with issues of origin and hierarchy,
often imaged as a 'chain of being' on which the species, and the races, were
arranged in hierarchical order. Species discourse, like racial discourse, was a rich
site of cultural construction. Seventeenth- and eighteenth-century naturalists
toyed with the notions of apes becoming human, and speculated on the intellec-
tual and biological issue of ape–human sexual encounters, finding them a pro-
ductive source of social satire and critique.[4] The European discovery of the great
apes in the seventeenth and eighteenth centuries spawned numerous stories
about ape–human hybrids, according to Londa Schiebinger, among them a nine-
teenth-century rumour that scientists had travelled from France to Africa to
'experiment with breeding a male orangutan and an African woman'.[5] 'Many
naturalists assert[ed] that women of Africa and. Asia "mixed" voluntarily or
through force with male apes, and that the products of these unions had entered
into both species' (p. 98). Rousseau even went so far as to suggest that a cross-
breeding experiment could answer the question of whether or not apes were
human: if the issue was fertile, his argument went, the apes' humanity would be
demonstrated (p. 98).

Interest in hybridity increased in the nineteenth century, when it became 'a key issue for cultural debate', according to historian Robert Young.[6] Preoccupied by the question of monogenesis or polygenesis – whether the human race issued from a single origin or from several different 'species' – mid-nineteenth-century thinkers found hybridity to be a useful term to express the anxieties produced, and articulated, by an evolutionary model that arranged not only species, but the races of humankind, hierarchically. The Victorian discourse of race expressed the enmeshed cathexis of inter-racial and interspecies transgression in texts portraying the Great Chain of Being, in which 'predictably the African was placed at the bottom of the human family, next to the ape, and there was some discussion as to whether the African should be categorized as belonging to the species of the ape or of the human' (Young, 1995, pp. 6–7). The definitive test for whether or not organisms were of the same species was whether they could successfully produce fertile offspring; if their offspring were fertile, the parents were judged to be of the same species. 'The dispute over hybridity thus put the question of inter-racial sex at the heart of Victorian race theory', Robert Young has observed (p. 102). Hybridity served as a powerful site of cultural construction, connected to issues of both racial and species origins, according to Young, 'because the claim that humans were one or several species (and thus equal or unequal, same or different) stood or fell over the question of hybridity, that is, intra-racial fertility' (p. 9). In the nineteenth century, then, the term hybridity expressed mingled attraction and repulsion. Laden with an implicit racial as well as heterosexual ideology, the term imports into contemporary theory the unacknowledged trace of that racist past.[7] 'Racial theory, which ostensibly seeks to keep races forever apart, transmutes into expressions of the clandestine, furtive forms of what can be called "colonial desire": a covert but insistent obsession with transgressive, inter-racial sex, hybridity and miscegenation.'[8]

Just as the boundary-constructing concept of race is overshadowed by a desire to transgress those racial boundaries, so too the taxonomic impulse that has given us the concept of species has, as its transgressive underside, the impulse to cross species boundaries. We can modify Robert Young's formulation of 'colonial desire' to theorize the existence of what we might call 'xenogenic desire' – a covert but insistent obsession with transgressive, interspecies sex, hybridity, and interspecies reproduction or xenogenesis.[9] Literature is one of the most powerful sites of the articulation of desire, precisely because – functioning like Freud's concept of 'negation' – literature can give expression to desire while simultaneously deauthorizing it as 'only fiction'. The articulation, construction and production of xenogenic desire – the fear/wish of interspecies reproduction – differs in relation to the changing construction of the subject in modern and postmodern literature, as I will sketch by moving through a number of literary texts, first modern and then postmodern. In the modern texts, three different representations of interspecies pregnancy reflect the changing scientific construction of the human body and subject during modernity: the surgical, the

reproductive technological, and finally the genetic. With the postmodern move to the affirmation of differences and the decentred subject, xenogenic desire takes on a new, positive construction. However, here too, the specific meaning of the image varies with the ideological agenda of the context, whether feminist postmodern or non-feminist 'amodern', and with the particular notion of reproduction being deployed.

Modern narratives of hybridity: from Frankenstein's monster to the fifth child

Mary Shelley's monster is an interspecies hybrid, pieced together in Victor Frankenstein's 'workshop of filthy creation' out of materials stolen from 'the dissecting room and the slaughter-house' (p. 39). As such, he functions as a point of origin for the negative literary image of xenogenic desire, although the image of the hybrid and the chimera extend back to Greek and Roman mythology. In its doomed fantasy of having 'a new species bless [Victor Frankenstein] as its creator and source' and in its preoccupation with the possibility that the monster might find a mate and breed 'a race of devils', *Frankenstein* establishes two major themes for literary treatment of interspecies reproduction in the modern era: devolutionary anxiety linked to a hierarchized racial taxonomy, and a proto-modernist notion of a tempting but dangerous scientific intervention enabling human perfectibility (pp. 39, 150).

We can trace through a range of turn-of-the-century and early twentieth-century British literary and philosophical texts the theme of hybridity, and its foundational emotions in modernity: anxiety over racial and species degeneration and an attraction to racial and species boundary crossing. In each of these texts, the notion of interspecies reproduction is linked to a fantasy of scientific control of reproduction, either to perfect the species or to annex abilities to one species that are customarily possessed by another. H.G. Wells' *The Island of Dr. Moreau* (1896) is perhaps the most powerful image of a surgical xenogenesis. The vivisectionist Dr Moreau, trained in London but now isolated on a remote Pacific island, surgically constructs Beast People, hybrids of human and animal species, in order to test the same human/animal boundary that preoccupied naturalists in the two centuries before. Moreau's explanation of his surgical creations combines racist and what we might call species-ist discourse:

> I took a gorilla I had, and upon that, working with infinite care, and mastering difficulty after difficulty, I made my first man. All the week, night and day, I molded him. With him it was chiefly the brain that needed molding; much had to be added, much changed. I thought him a fair specimen of the negroid type when I had done him, and he lay bandaged, bound, and motionless before me.[10]

While Wells used vivisection as his point of entry to the Victorian debate over the boundaries of race and species and the origin of humanity, writers in the early twentieth century were more likely to find their point of entry in the notion of scientifically controlled reproduction. Thus they turned to the second technique for interspecies reproduction that the Muller Panel invokes and prohibits, in that powerful double move of negation and the gratification of desire: the idea of gestating a human foetus in a non-human uterus. J.B.S. Haldane's celebrated discussion of extra-uterine gestation in *Daedalus, or Science and the Future* (1923) prompted Nietzschean philosopher Anthony Ludovici to respond with his own image of interspecies extra-uterine gestation: a human foetus gestating in 'a cow or an ass' (p. 92). Unlike Wells' scathing portrait of the human drive to improve nature through science, Ludovici's image of human–animal hybridity expressed sexist and racist anxieties through the metaphor of human devolution:

> Science already suspects that vital fluids are not specific, and it is probable, therefore, that in the early days of extra-corporeal gestation, the fertilized human ovum will be transferred to the uterus of a cow or an ass, and left to mature as a parasite on the animal's tissues, very much as the newborn baby is now made the parasite of the cow's udder. And with this innovation, we shall probably suffer increased besotment, and intensified bovinity or asininity, according to the nature of the quadruped chosen. Thus extra-corporeal gestation, or 'ectogenesis' (to use a word coined by Mr. J.B.S. Haldane for the purpose) will become a possibility, and the Feminist ideal of complete emancipation from the thraldom of sex will be realized.
>
> (p. 92)

Lysistrata, or Woman's Future and Future Woman was philosopher and translator of Nietzsche Anthony Ludovici's contribution to the 'To-day and tomorrow series', a curious set of futurological tracts published in London in the 1920s. The volume warns that the increasing artificiality of modern life threatens masculinity and high culture in the name of a feminized, feminist mass culture. Ludovici's remarkable paranoid fantasy that feminists would seize on interspecies methods of reproduction to gain emancipation from reproductive service to the species is a rare modern prefiguration of the postmodern trend I will discuss later: the affirmative view of interspecies reproduction as positive and emancipatory, rather than negative and devolutionary.

Two final texts can round out the picture of modernist visions of interspecies reproduction. Five years after Ludovici's anxious fantasy of a feminist escape from childbearing, Aldous Huxley gave us the Taylorized reproductive factory in *Brave New World* (1932), where babies are mass-produced *in vitro*, tailored to job specifications, and the term 'mother' has become an obscenity. About thirty years later, Roald Dahl's macabre little short story 'Royal Jelly' picks up this theme of modern science improving the human body, to tell the tale of the (aptly named)

Albert Taylor, a devout reader of the *American Bee Journal*, whose interest in scientific strategies for improving the human takes a grotesque turn.[11] In an ironic nod to Gregor Samsa, Dahl's description of Albert gives us a hybrid that is not human-animal, but human-insect, even to the loving eyes of his wife:

> Looking at him now as he buzzed around in front of the bookcase with his bristly head and his hairy face and his plump pulpy body, she couldn't help thinking that somehow, in some curious way, there was a touch of the bee about this man. She had often seen women grow to look like the horses that they rode, and she had noticed that people who bred birds or bull terriers or pomeranians frequently resembled in some small but startling manner the creature of their choice. But up until now it had never occurred to her that her husband might look like a bee. It shocked her a bit.
>
> (p. 122)

Adapting research on rat reproductive capacities to his own fertility problem, Albert has been taking massive doses of royal jelly – doses which, the story makes clear, have enabled him finally to impregnate his wife. When his precious new-born daughter seems to be ailing, Albert – inspired by his lifelong hobby of amateur bee-keeping – decides to feed his little girl the 'wonderful substance called royal jelly', which in the hive is given undiluted to those larvae 'which are destined to become queens' (p. 107). With classic Dahl mordancy, the story includes an ironic version of a set piece of such tales of hybrid birth: a scene in which the monstrous, scientifically engineered baby is seen through her horrified mother's eyes:

> The woman's eyes travelled slowly downward and settled on the baby. The baby was lying naked on the table, fat and white and comatose, like some gigantic grub that was approaching the end of its larval life and would soon emerge into the world complete with mandibles and wings.
>
> 'Why don't you cover her up, Mabel,' he said. 'We don't want our little queen to catch a cold.'
>
> (p. 130)

The royal jelly has enabled the scientist-hobbyist-father to produce his own little queen, displacing the bewildered woman who was once the mother. Dahl's story, like the stories of scientific tinkering with reproduction before it (from *Frankenstein* to *Dr. Moreau* to *Brave New World*) portrays a new-born produced with no help from women, and from which women are pointedly, uncomprehendingly, distanced.

One final modernist text of interspecies reproduction is Doris Lessing's *The Fifth Child*, a novel published in 1988 but suffused with modernist concerns. Lessing's novel expresses both the masculinist anxiety at social and biological

devolution articulated earlier in Anthony Ludovici's connection between 'increased besotment' and feminism and the image of a mother's horrified response to her hybrid child, merging them in a disturbing fantasy of mothering a monstrous devolved child. Lessing's heroine, Harriet Lovatt, finds herself pregnant with a monstrously alien foetus:

> Phantoms and chimeras inhabited her brain. She would think, When the scientists make experiments, welding two kinds of animal together, of different sizes, then I suppose this is what the poor mother feels. She imagined pathetic botched creatures, horribly real to her, the products of a Great Dane or a borzoi with a little spaniel; a lion and a dog; a great cart horse and a little donkey; a tiger and a goat.
>
> (Lessing, 1988: 41)

After a horrific pregnancy, Harriet gives birth to a baby whose 'forehead sloped from his eyebrows to his crown', a description recalling the racist craniology of Petrus Camper, with its central notion of the 'facial angle', a measurement that could be used to differentiate the ape from human beings of different races. (Lessing, 1988: 48–9, Schiebinger, 1993: 150). Londa Schiebinger argues that this concept of the facial angle was the 'central visual icon of all subsequent racism: a hierarchy of skulls passing progressively from lowliest ape and Negro to loftiest Greek' (p. 150). Although it shares the racial subtext of nineteenth- and early twentieth-century tales of interspecies reproduction, this story of the birth of a Neanderthal baby, to a woman whose rejection of feminism makes her seem a throw-back herself to an earlier time of female submissiveness and traditional values, is not a cautionary tale of scientific power gone wrong. Ben, the uncanny child with the beetling brow and the bruising manner, is not the engineered product of an ape and a human; no Moreau or Frankenstein has produced him. Rather, as Lessing imagines him, he is simply a genetic accident – the unexplained re-emergence of that missing link between contemporary humans and the apes that were our ancestors.

> She felt she was looking, through him, at a race that reached its apex thousands and thousands of years before humanity, whatever that meant, took this stage. 'Did Ben's people live in caves underground while the ice age ground overhead, eating fish from dark subterranean rivers, or sneaking up into the bitter snow to snare a bear, or a bird – or even people, her (Harriet's) ancestors? Did his people rape the females of humanity's forebears? Thus making new races, which had flourished and departed, but perhaps had left their seeds in the human matrix, here and there, to appear again, as Ben had?
>
> (p. 130)

In this scene of the alienated mother gazing at the hybrid child, Lessing's disturbing novel recapitulates the familiar seventeenth- and eighteenth-century racist fantasy of an interspecies rape as a racial origin. Yet unlike its predecessors, *Frankenstein*, *The Island of Dr. Moreau*, and even 'Royal Jelly', which moved from the fantasy to a notion of eugenic power and control, Lessing's novel provides us with virtually no control over hybridity. The act of interspecies reproduction that produces the hybrid is not a contemporary transgression (whether surgical, reproductive technological, or genetic) but rather an event in the far distant past. No act of scientific, technological or medical abstinence can guarantee freedom from the eruption of disturbing hybrids.

From modernist fear of hybrids to postmodern fascination

> [T]he monstrous fear and hope that the child will not, after all, be like the parent.
>
> (Haraway, 1989)

In the arc from *Frankenstein* to *The Fifth Child*, we can see the hopes and fears articulated by the modern strand of the narrative of interspecies reproduction: the eugenic aspiration to control the development of the species through scientific intervention into reproduction, with its foundational preoccupations with the boundaries of race and species, and the repressed fantasy of transgressing those very same racial and species boundaries through interspecies reproduction, or xenogenesis. Yet if Frankenstein's monster, Albert Taylor's little queen bee and the Lovatts' Neanderthal child Ben all express the horrified attraction to interspecies reproduction, another novel published seven years before Lessing's modernist parable articulates a feminist vision of interspecies reproduction closer to postmodernism, using xenogenesis as the platform on which to stage a critique of the Enlightenment subject of science.

Maureen Duffy's *Gor Saga* (1981) concerns the life of Gordon Bardfield, the 'hominid' result of the *in-vitro* fertilization of chimpanzee mother Mary by the evil scientist father Forester, director of the primate section of an institute linked to the Ministry of Defence. *Gor Saga* broadens the implications of hybridity, for Gor's physique marks him not only by race, but by class: he is thought to be one of the 'nons', the working-class group whose cultural illiteracy is understood to place them closer to the apes. Recalling seventeenth- and eighteenth-century stories on educating an ape as a gentleman, the *Gor Saga* traces the construction of the 'hominid' Gor as the middle-class young man, Gordon. Boarded with human foster-parents during his infancy, Gordon is provided with throat surgery so that he can speak, and then sent to a middle-class boarding school run on a military model. All signs point to a successful transition to bourgeois adult life,

when puberty disrupts the experiment. 'As in *Frankenstein*,' Jenny Newman has observed, 'it is the monster's nascent sexuality that provokes the major crisis.'[12] However, unlike Frankenstein's monster's demand for a mate which, when unmet, unleashes murderous rage, Gor's mis-step – kissing the young girl who is, unbeknown to him, his half-sister – seems less a monstrous transgression than a bit of teenage exuberance. None the less, Gor's scientist father decides his little experiment is over, and chases Gor with murderous intent. Gor hides himself among the 'urban guerrillas' (the pun is intended by Duffy) who have built a secret collectivity in the waste towns. From that hideout he investigates his origins until – upon learning the truth – he must choose between suicide and self-acceptance. The latter wins; helping his fellow outsiders to battle against the repressive forces of the army who would destroy their nascent off-grid communities in the name of a homogenized commodity culture, Gor finds himself crowned king of the day for his brave service to the new hybrid community.

Frankenstein, *Dr. Moreau*, 'Royal Jelly' and *The Fifth Child* all portray the xenogenic birth as a tragedy at best, and an abomination at worst, to the autonomous human subject. Despite the painful testimony of Frankenstein's monster, the litany of Moreau's 'beast people' and the alien buzzing or howling of the little queen and of Ben Lovatt, the hybrid beings imagined by Shelley, Wells, Dahl and Lessing are portrayed more often as alien objects of scientific intervention than they are as speaking subjects. In contrast, in its openness to a decentred, xenogenic subject, Duffy's novel represents an important shift; we experience fully half the novel through Gor's eyes, and by the conclusion it is Gor's perceptions, rather than those of the government or religion, that are affirmed. Duffy's novel subjectifies the hybrid, giving us the perspective of the hominid, whose community embraces him, and rejecting the perspective of the male scientist who created him out of a perverse desire for instrumental mastery.

Although in its realistic narrative strategies *Gor Saga* is far from the self-reflexive pastiche characteristic of much postmodern fiction, in its affirmation of a hybrid subjectivity it anticipates one of the most prominent postmodern celebrations of interspecies reproduction, Donna Haraway's *Primate Visions*. Haraway's study of the discipline of twentieth-century primatology examines the ways that as human beings we inscribe our changing self-constructions and subjectivities on the primates we study. Affirming interspecies reproduction in a casual aside, in its main argument Haraway's study embraces hybridity as a route to increased communication and community:

> *Primate Visions* does not work by prohibiting origin stories, or biological explanations of what some would insist must be exclusively cultural matters, or any other of the enabling devices among primate discourses' apparatuses of bodily production. I am not interested in policing the boundaries between nature and culture – quite the opposite, I am edified by the

traffic. Indeed, I have always preferred the prospect of pregnancy with the embryo of another species.

(Haraway, 1989: 377)

If Donna Haraway embraces the hybrid in the name of feminist communication, sociologist of science Bruno Latour does so not in the name of feminism but in the name of a retheorized modernity. In *We Have Never Been Modern* (1994), Latour argues that modernity itself has been formed through a dual process of sanction and prohibition bearing a certain resemblance to Freud's analysis of the process of negation, discussed in the opening section of this article. Latour attributes our current proliferation of hybrids to the modernist act of purification: the separation of human from non-human, nature from culture, and all of the binary oppositions that follow from that.[13] Such acts of purification paradoxically result in the continued production of hybrids, Latour argues. If we wish to ratify, rather than deny, the place of hybrids in contemporary life, we must renegotiate the implicit agreements for perceiving the self and the world that he dubs 'the modern constitution'. Advocating that we 'rethink the definition of modernity, interpret the symptom of postmodernity, and understand why we are no longer committed heart and soul to the double task of domination and emancipation', he urges us to draft another constitution, one that enfranchises more than just human beings:

> If I am right in my interpretation of the modern Constitution, if it has really allowed the development of collectives while officially forbidding what it permits in practice, how could we continue to develop quasi-objects, now that we have made their practice visible and official? By offering guarantees to replace the previous ones, are we not making impossible this double language, and thus the growth of collectives? That is precisely what we want to do. This slowing down, this moderation, this regulation, is what we expect from our morality. The fourth guarantee — perhaps the most important — is to replace the clandestine proliferation of hybrids by their regulated and commonly-agreed-upon production. It is time, perhaps, to speak of democracy again, but of a democracy extended to things themselves.
>
> (Latour, 1994: 141–2)

Latour's analysis of the way that purification *produces* hybrids has a suggestive similarity to the representation of interspecies reproduction in government documents with which this article began. The modern process Latour describes — the denial of hybrids and consequent proliferation of them — recalls the linked fascination with/fear of interspecies reproduction that is revealed in the government documents discussed above. Moreover, the move towards the 'regulated and commonly agreed upon production' of hybrids called for by Latour may be precisely what is going on when the authors of the Warnock report and the

Muller Panel report acknowledge the production of human-animal chimeras as part of normal reproductive technology, and recommend regulation of their production, in the passages from government documents concerning reproductive technology with which I began.

Yet while Latour's language – like that of the Muller Panel – is overshadowed by the racializing discourse of the nineteenth century, his text is disturbingly blind to the gender categories that – if mapped on to his tidy diagram – would cross-cut his gridded areas of purification and translation. What does Latour leave out of the picture, due to his gender blindness? One way of understanding the project of *We Have Never Been Modern* is as a call for a more complete acknowledgment of the fullness of all being, of life itself.[14] Latour's call for wider enfranchisement, with its self-conscious rhetoric of a new 'Nonmodern Constitution' and a 'Parliament of Things', is an echo of the Enlightenment moment of the formation of the liberal civil state. Latour even redefines the freedom that state promised: 'freedom is redefined as a capacity to sort the combinations of hybrids'(p.141). Yet the very discourse Latour uses invokes an era when the political subject, while newly redefined, was anything but hybrid. If it was no longer the child-subject of a patriarchal king-father, it was instead the new autonomous, homogenous, white male individual subject of fraternal democracy. Precisely that Enlightenment echo reveals the flaw in the affirmation of interspecies reproduction put forth by both Latour and Haraway. As Carole Pateman has shown, both that government and that science are founded on the notion of the autonomous male individual with the normative male body, bound in a social contract that occludes both racial and gendered others, and the sexual contract to which they are both, to different degrees, relegated.[15] A reconsideration of Haraway's treatment of the reproductive body will suggest the boundary conditions that are still in force, in Latour's and Haraway's representations of xenogenesis.

'Becoming insect': xenogenesis beyond the animal kingdom

The body as seen by the new biology is chimerical.

(Sagan, 1992)

Donna Haraway concludes her history of twentieth-century primatology with a reading of science fiction – Octavia Butler's trilogy entitled *Xenogenesis*. Concerning a species of 'gene traders' called the Oankali, who must engage in interspecies reproduction in order to survive, Butler's novels explore the psychological and social implications of the human horror of xenogenesis, portraying humanity's fear of interspecies reproduction as a genetic flaw linked to human beings' excessive aggressivity and hierarchical thinking. Despite her appreciation of Butler's fictional attention to 'miscegenation, not reproduction

of the One', and her exploration of the links between racial and species boundary crossings, Haraway judges the first volume of *Xenogenesis* to be an only partially successful narrative of an alternative to the modernist heterosexual origin story. '*Dawn* fails in its promise to tell another story, about another birth, a xenogenesis. Too much of the sacred image of the same is left intact' (p. 380).[16]

Haraway's comment alerts us to one important, and overlooked, philosophical implication of our responses to the image of interspecies reproduction: that we can be engaged in protecting the status quo not only when we prohibit reproduction with members of other species, but also when we fail to question the *kind* of reproduction we 'think with' when we imagine such transgressions. Sexual reproduction is only one, and arguably not even the predominant, kind of reproduction that is found in nature; bacterial budding, rhizomic replication, spore production, viral infection, symbiosis, bacterial recombination – such reproductive models challenge not only our *humanness*, but also (and perhaps more profoundly) our *animalness*. A work of fiction that articulates the powerful disorientation or deterritorialization catalysed by a reconceptualization of reproduction as other-than-[hetero]sexual is Clarice Lispector's *The Passion According to G.H.* (1978), a novel that calls into question the boundaries not only of class, race, gender and species, but of propagative methods as well. The novel was written after a failed episode of heterosexual reproduction, according to Rosi Braidotti: 'Clarice Lispector acknowledges that she wrote *La Passion selon G.H.* following the experience of an abortion: consequently, the maternal is one of the horizons within which the deconstruction of Woman takes place in this story' (Braidotti, 1994: 128). Motherhood and even womanhood being left behind in the course of G.H.'s ecstatic experience of becoming-woman, the novel ends with a transfiguring moment of symbiotic connection with a cockroach. This encounter can be understood not only as a transcendence of humanness, but as an act of 'becoming-insect', and as such, an act of interspecies propagation (ibid.). Lispector's novel thus extends Haraway's feminist postmodern articulation of interspecies reproduction into the space *beyond* 'the sacred image of the same' that even Haraway herself has explained (perhaps unavoidably, given her topic) in *Primate Visions*. The result is both the creation of a new sort of hybrid – 'becoming-insect' – and a new vision of interspecies reproduction. As Braidotti explains Deleuze and Guattari's theory of 'becoming-animal', it is 'a question of multiplicity . . . the chain of becomings goes on: becoming-woman/ child/animal/insect/vegetable/matter/molecular/imperceptible, etc., etc.' (p. 129). 'The insect as a life form is a hybrid insofar as it lies at the intersection of different species: it is a winged sort of fauna, microcosmic' (p. 127). Introducing the woman 'becoming-insect', *The Passion According to G.H.* also introduces a new perspective on interspecies reproduction. G.H.'s abject, feminized experience of encounter with the cockroach, which as an insect is one of the range of abject beings that 'correspond to hybrid and in-between states, and as such . . . evoke both fascination and horror, both desire and loathing', shifts the whole

notion of xenogenesis from the register of heterosexual reproduction to the register of propagation 'by contagion, [that] has nothing to do with filiation by heredity' (Braidotti, 1994: 128; Deleuze and Guattari, 1993: 241). Yet crucially, unlike Kafka's *Metamorphosis* as read by Deleuze and Guattari, this shift to a non-filiative reproduction does *not* involve the abandonment of sexual differences, according to Braidotti:

> in Clarice Lispector's story . . . the entire process of becoming, down to the crux of the encounter with the insect, is specifically sexed as female. References to sexuality, to motherhood, to body fluids, to the flow of milk, blood, and mucus are unmistakably female. At the same time, however, the structure of the successive becomings experienced by G.H. is in keeping with Deleuze's analysis of becoming as a symbiotic metamorphosis.
>
> (p. 129)

Let me briefly elaborate on the connections Braidotti only implies, since she is not considering the implications of Lispector's story for the image of interspecies reproduction, between a non-heterosexual, non-animal conception of repro-duction and a proliferation of differences. As Deleuze and Guattari theorize it, 'filiative production or hereditary reproduction' (heterosexual reproduction whether human or animal) is more about sameness than difference: 'the only differences retained are a simple duality between sexes within the same species, and small modifications across generations' (p. 242). Interspecies reproduction within the register of filiative production/hereditary reproduction would thus maintain the dominant sameness, adding only the difference of species to the difference of sex (M or F). In contrast, interspecies reproduction beyond that fil-iative register, the notion of 'a propagation, a becoming that is without filiation or hereditary propagation', proliferates differences. Deleuze and Guattari illus-trate this in a paragraph that is a veritable catalogue of posthuman reproductive possibilities:

> We oppose epidemic to filiation, contagion to heredity, peopling by conta-gion to sexual reproduction, sexual production. . . . Like hybrids, which are in themselves sterile, born of a sexual union that will not reproduce itself, but which begins over again every time, gaining that much more ground. Unnatural participations or nuptials are the true Nature spanning the king-doms of nature. . . . That is the only way Nature operates – against itself. . . . For us . . . there are as many sexes as there are terms in symbio-sis, as many differences as elements contributing to a process of contagion.
>
> (pp. 241–2)

Yet although they are occurring in the register of the posthuman, these new differences catalyse the same doubled pattern of 'fascination and horror, both

desire and loathing', suffusing the fantasies of racial and species boundary-crossing with which I began (Braidotti, 1994: 128). The link here seems to be the persistence of the gendered female in all hybrid and in-between states, whether or not they occur in the realm of binary gender constructions. In short, gender constructions persist even into the realm beyond gender, beyond the human. The way that the attraction/repulsion to boundary crossing is feminized recalls the epigraph from Irigaray with which Braidotti begins her analysis of the feminist limitations of Deleuze's notion of 'becoming woman': 'In order to become, it is essential to have a gender or an essence (consequently a sexuate essence) as *horizon*' (p. 111).

The act of trying to think interspecies reproduction within an alternative register of symbiotic becoming is, according to Braidotti, a 'historically necessary' project for feminists, because she believes there are philosophical implications to the affirmation or refusal of the register of oedipal sameness within which heterosexual filiative reproduction occurs (Braidotti, 1994: 134). Yet because the boundary-crossing such a project entails will always evoke the feminized abject, it will also always place us as feminists in 'paradoxical space' – the peculiar condition, as Gillian Rose describes it, of occupying simultaneously 'spaces that would be mutually exclusive if charted on a two-dimensional map – centre and margin, inside and outside' (Rose, 1993: 140). Working between centre and margin, theory and practice, we must come to terms with the appeal of a model of non-filiative interspecies propagation that challenges the dominance of what Deleuze and Guattari rather dismissively term 'the simple duality between sexes within the same species' while still retaining our attention to the material effects of that 'simple duality', 'the *practice* of sexual difference as a conceptual and political project' (Deleuze and Guattari, 1993: 242; Braidotti, 1994: 135).

Who gets a voice?

If the philosophical implications of the postmodern embrace of interspecies reproduction within the alternative register of non-sexual reproduction are the affirmation of 'connections, alliances, symbiosis', of multiplicity and diversity rather than uniformity, what of the practical, material implications of interspecies reproduction considered within the realm of present, or potential, practices of sexual reproduction (Braidotti, 1994: 129)? Returning to the government documents with which we began, we can consider the implications of two different contexts (at least): interspecies reproduction within the existing programme of reproductive technology, and interspecies reproduction as part of a potential programme of feminist reproductive intervention. (British author and science writer Naomi Haldane Mitchison anticipated the latter in her 1975 novel of feminist reproductive technologies, *Solution Three*.)

Since the latter scenario is closest to Lispector's passionate revelation, let us begin there – by challenging its practical implications. We can ask: What would be the material consequences of a feminist enactment of interspecies reproduction? The crucial point here is that even when we are considering the feminist implications of hybrids within the realm of animal reproduction, such fantasies of disrupting the oedipal economy of the same will *differ in their emancipatory potential depending on the subject position of the woman engaging in it*. To give just one example of the ways such feminist positions can differ: a white, middle-class, post-child-bearing, premenopausal woman, who is socially constructed as a member of the dominant, non-criminal class, and whose political sympathies are both technophiliac and conservationist, could be drawn to interspecies reproduction because of the ways it can challenge the boundaries of class and species. That is, while surrogate mothers often imagine themselves achieving class mobility by gestating a child for a middle- or upper-class couple, interspecies reproduction (with all of its legacy of hierarchized racial and species shift) would clearly disrupt that fantasy. Similarly, while First World conservationists advocate the preservation of endangered species as a resource for human medical, environmental, psychological and aesthetic needs, the act of gestating a non-human inverts a human-centred scenario, using the human body as a vehicle for another's species survival. In contrast, a middle-class, technophiliac, African-American woman, still of child-bearing age, coded as criminal in the racist West, and strategically identified with her racial group, could find the fantasy of interspecies reproduction a horrifying replay of racialized notions of race-and-species hierarchy, of devolution, and ultimately of racial extirpation, through the threatening prospect of losing an identity-relevant essentialism with the birth of a hybrid baby.[17]

Just as subject position, and particular race and class location, shape the implications of the fantasy of a feminist creation of hybrids, so too the subject positions of the scientist/doctor and the object of scientific/medical intervention shape the implications of xenogenesis were it to be carried out in the context of existing reproductive technological practices. Returning for a moment to the Muller Panel's recommendations, if, as my reading of Latour suggested, the panel's regulation of hybrids represents a move to 'rewrite the Modern Constitution' as Latour would put it, we need to consider who is enfranchised by that new constitution, and whom it excludes. If the hybrid is gaining a voice as part of this increasing move to interspecies reproduction, does that gain come at a time when there is no voice for the women who act as surrogate mothers and undertake the arduous processes of *in-vitro* fertilization and egg and embryo harvesting? While the hybrid is achieving a voice, are women losing ours?

Although it is unfashionably utopian, I want to end this article with an exhortation. We have seen that even so charged and seemingly unambiguously negative an image as interspecies reproduction means something very different in its different discursive contexts. We must continue our work of contextualization

– both historical and literary – as part of the project of feminist cultural studies of science. Keeping the context in mind, then, we should not embrace the hybrid or affirm xenogenic desire until and unless we are satisfied that we are not obscuring the persistence of gender hierarchies (even into the realm of the posthuman), and that we are not silencing or objectifying the reproductive experiences of women, in all of their variety, multiplicity and diversity.

Notes

1 Mary Warnock, *A Question of Life: The Warnock Report on Human Fertilisation and Embryology* (London: Basil Blackwell, 1985): 70.

2 *Final Report of the Human Embryo Research Panel*, National Institutes of Health, 27 September 1994: 95–6. Because the panel is also known under the name of its chair, Stephen Muller, Ph.D., President Emeritus, Johns Hopkins University, further references will appear in parentheses in the text, under this form: (Muller Panel, 00).

3 Sigmund Freud, 'Negation (1925)', *Collected Papers*, Vol. 5, *Miscellaneous Papers, 1888–1938*, ed. James Strachey (New York: Basic Books, 1959): 181–5, 182.

4 As Michelle Cliff has reminded us recently: 'Did you know . . . that Thomas Jefferson held the popular view that the Black race was created when Black women mated with orangutans? (I do not know where the original Black women were supposed to have come from.)' (Michelle Cliff, 'Object into subject: some thoughts on the work of black women artists', in Gloria Anzaldua (ed.) *Making Face, Making Soul: Haciendo Caras: Creative and Critical Perspectives by Women of Color* (San Francisco, CA: Aunt Lute Foundation Books, 1990): 271–90, 273.

5 Londa Schiebinger, *Nature's Body: Gender in the Making of Modern Science* (Boston, MA: Beacon Press, 1993): 95. Schiebinger is citing William Cohen, *The French Encounter with Africans: White Responses to Blacks, 1530–1800* (Bloomington: Indiana University Press, 1980): 242. Schiebinger notes, 'As Cohen pointed out, this was a rumor started by the English' (p. 239).

6 Robert Young, *Colonial Desire: Hybridity in Theory, Culture, and Race* (New York and London: Routledge, 1995): 6.

7 '[H]ybridity as a cultural description will always carry with it an implicit politics of heterosexuality. . . . The reason for this sexual identification is obvious: anxiety about hybridity reflected the desire to keep races separate, which meant that attention was immediately focused on the mixed race offspring that resulted from inter-racial sexual intercourse, the proliferating, embodied, living legacies that abrupt, casual, often coerced, unions had left behind' (Young, 1995: 25).

8 Ibid.: xii.

9 The term 'xenogenesis' first received mass public attention when it appeared in Octavia Butler's *Xenogenesis Trilogy*, the science fiction trilogy exploring

interspecies communication and reproduction. The three volumes of the trilogy are *Dawn* (New York: Warner Books, 1987), *Adulthood Rites* (New York: Warner Books, 1988), and *Imago* (London: Victor Gollancz SF, 1989). As Donna Haraway observes in one of the earliest and best analyses of Butler's trilogy, 'Butler's fiction is about miscegenation, not reproduction of the One' *Primate Visions: Gender, Race and Nature in the World of Modern Science* (New York: Routledge, 1989): 378–9.

10 H. G. Wells, *The Island of Dr. Moreau* (1896) (New York: Signet, 1988): 76.

11 Roald Dahl, 'Royal Jelly', in *Kiss Kiss* (1959; London: Penguin Books, 1962): 103–30.

12 Jenny Newman, 'Mary and the monster: Mary Shelley's *Frankenstein* and Maureen Duffy's *Gor Saga*', in Lucie Armitt (ed.) *Where no Man has Gone Before: Women and Science Fiction* (London: Routledge, 1991): 85–96, 92.

13 While Latour never explicitly defines hybrids, he speaks of them as 'entirely new types of beings, hybrids of nature and culture'. Though the examples he gives are predominantly networked combinations of natural and technical objects, the engineered conjunction of human and animal species, or of two divergent life forms, is clearly also part of his understanding of hybridity (pp. 10, 1–2).

14 Barbara Duden (1994) has explored the simplifications built into the increasing use of this term, as has Evelyn Fox Keller (1995) and Richard Doyle (1997).

15 Pateman does not discuss how the sexual contract is shaped by racialization, but the work of Robert Young suggests that a similar contract of sexual access to the bodies of disenfranchised racial others is integral to the institution of slavery.

16 Another recent novel that comes closer to telling the alternative story of xenogenesis that Haraway misses in Butler's sociobiologically overdetermined trilogy, though still in the predominant register of animal reproduction, is Geoff Ryman's *The Child Garden* (1989). Although the narrative context is a world in which viral replication is central to all life, its focal story is that of Rolfa, a genetically engineered polar bear, pregnant with an interspecies foetus.

17 My thanks to Charis Cussins for this analysis and to both Charis and Angela Lintz for their very helpful comments on an earlier version of this article, 'Interspecies reproduction: the feminist implications of hybrids', delivered at the conference on 'Women, gender and science', University of Minnesota, Minneapolis, Minnesota, 12–14 May 1995. See Cussins, forthcoming.

References

Braidotti, Rosi (1994) 'Of bugs and women: Irigaray and Deleuze on the becoming-woman', in Caroline Burke, Naomi Schor and Margaret Whitford (eds)

Engaging with Irigaray: Feminist Philosophy and Modern European Thought, New York: Columbia University Press: 111–37.

Butler, Octavia (1987) *Dawn*, New York: Warner Books.

—— (1988) *Adulthood Rites*, New York: Warner Books.

—— (1989) *Imago*, London: Victor Gollancz SF.

Cliff, Michelle (1990) 'Object into subject: some thoughts on the work of black women artists', in *Making Face, Making Soul: Haciendo Caras: Creative and Critical Perspectives by Women of Color*, San Francisco, CA: Aunt Lute Foundation Books: 271–90.

Cussins, Charis (forthcoming) 'Confessions of a bioterrorist', in E. Ann Kaplan and Susan M. Squier (eds) *Playing Dolly: Technocultural Formations, Fantasies, and Fictions of Assisted Reproduction*, New Brunswick: Rutgers University Press.

Dahl, Roald (1959) 'Royal Jelly', in *Kiss Kiss*, London: Penguin Books: 103–30.

Deleuze, Gilles and Guattari, Felix (1993) *A Thousand Plateaus: Capitalism and Schizophrenia*, Minneapolis: University of Minnesota Press [1987].

Doyle, Richard (1997) *On Beyond Living: Rhetorical Transformations of the Life Sciences*, Stanford University Press.

Duden, Barbara (1994) *Disembodying Woman: Perspectives on Pregnancy and the Unborn*, Cambridge, MA: Harvard University Press.

Duffy, Maureen (1982) *Gor Saga*, New York: Viking Press.

Freud, Sigmund (1959) 'Negation (1925)', in James Strachey (ed.) *Collected Papers*, Vol. 5, *Miscellaneous Papers, 1888–1938*, New York: Basic Books: 181–5.

Haldane, J. B. S. (1923) *Daedalus, or Science and the Future*, London: Kegan Paul, Trench, Trubner & Co.

Haraway, Donna (1989) *Primate Visions: Gender, Race, and Nature in the World of Modern Science*, New York: Routledge.

Huxley, Aldous (1969) *Brave New World* [1932], New York: Harper & Row.

Keller, Evelyn Fox (1995) *Refiguring Life: Metaphors of Twentieth-Century Biology*, New York: Columbia University Press.

Lessing, Doris (1988) *The Fifth Child*, New York: Alfred A. Knopf.

Lispector, Clarice (1988) *The Passion According to G.H.*, trans. Ronald W. Sousa, Minneapolis: The University of Minnesota Press.

Ludovici, Anthony (1929) *Lysistrata or Woman's Future and Future Woman*, London: Kegan Paul, Trench, Trubner & Co.

Mitchison, Naomi (1995) *Solution Three* [1975], New York: The Feminist Press.

National Institutes of Health (1994) *Final Report of the Human Embryo Research Panel*, 27 September.

Newman, Jenny (1991) 'Mary and the monster: Mary Shelley's *Frankenstein* and Maureen Duffy's *Gor Saga*', in Lucie Armitt (ed.) *Where No Man Has Gone Before: Women and Science Fiction*, London: Routledge: 85–96.

Pateman, Carole (1988) *The Sexual Contract*, Stanford: Stanford University Press.

Rose, Gillian (1993) *Feminism and Geography: The Limits of Geographical Knowledge*, Minneapolis: The University of Minnesota Press.

Ryman, Geoff (1989) *The Child Garden or A Low Comedy*, London: Unwin Hyman.

Sagan, Dorion (1992) 'Metametazoa: biology and multiplicity,' in Jonathan Crary and
 Sanford Kwinter (eds) *Incorporations*, New York: Zone Press: 362–85.

Schiebinger, Londa (1993) *Nature's Body: Gender in the Making of Modern Science*,
 Boston, MA: Beacon Press.

Shelley, Mary (1981) *Frankenstein* [1818], New York: Bantam.

Warnock, Mary (1985) *A Question of Life: The Warnock Report on Human Fertilisation
 and Embryology*, London: Basil Blackwell.

Wells, H. G. (1988) *The Island of Dr. Moreau* [1896], New York: Signet Classics.

Young, Robert (1995) *Colonial Desire: Hybridity in Theory, Culture and Race*, New York
 and London: Routledge.

Ron Eglash

CYBERNETICS AND AMERICAN YOUTH SUBCULTURE

Abstract

Similar shifts can be seen in the use of cybernetic modelling across a wide variety of scientific disciplines. This article will categorize these shifts in terms of three historical phases: (1) modern cybernetics, focused on digital hierarchical systems, which reached its high point in the late 1960s; (2) transitional postmodern cybernetics, focused on analogue decentralized systems, which started in the late 1970s; and (3) stable postmodern cybernetics, based on a synthesis between the analogue/digital and centralized/decentralized oppositions, which started in the late 1980s. While the shifts themselves can be explained by internalist narratives, the ways in which youth subculture closely parallels these changes suggests that there are causal links between cybernetics and popular culture which work in both directions.

Keywords

cybernetics; chaos theory; fractals; youth subculture; hippies; rap

CYBERNETICS, THE INTERDISCIPLINARY application and synthesis of information sciences, has occupied a central place in analyses of postmodernity as a cultural condition. Lyotard (1984: 60) contends that a focus on

information has led to sciences based on 'undecidables, the limits of precise control, conflicts characterized by incomplete information, "*fracta*," catastrophes, and pragmatic paradoxies', an anarchic freeing of information in which he sees socially liberating potential. Jameson (1991) sees the postmodern theme of 'depthlessness' as both the product of cybernetic simulacra and the symptom of a social loss of history and place. Poster (1990) and Turkle (1995) suggest that cybernetic modes of communication have resulted in postmodern subjectivities in which personal (and even national) identity is unstable, multiple and diffuse. Martin (1994) weaves the narratives of flexible accumulation in capitalism with the flexibility fostered by cybernetic models of the immune system. Haraway (1997: 219-29) produces an eleven-page taxonomy of intersecting cultural, natural and technological categories offering vivid illustrations of a three-stage mutual construction between postmodern culture and cybernetics.

These interpretative accounts are evocative, literary and speak to the need for an emancipatory poetics that can decode and recode the otherwise ineffable dynamics of a threatening technopolitical economics. They stand in sharp contrast to the kinds of 'internalist' historical narratives that much of the scientific community has produced to account for these technological changes. Take, for example, the internalist explanations for the rise of chaos theory. Mathematician John Franks (1989: 65) put this baldly in his negative review of Gleick's famous popular text *Chaos – Making a New Science*, where he insisted that Gleick had missed 'the obvious explanation of the sudden interest in chaos in many branches of science', which was 'the advent of inexpensive, easy-to-use digital computers'. In a rebuttal to Franks' review, Gleick did not disagree with the explanation, but quoted his own perpetual and insistent observations on the importance of computers, which Franks oddly seemed to have overlooked (and one which he apologized for in his reply). This explanation of technological determinism is quite common in both popular and professional circles. For example, it was included in Heinz-Otto Peitgen's introduction to his fractal geometry course at UCSC, in Stewart (p. 138), in Pagels (1988: 85) and even by Benoit Mandelbrot (1989: 6). There is no mention of any social changes in connection to this technological transition in these accounts.

The two approaches I have outlined above – interpretative and internalist – are complementary in their abilities and blind spots. On the one hand, interpretative evocations can easily lose touch with the internal logic of a particular science. As an anthropologist, I am delighted to see Haraway write 'transuranic elements: transgenic organisms: the cold war: the new world order', but as an engineer it leaves me bewildered; there is no internal connection between transuranic and transgenic. The same could be said of the conflation of uncertainty in quantum mechanics and uncertainty in deterministic chaos in Lyotard (1984) and Hayles (1990), or Jameson's comparison of cybernetic and architectural depthlessness. But this ability to make leaps between internally separated technological features is crucial to the power of these accounts in revealing the

elusive yet systemic relations between science and culture. Conversely, the internalist view of steady progress through causal chains of scientific production, while providing a high-fidelity representation of the technical features, becomes blinded to their deeply intertwined social patterns.

This article will attempt to combine the technologically centred view of internalist accounts of cybernetic sciences with the cultural semiotics of interpretative representation. As in Haraway, the analysis will distinguish between three historical phases: (1) modern cybernetics, focused on digital hierarchical systems, which reached its high point in the late 1960s; (2) transitional postmodern cybernetics, focused on analogue decentralized systems, which started in the late 1970s; and (3) stable postmodern cybernetics, based on a synthesis between the analogue/digital and centralized/decentralized oppositions, which started in the late 1980s. The technical characterization of this sequence has been remarked upon by some of the participating scientists and engineers, who see it as a 'natural' chain of events. What does beg for an explanation, however, is the way in which youth subculture closely parallels these changes. The simultaneous nature of the parallel transitions suggests that there are causal links between cybernetics and popular culture which work in both directions.

Information and representation in cybernetics

Cybernetic theory is based on two dimensions of communication systems (Figure 1). One is the information structure, the other is the physical representation of that information. The most fundamental characterization for an information structure is its computational complexity, which is a measure of its capacity for recursion. The extremes of this measure give us the distinction between a non-linear, self-organizing system, in which information is recursively assembled in a bottom-up structure and a linear hierarchy, in which information is imposed top-down.

The most fundamental characterization for representation is the analogue–digital distinction. Digital representation requires a code table (the dictionary, the Morse code, the genetic code, etc.) based on physically arbitrary symbols (text, numbers, flag colours, etc.). Sassure specified this characteristic when he spoke of the 'arbitrariness of the linguistic signifier'. Analogue representation is based on a proportionality between physical changes in a signal (e.g. waveforms, images, vocal intonation) and changes in the information it represents. A computer mouse, for example, guides cursor movement in proportion to hand movement (although there is a great deal of digital circuitry mediating in between). The difference between analogue and digital is often referred to as a dichotomy between continuous and discrete signals, although that is quite misleading, since an analogue parameter might change only in discrete increments. It is more important to consider that digital systems use grammars, syntax and

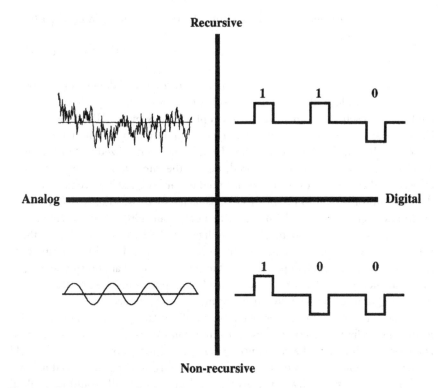

Figure 1 Two dimensions of cybernetics

other relations of symbolic logic, while analogue systems are based on physical dynamics – the realm of feedback, hysteresis and resonance (Dewdney, 1985; Eglash, 1993).

This article will examine these two dimensions of cybernetics at three different historical moments; I have arbitrarily used the years 1967, 1977 and 1987 as foci.[1] As noted in the first paragraph, these moments can be associated with (although certainly not reduced to) changes in technological emphasis on the two cybernetic dimensions, from the promotion of digital hierarchies typical of 1967, to the new focus on analogue decentralized systems starting around 1977, to the synthesis of these approaches starting around 1987. These technical changes will be illustrated by examining instances of the use of these two cybernetic dimensions in four different disciplines: machine intelligence, visual neurobiology, cerebral lateralization and mathematical modelling.

Cybernetics in the modern era

It was . . . a considerable revelation when writing came to detribalize and to individualize man. . . . Cybernation seems to be taking us out of the . . .

world of classified data and back into the tribal world of integral patterns
and corporate awareness.

(McLuhan, 1966: 102)

In the first few years of American cybernetics, analogue and digital systems were
seen as epistemologically equivalent; both were considered capable of complex
kinds of representation. In 1952, for example, a study by the US office of Naval
Research concluded that 'a choice between analogue and digital simulation is not
clear cut' (Rubinoff, 1953: 1262). Similarly, both decentralized and hierarchical
information structures were explored, but by the late 1960s this was dramati-
cally altered and most research was oriented towards digital hierarchies. Perhaps
the most notorious example of this exclusionary focus was the text *Perceptrons*,
by Minsky and Papert, which was extremely damaging to research on the
decentralized approach to machine intelligence (Pollack, 1989). The authors
presented a mathematical proof for the inability of distributed processing net-
works to recognize certain patterns; at the time it seemed an indisputable argu-
ment for their classic 'artificial intelligence' (AI) approach, based on the 'central
processing unit' of the von Neumann computer architecture.

While artificial brains were being centralized, the natural brain was also
losing its distributed characterization. In Hubel and Wiesel's model of visual neu-
robiology, each cell of the retina used lateral inhibition to break the visual field
into discrete points, like a digital video. These neurons were connected in rows
to cells in the first cortical layer, so that each first layer cell would fire only if
there was a line in the visual field that corresponded to its particular orientation.
These were connected to the next cortical layer so that its cells could detect
edges, corners and so on to successive cortical layers in an increasing hierarchy
of specificity. Following this to its logical conclusion resulted in a paradox,
because the cells at the top layer would have to be so specific that there would
be one cell for every image you could recognize (often referred to as the 'grand-
mother cell' for its hypothetical ability to fire only when the visual field held an
image of your grandmother), but Hubel and Wiesel had excellent experimental
evidence for the lower layers and the digital video metaphor was easy to under-
stand.

At a much larger scale, the models for cerebral lateralization in the late 1960s
not only spanned the whole brain, but reached across human behaviours from
motor movement to gender (Star, 1979). The left hemisphere was seen as digital,
reductionistic, mathematical and male; the right was analogue, holistic, artistic
and female. The association was not necessarily sexist *per se*; Bogen (1969), for
example, defends the right hemisphere as unjustly disparaged and suggests that
since these same attributes (intuition, Gestalt perception) are attributed to
women, the belittlement has a sexist bias.

It may seem all too easy to make social-historical characterizations of such
wildly generalizing claims from behavioural biology, but even in mathematics, at

the opposite end of the hard science/soft science spectrum, the same bias towards digital linear hierarchies can be seen during this time period. As noted in Gleick's (Franks, 1987) historical account, linear approaches to mathematical modelling, such as piece-wise linear approximation in dynamical systems, linear programming theory and symbolic logic were well funded, while nonlinear dynamics received little attention. The foundations for what is today known as deterministic chaos – an explicit illustration of the computational complexity of analogue recursion – were largely ignored. Physicist Joseph Ford, for example, recalled his early failure to introduce notions of complex nonlinear behaviour in a lecture on the Duffing equation:

> When I said that? Jee-sus Christ, the audience began to bounce up and down. It was 'My daddy played with the Duffing equation and my grand-daddy played with the Duffing equation and nobody seen anything like what you're talking about.' You would really run across resistance to the notion. . . . What I didn't understand was the hostility.
>
> (Franks, 1987: 305)

Meteorologist Edward Lorenz met similar resistance: his seminal paper on deterministic aperiodicity was ignored despite the efforts of respected supporters such as Edward Spiegal and James Yorke. As noted above, most mathematicians have insisted that the change was due to the availability of digital computers. But the implication that digital computers can explain the revolution in nonlinear dynamics is misleading. The emergence of chaos as a legitimate and valuable research topic in the early 1970s was often carried out on *analogue* computers. This was true for Ueda in Japan, Rössler in Germany and 'chaos cabal' of Rob Shaw, James Crutchfield, Doyne Farmer and Norman Packard in the US. Not only was the cabal's method of analysing equations and experimental data performed on the analogue computer, but his theoretical breakthrough was in viewing all physical dynamics as a kind of analogue computing (cf. Pagels, 1988).

Rather than the lack of digital computers, a better explanation for the dominance of linear hierarchical modelling in the 1960s can be found in the political affiliations of the scientists involved. Ralph Abraham, for example, who would later become the main mathematical supporter for Shaw's chaos cabal at UCSC; reports that the political lines in the mathematics department at UC Berkeley in the 1960s divided right versus left along linear versus nonlinear (personal communication, 1991). James Yorke, whose attempt to promote the work of Lorenz was met with staunch resistance, was also known for his war resistance, having made direct use of his mathematical skill during the antiwar demonstrations in his analysis of a fraudulent government photo. In 1966 mathematician Steve Smale learned that his research funding for nonlinear dynamics was being revoked by the NSF. But at the time Smale was also subject to a subpoena by the

House Un-American Activities Committee due to his leftist activism; it was not clear whether his offence was nonlinear science or un-American politics.

This political polarization along both the analogue–digital and recursive–nonrecursive dimensions was widespread in the late 1960s and this was nowhere more evident than in cybernetics itself. The process by which the analogue–digital dichotomy was established as a field for contestations began at the origins of cybernetics in the first Macy conferences of the late 1940s. This was commented on at the time by Gregory Bateson:

> There is a historic point that perhaps should be brought up; namely, that the continuous–discontinuous variable has appeared in many other places. I spent my childhood in an atmosphere of genetics in which to believe in 'continuous' variations was immoral. . . . There is a loading of affect around this dichotomy which is worth our considering.
>
> (Von Foerster, 1952)

Bateson eventually took a position opposite to that of his father's; for him analogue systems were closer to the real and thus preferred as a more holistic or natural form of communication. Bateson, together with Margaret Mead, came to represent the anthropological sciences for cybernetics. Mead took advantage of this position to offer some recursive perspectives on cybernetics at the first Annual Symposium of the American Society for Cybernetics in 1962. She began her introductory speech, 'Cybernetics of cybernetics', with some memories of the foundational meeting of the society for general systems theory.

> I suggested that, instead of founding just another society, they give a little thought to how they could use their theory to predict the kind and size of society they wanted, what its laws of growth and articulation with other parts of the scientific community should be. I was slapped down without mercy. Of all the silly ideas, to apply the ideas on the basis of which the society was being formed to *Itself!*
>
> (Von Foerster et al., 1968: 10)

Mead was already famous for her blending of scientific analysis with cultural critique, dating from her refutations of theories on the biological determination of gender characteristics in the 1920s. In this talk she warned against the unreflective use of cybernetics, pointing to L.F. Richardson's pacifist approach to mathematical models of warfare and Edmund Bacon's use of cybernetics in participatory city planning as alternatives. Mead's articulation of the ironic lack of 'circular self-corrective systems' in the science of circular self-corrective systems underscored the impending politicization of recursion in cybernetics.

This association of analogue representation with the real and recursion with liberation was taken up by many leaders of the cybernetics community: Kenneth

Boulding (a founder of general systems theory), Tolly Holt (director of Advance Systems in Princeton), C. H. Waddington in biology, Karl Pribram in neuropsychology, Hazel Henderson in social systems and Magoroh Maruyama and Heinz von Foerster in cybernetics proper, to name a few. The humanist translation of recursion (in his terminology 'feedback') as liberation was previously proposed by cybernetics founder Norbert Wiener (Heims, 1984) and the view of analogue systems as closer to the natural or the real was independently championed by Francisco Varela[2] and Humberto Maturana, who worked under Perceptron founder Warren McCulloch.

Youth subculture and cybernetics in the modern era

Youth subculture studies (e.g. Hebdige, 1979,1988; McRobbie, 1994; Hall, 1980) have made the reading of stylistic expressions (music, dress, speech, etc.) in these social groups accessible to semiotic analysis and this is nowhere more evident than in the contrast between the youth subculture and parent culture of the 1960s. The contrast between the recursive analogue dynamics in the counter culture and digital hierarchy in the 'military-industrial establishment' was evident in the geometry of material designs chosen by each subculture. The psychedelic aesthetic of hippy adornment was essentially what we would today call fractal: paisleys with-in paisleys with-in paisleys, flowing robes with folds of folds, rippling organic hairstyles. Establishment icons were in the Euclidean shapes of rectangles, circles and triangles, as evidenced by the computer font introduced with the IBM punched card system. It is no coincidence that hippies accused 'straights' of being 'square'.

That the (primarily white[3]) romantic organicism of American youth subculture in the 1960s would be taken up by a scientific community is not surprising, given the personal ties of these individuals. Kenneth Boulding's house, for example, was a central location for organizational meetings of the Students for a Democratic Society (SDS) in the early 1960s (Kerman, 1974). Many of the first SDS manifestos were based on the idea of 'face to face communication' as a more ethical means of representation than digital encodings; this analogue anarchism came from Paul Goodman, who was in turn influenced by a line of holistic scientists from Peter Kropotkin to Gregory Bateson (Goodman's next-door neighbour during his stay in Hawaii). In the amalgam created by late modernist youth subculture, zen philosophers (Watts, 1961), psychoactive drug advocates (Leary, 1968) and social scientists (McLuhan, 1966) began to use cybernetics themselves, proclaiming that by reviving the analogue chaos of an organic past, we would escape the oppressive digital order of the present.

The conservative half of this cybernetic politics, starting with von Neumann in the 1940s, is already well described in a literature which, in my view, over-emphasizes this side due to technophobic bias (e.g. Lilienfeld, 1978). Here

we see rationalists with an affirmation of the artificial and an authoritarian love for imposed control. The digital hierarchists managed to take control of the majority of funding and institutions for cybernetic research during the 1960s and made an effort to suppress the legitimacy, if not the existence, of the analogue decentralists. It is a sad irony that critics such as Lilienfeld have simply duplicated that erasure.

The political polarization of cybernetics was not, of course, absolute. In the 1968 conference organized by Bateson, for example, Barry Commoner's claims for humanist recursion and natural analogue communication (illustrated with examples ranging from urban recycling to African anthropology) were aggressively countered by Gordon Pask, who constantly reasserted his need for professional authority and corporate managerial practice throughout (Bateson, 1972). As a converse of Pask, one might point to Anatol Rapoport, an advocate of the linear digital approach (e.g. the von Neumann game theory), who supported anti-authoritarian politics. But these were exceptions to a paradigmatic pull in which researchers were increasingly asked to take sides, as illustrated in Figure 2.

This portrait of the historical changes in the cybernetic map, from its flat equipotential surface of 1947 to its bifurcated basins of attraction in 1967, should be seen as coupled to a similarly changing map of politics, as I have drawn for Bateson and Mead (Figure 3). Here the changes are coming from opposite causal directions for the two individuals. Mead's political involvement was a long-term commitment for her; but the technical dimensions were not polarized for Mead until after she understood how the politics might couple with this cybernetic map. For Bateson, the direction of causality was the reverse. His collaborator Ken Norris (personal communication) suggests that, for Bateson, cybernetics was an opening into the political arenas he had previously avoided and Bateson's daughter has made similar implications (Bateson, 1984: 217–20). Bateson was quite fixed on the technical significance of both analogue representation and recursion, but his political map was flat until he saw how a hyperbolic humanism could match his own cybernetic topology.

The actor-network formalism of Latour, Callon and others is typically portrayed as a struggle in attempts to recruit scientists (and in more recent versions, non-human actors) into a web of power relations that supports a particular device or theory. But the polarizations in these two cybernetic dimensions go far beyond a particular laboratory or even a single discipline, and have specific links to socio-political positions of their day. Between the decentralized organicism of hippie lifestyle and the hierarchical linearity of industrial and governmental institutions, the 1960s could be summarized as a fight between the natural chaos of counter-culture and the artificial order of 'the establishment'.

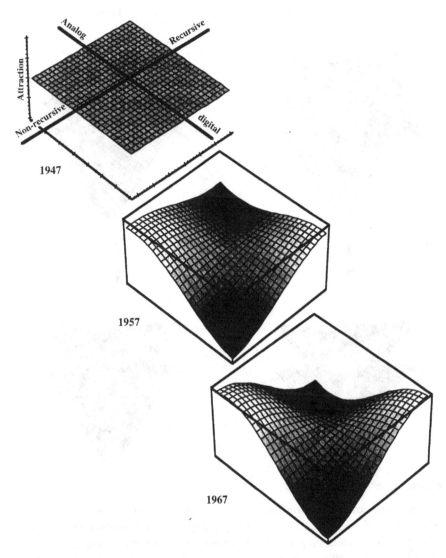

Figure 2 The political polarization of cybernetics

Transitional postmodernism and youth subculture

To this career I did ordain
Doin' things the anthropologists can't explain
Arrhythmic sounds float like Lake Erie
Altering any scientific theory
Sweet Tee, 'On the Smooth Tip'

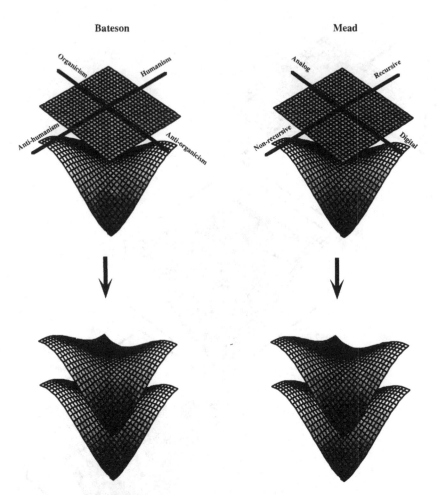

Figure 3 Cybernetic polarizations in Bateson and Mead

African-American urban youth movements of the transitional postmodern era, often grouped under the term 'hip-hop', constitute yet another move in the analogue–digital dualism game; but this time with revolt on the digital side. The term 'digital' is itself used by these movements (best exemplified by the popular rap group Digital Underground) to signify a guerilla cybernetics, both in terms of street-wise technical competence and in cultural communication forms (Dery, 1994; Rose, 1994; Eglash, 1995).

Rap is notorious for its non-melodic sound: a disjoint collage of flat punctuated speech, spliced sound bytes from James Brown, *The Andy Griffith Show*, video game lasers and above all the scratch: deejays playing the normally silent back-cue of the record in time to the beat, letting the raw signal of a misused stylus interface the acoustic codes into a single mutant form. Although not a commercial success until the Sugar Hill Gang's 'Rapper's Delight' of 1979 and

Grandmaster Flash's 'The Message' of 1982, by 1977 most of these forms were already existing from low-tech necessity: budget disco parties without the money for a band or the passivity for records. Out of the pit of commercialized pop music – the gold-chained discotheque scene of John Travolta and Studio 54 – scratch turned tables on the turntables.

At the same time rap was cutting organic sounds into oppositional symbolics, breakdancing was digitizing the human body. Like rap, histories of breakdancing (Hager, 1984; DiLorenzo, 1985) cite traditions from African prehistory to contemporary African-American dance, in which discrete moves, rapid-fire symbolic gestures and percussive 'popping' originated. Breakdancing also uses a stylistic collage of odd elements: 'King Tut' friezes, Russian folk dance and street gymnastics are fused with the pro-artifice titles of 'Electric Boogie', 'Moonwalk' and 'Robot'. The android movements of Shields-and-Yarnell, a husband-and-wife performance team seen widely on popular television in 1977, were often incorporated by breakdancers in routines which code the machine–human interface in much stronger ambiguity than anything seen in the modern era. While an element of irony and parody is always present, there is also pride in the technical competence required to take on the cybernetic stronghold of industry and a historical claim of ownership for these powerful modes of representation.

A third important element is graffiti: not only a claim to ownership of coding, but coding as a claim to ownership. In 1969 an unemployed 17-year-old New Yorker started writing his nickname together with his street number on public spaces; soon Taki 183 was joined by hundreds of male and female writers of various ethnicities, genders and economic backgrounds. Since the majority are poor, the activity is often interpreted as a rebellion against their economic trap: a signature marks possession.

Castleman (1982), in a solid ethnographic study of New York graffiti writers, balks at such interpretations – not necessarily because they are incorrect, but because it is all too easy to read these meanings into their work rather than seeking a thick description of their lives and activities. What stands out in his account is the assertion of identity, both as individuals and as members of the writer's community (gangs, groups, organizations and the city as a whole). While the literal reading of the graffiti tended towards simple identification (for example, 'Barbara and Eva 62'), the style in which the letters were written was an entire symbolic code unto itself, reflecting manipulations of media technology as well as a wide range of personal attitudes, ideas and affiliations. Like rap and breakdancing, graffiti carries a positive affirmation of the artificial – urban life is celebrated, and many styles are tight geometric forms titled 'computer', 'mechanical', 'robot', etc. – along with the irony and parody that keeps their sentiments accountable to the brutalities that technology can carry (Delany, 1988; Tate, 1992).

All three of these aspects of hip-hop include instances of analogue communication, but all three emphasize the digital features in ways which make the

movement as a whole far more friendly to artificial states of being: to urban life, machines, science, and even to artificial origins.

> Post-liberated black hair-styling emphasizes a 'pick n' mix' approach to aesthetic production, suggesting a different attitude to the past in its reckoning with modernity. The philly-cut on the hip-hop/go-go scene etches diagonalized lines across the head, refashioning a style from the 1940s where a parting would be shaved into the hair.
>
> (Mercer, 1988: 51)

The way in which the use of arbitrary symbols *signifies* artificiality is a crucial part of this postmodern distinction. The New York graffiti painters may be analogue artists in many ways, but their preference for the term graffiti 'writer' reflects their own textual emphasis. In the modernist discussions of African music, an emphasis on percussion was typically a demonstration of the analogue character of African culture (for example, Senghor's Negritude), but in postmodern descriptions of hip-hop (cf. Toop, 1984) it becomes proof of Africa's digital heritage:

> The hums, grunts and glottal attacks of central Africa's pygmies, the tongue clicks, throat gurgles, and suction stops of the Bushmen of the Kalahari Desert . . . all survive in the mouth percussion of 'human beatbox' rappers.
>
> (Dery, 1988: 34)

While black youth subculture was reinventing itself as digital, white youths made a similar transformation. In 1977 – at the all-time high of teenage suicide in the US – the Sex Pistols' *Never Mind the Bullocks* sounded a call to arms for a generation unimpressed by their parents' claims for a peace and love revolution. Hebdige suggests that punk expressed a white ethnicity, but one which was bound to present time rather than the skinhead's utopic past. Rather than a modernist despair over alienation, punk affirms alienation as a part of its ethnic identity, parodying the sympathetic beneficence of liberal sociologists.

The arbitrariness of symbols and symbolic arrays is essential to all punk material culture. The clothing is a an urban screech of plastic and metal; the hair a neon-dyed, machine-sculpted artefact; the make-up flaunts the taboos of all fashion advice; and the music itself is an unrelenting succession of noise. Despite the frequent use of the term 'chaos' to describe punk (for example, Johnny Rotten's famous line 'we're not into music, we're into chaos'), the punk aesthetic bears no resemblance to the hippy use of natural flowing chaos, to patterned organic shapes which opposed the establishment's Euclidian order. The disorder of punk is 'white noise', the randomness of disrupted syntax, 'a place where the social code is destroyed and renewed' (Kristeva, 1989). The songs of the Minute Men are all under sixty seconds, the Circle Jerks' songs not only standardized in

time, but repeat the same chord pattern as well. Just as rap uses speech to break up the organic flow of music, punk interjects order where it does not belong. In hippy culture plastic meant the establishment's order (as in 'plastic hippy', or Dustin Hoffman's economic advice in *The Graduate*). To punks, plastic is 'plastic' in the sense of transformable; its excesses could force the system against itself, drowning institutional order in the noise of its own symbolics.

If punk is so intent on self-defined symbolics, doesn't that mean they subscribe to a modernist programme of recursive control or humanist self-definition? Far from it. In terms of individuals, humanism differentiates between control from false authority and control from the true, authentic self. With no interest in authenticity or the 'true self', Punks promote fakes as the only legitimate sincerity. In terms of collective activity, the same disruption occurs. Chambers (1985: 228) describes this for punk efforts to subvert the recording industry.

> Punk's rough populism, what it would call . . . 'street level' music, was frequently translated into a flood of small, independent record labels. These apparently mushroomed around the subculture's early leitmotif: musical populism + recording independence = cultural autonomy. But as the idea of 'authenticity' (hence the measure of 'autonomy') was also a rather non-punk concept, the whole formula remained precarious.

In contrast to the 1960s counter-culture's search for recursive control, the post-modern youth culture fought for a critique of this humanist self-reference. Just as the paradox of rap's natural artifice opened a space for new cultural constructions, punk's recursive critique of recursion provided another opportunity for creating new kinds of resistance. Just as the counter-culture of the 1960s co-evolved with cybernetics, defining itself as the cybernetic opposite of digital hierarchy (in parallel with the military, industrial and institutional move to define itself as the cybernetic opposite of analogue decentralization), the affirmation of digital representation and scepticism about recursive control in postmodern youth subcultures occurred in tandem with a scientific revolution in the opposite direction. Postmodern cybernetics requires analogue recursion; it is here that science seeks chaos.

Cybernetics in transitional postmodernism

Despite the institutionalization of digital representation and linear hierarchy in many areas of modernist technoscience, 1967 – the 'summer of love' – was the peak for cybernetic order and by 1977 this had begun to reverse. In the same year that the Sex Pistols declared their love for the sharp Euclidian lines of urban artificiality, cybernetic models of the military-industrial establishment began to side with the natural holistic flow of chaos.

Of course, chaos theory itself is the clearest example of this transition. Fractal geometry, dynamical systems theory, cellular automata and other models of self-organizing process created a dramatic acceleration in the ability of scientists to study the recursive flow of information which underlies a wide variety of complex nonlinear phenomena. As noted earlier, it was by reinterpreting physical dynamics as analogue representation, not by sticking to the old guns of progress in digital computers, that the chaos revolution made its real impact.

It is here that the semiotic claim for a special status of digital representation is proved wrong: analogue waveforms can express recursive complexity as well as can any symbolic code. But many scientists during this transitional moment went entirely overboard, now claiming that analogue systems were computationally *superior* to digital. Dewdney (1985), for example, announced that he had devised an analogue version of the Turing machine,[4] and had proved that it could out-perform the original digital Turing machine (I later wrote to ask him for details, but he replied that those notes were 'buried somewhere' in his files). Researchers at the Princeton University Computer Science Department (Vergis *et al.*, 1985) claimed to have an analogue machine that could solve an NP-complete problem in less than exponential time – a performance which is theoretically impossible for any digital machine. Their claims were disproved in Rubel (1989). A number of prominent physicists (Pagels, Feynman, Penrose and others) took refuge in quantum indeterminacy to claim that there are analogue systems (i.e. the human brain) that have computational powers superior to digital Turing machines. The study of non-deterministic Turing machines is decades old and has not demonstrated that there is a computational advantage to these systems.[5]

In machine intelligence, both hardware and software went through a sudden transition away from centralized hierarchies. In the digital parallel processing approach, many von Neumann-type (linear centralized) processors are linked together, working on different parts of the problem at the same time. The problem may be divided up in different ways with varying degrees of autonomy. At the most extreme decentralization we return to the perceptron. It turned out that Minsky and Papert's analysis did not take into account the possibility of perceptrons in which there was a 'learning layer' mediating between input and output; this minor addition resolves the pattern recognition limitations they had raised (Pollack, 1989).

In the simulated annealing approach (cf. Kirkpatrick *et al.*, 1983), an optimal state for an information system is approached by allowing carefully controlled randomness to perturb local elements, tossing them into desired configurations (i.e. 'hill-climbing' to local maxima) and then decreasing the randomness before they are tossed out. This method makes use of the digital simulation of a physical process (thermal control of annealing in metals). The holistic extreme for hardware was the coupled oscillator approach (cf. Hopfield, 1982), where

computation was carried out by decentralized networks of analogue units mod-elled on neurons.

The software decentralization in machine intelligence research was first uti-lized in the language ABSET (Elcock *et al.*, 1972), which allowed data-directed control. More explicit decentralization was achieved in the 'actor' formalism of the work of Hewett (1977) and the knowledge representation system of Bobrow and Winograd (1977). In explaining decentralization in AI software, Pylyshyn (1981: 79) declares that 'this means loosening the hierarchical authority relation common to most programs, and distributing authority in a more democratic manner, allowing for "local initiative"'. By the 1980s even Minsky suggested that decentralization was a good idea in software (and in his 1986 *Society of Mind* he claimed that was what he had been thinking about all along).

In visual neurobiology the challenge to Hubel and Weisel's work began with Campbell and Robinson (1968), in which suggestive evidence was presented for global frequency functions (for example, the fourier transform) in the striate cortex. For instance, one experiment showed a neuron which fired optimally for an image of a monkey's hand: a specificity which is too great for Hubel and Weisel's model, but which fits well with the global frequency model since the monkey's fingers form a spatial grating. However, it was not until DeValois *et al.* (1978) that 'critical' experiments which purported to decide the issue actually challenged the dominance of local feature extraction models. Many researchers concluded that the best analogy for visual neurobiology was not the digital video camera, but rather the analogue medium of a laser hologram.

As in visual neurobiology, changes in cerebral lateralization models were presented as compelling objective data requiring a different conceptual frame, not as a more sensible or fashionable theory. Once researchers had settled on a postmodern reversal – assigning the digital left hemisphere to women and the analogue right hemisphere to men – a multidisciplinary complex of theoretical apparatus was quickly assembled. Levy (1978) developed an origin story in which 'man the hunter' needed the Gestalt skills of mapping and spear tossing while 'woman the gatherer and childrearer' needed her social communication skills. While Buffery and Gray (1972, quoted in Star, 1979: 68) suggested that female superiority in symbolic systems corresponded with 'good performance on cler-ical tasks', Geschwind (reported in Kolata, 1983) linked a supposed innate math-ematical superiority in males to testosterone effects in foetal brain development, which would then produce 'superior right hemisphere talents, such as artistic, musical, or mathematical talent' (p. 1312). Note that mathematics in this descrip-tion has moved from its 1960s association with the symbolic left hemisphere to a postmodern association with the analogue right hemisphere.

In summary: while the 1960s counter-culture sought analogue naturalism and recursive humanism, anti-hegemonic youth subculture in transitional post-modernism fought for a legitimation of artifice and a critique of humanist

self-reference. At the same time, mainstream information sciences[6] switched to a serious consideration of analogue representation and nonlinear decentralization.

Stable postmodernism and cybernetics

Starting around 1987, cybernetic models again shifted, this time to a synthesis of the competing opposites. The term 'stable postmodernism' is appropriate in that the move resolves both technical and social tensions of the previous sharp reversal in these information dimensions.

When we last left mathematics, it had moved from the Euclidian linearity of the 1960s to the fractals and dynamical chaos of the 1970s. In the late 1980s these two approaches were brought together. This was nicely illustrated by the 'multi-fractal' approach initiated by Uriel Frisch (Nice Observatory) and Giorgio Parisi (University of Rome) in 1985. Multifractals are shapes which cannot be characterized by a single fractal dimension. Since they have multiple dimension measures attributed to them, some of these can be whole numbers. Thus multi-fractals can incorporate *both* fractal and Euclidian structures. A similar fractal–Euclidian synthesis has developed in the use of Michael Barnsley's Iterated Function Systems (IFS). Because combinations of both fractal and Euclidian shapes can be created (based on Barnsley's 'collage theorem'), by the late 1980s a corporation had been formed for commercial application to image compression (transmitting algorithms for producing the picture instead of the picture itself).

In machine intelligence, we saw the postmodern transition from linear digital hierarchy in the 1960s to both decentralization and analogue systems in the late 1970s. By 1987 many researchers decided that the difficulty of nonlinearity, despite the new knowledge rising from chaos theory, was still too great for a pure analogue approach and that analogue and digital would need to work together in new hybrid machines. Marvin Minsky, for example, had trashed holism in his modernist text *Perceptrons* and had valorized it in his transitional postmodernist text *Society of Mind*. In his stable postmodernism essay of 1988, he suggested that the ultimate fulfilment of his 'Society of Mind' approach would be a synthesis of the two: analogue neural nets as the individual 'agents' of his AI system, with centralized digital algorithms providing its governing structure.

Pollack (1989) differentiates between 'the *old* new connectionism, circa 1980–1985' and 'the *new* new connectionism' on this basis, noting the crucial addition of digital representation to neural nets in 'semantically interpretable higher-order elements'. The reverse adaptation can also be seen in the work of Stephen Omohundro. In a widely circulated technical report of 1987 he described some important innovations for algorithms in digital centralized computers which could emulate neural network behaviour. Equivalences between recursion in both analogue and digital systems were also approached at this time

(see e.g. Touretzky, 1986), and later commercial production of the hardware that could support such hybrids (*Electronic Design*, 1989) also occurred.

Also appearing at this time were neural nets based on a harmony theory similar to Bak's self-organized criticality. Whereas modernist networks were based on competition and transitional postmodernist networks exploited formal systems of cooperation, these stable postmodernist neural nets used a balance of cooperation and competition to achieve their tasks (Maren, 1990). This change from the transitional trope of reversal to the stable trope of synthesis or harmony allows a resolution of previous tensions, thus opening a new acceptability. Harston *et al*. (1990) cite an exponential rise in the number of neural net projects starting in 1987.

Analogue–digital synthesis in more banal computing machines had been suggested by the UCSC 'Chaos Cabal' in a 1981 NSF grant proposal, but the idea was premature and the grant was rejected, although they did receive NSF support for work on their analogue computer. By the late 1980s NSF grant directories specifically mentioned analogue–digital hybrids as an area of interest. Much of the theoretical work in this new synthesis goes under the rubric of 'computational dynamics', a title which not only emphasized the new fusion of analogue and digital computation, but could also serve as a respectable sounding alias for 'chaos'.

Reassessment of the analogue optimism from transitional postmodern cybernetics was an important part of this new effort towards harmony. While many transitional postmodern researchers saw analogue computation as uncharted territory, a potentially utopic space where physical dynamics could beat a Turing machine, the new stable postmodern theories viewed analogue and digital as equivalent representational forms. The most formal recognition for this equivalence was in the work of Blum *et al*. (1989), which developed a system of mathematics that could show limitations for analogue computation that were isomorphic to the undecidability limitations of Turing machines. Similar implications were reached through work in symbolic logic by Rubel (1989), who used this to critique the earlier claims of analogue superiority by Vergis *et al*.

In visual neurobiology, we moved from the 1960s reductionist feature extraction hierarchy of Hubel and Weisel to the 1970s holistic fourier transform model of DeValois. But the experiments which had supported this view of global spatial frequency detection did not necessarily negate Hubel and Weisel's results and following some debate a synthesis was proposed (MacKay, 1981). The model that was finally adopted used the Gabor transform, a combination of local and global information extraction (Figure 4) which had been developed in early communication theory, prior to the polarizing split of the 1960s (Gabor, 1946). Empirical confirmation soon followed (Daugman, 1984).

In cerebral lateralization, modernist theories had suggested that the digital left hemisphere was mathematical and male and that the analogue right hemisphere was artistic and female. Transitional postmodernism saw a reversal of this

Hubel and Wiesel model: lateral inhibition in retina isolates local points. Cortical layers combine points > lines > simple shapes > complex shapes > 'grandmother cell' (reductionist processing).

DeValios and Albrecht model: lateral inhibition in retina creates fourier transform. Cortical layers combine global spatial frequencies in holistic processing.

Daugman model: lateral inhibition in retina creates Gabor transform. Cortical layers combine global spatial frequencies with local points (reductionism–holism synthesis).

Figure 4 Information models in visual neurobiology 1967–87

association, with mathematics as an imagerial, holistic function of the right hemisphere and 'man the hunter' preferring spatial mapping in his neural evolution. In stable postmodern lateralization, mathematical superiority is now said to depend on the interaction between both hemispheres, again leaving room for male superiority through studies reporting sex differences in interhemispheric information transfer (first described in De Lacoste-Utamsing and Holloway, 1982).

In all four disciplines, information processing shifted from the holism reversal of the postmodern transition to a new, more stable holism–reductionism synthesis. As in the case of the previous two transitions, this paradigm not only extends across many sciences, but also into popular culture. If hippies epitomize radical modernity and punk and hip-hop give us transitional postmodernism, then an obvious choice for the pop subculture of stable postmodernism is New Age. I hesitate to call this a youth subculture, since most of its members are not very young, but in some ways it fetishizes youthfulness even more than its predecessors.

New Age and the cult of harmony

Like hippy and punk rock enthusiasts, New Agers are primarily white and middle class, and the semiotics of their subculture often concern this ethnic/class identity. Hippy signifiers could often be read as an avoidance of whiteness, an attempted transformation into primitivized Native Americans or orientalist holy beggars. For hippies artificial (for example, Euclidean shapes, synthetics) signified a semantically empty whiteness and natural (chaotic shapes, organic materials) filled in this blank with a more earthy identity. Punk subculture claimed the blankness as its own, using artificial and urban-associated materials to signify both their acceptance of their ethnic identity and a refusal to ignore its ugliness. New Age members, like the cybernetic engineers of their era, solve this problem of identity conflict neither by taking one side nor the other, but by harmonious synthesis.

The symbol which best portrays this hybrid identity is the crystal embedded in unpolished rock, a common motif in New Age fashion, art and literature. Like multifractals (and New Age hairstyles), these objects are both Euclidean and fractal, both orderly and chaotic, and carry the paradoxical message that something can be both natural and artificial. In New Age subculture whiteness is just one of many ethnicities — one which happens to have an odd association with artificiality, but that too is natural. Hence the solution of identity conflict here allows New Age members to 'channel' through cultures (even those long gone) in ways which make the most wanna-be of hippies look like white pride advocates.

The synthesis of artificial and natural is also conveyed in New Age music, which typically uses artificial (i.e. electronic) instruments to make natural sounds. But the natural sounds are themselves supposed to reflect only the soothing harmonious essence of nature, the 'music of the spheres', and therefore have an ethereal, unworldly character to them. Another popular symbol among New Age participants is the yin-yang sign, which has a history of orientalist interpretations that has shown great flexibility. In the 1960s the yin-yang was said to represent holism, the true unity that lies beyond dualist illusions of day and night, hot and cold, etc. In New Age subculture the same symbol is used to represent the unity of holism and reductionism (which Toffler, writing primarily for a management science audience, terms 'wholism'). Figure 5 summarizes this comparison of youth subcultures and cybernetics in the three historical moments outlined above.

While this synthesis solves many of the tensions that the transitional reversal posed — for example, justifying the lifestyles of thousands of ex-hippie computer programmers — it presents some conceptual problems. Should holism and reductionism be combined holistically, or reductionistically? If holism is not the answer at the first level, why should it be the meta-level solution? Doesn't this imply two different methods of synthesis, meta-holism and meta-reductionism, which could again be brought together in yet another brilliant philosophical *coup*?

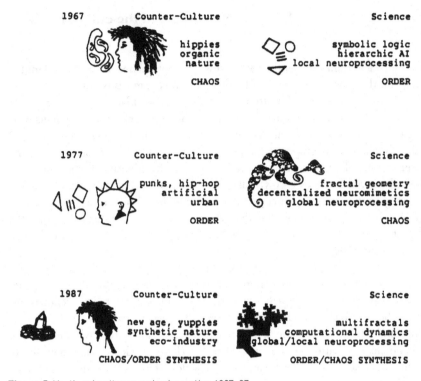

Figure 5 Youth subcultures and cybernetics 1967–87

My cynicism here comes in part from an exasperation with the free-floating politics that this meta-holism has allowed. Riane Eisler's 1987 meta-holism manifesto, *The Chalice and the Blade*, cites Karl Marx, Donna Haraway and Alvin Toffler as participants in her 'glyanic' (gynic/andro synthesis) wave, a sweeping inclusiveness that leaves one wondering if there is anything she does *not* support. More ominous is the advocacy of prayer in public schools suggested by meta-holism theorists Charlene Spretnak and Fritjof Capra. While this may indeed combine holistic spirituality with reductionist institutionalization, it hardly seems like the cutting edge of progressive politics that they claim.

As in the case of holism pure and unmodified, I see no inherent ethical content to holism–reductionism synthesis. Eisler, for example, suggests that the concepts of both patriarchy and matriarchy imply domination and provides a utopic origin story in which the edenic state was a 'glyanic' holism–reductionism synthesis of 'partnership' rule. But it is hard to see how this notion of partnership is inherently more liberating; it recalls Rich's 'compulsory heterosexuality' and bourgeois ideals of family norms (see Eisler, 1987: 39). And like the holism of transitional postmodernity, this holism–reductionism synthesis is also hard at work in military and industrial applications. Robert Smithson of Lockheed, for example, recently suggested that the ultimate defence computing

system would 'operate in a continuum of modes ranging from analog to digital, and from network to sequential processor' with an optimum combination sought for each problem (Stoddard, 1990: 15).

Conclusion

How can we account for these parallel transitions between changes in information processing models and changes in popular culture? Hess (1995: 18–19) categorizes two different explanatory methods in science studies. In what he terms the 'sociological approach', empirically identifiable social variables or actors are shown to have both a correlation and causal connection with particular technological counterparts. In contrast, Hess refers to a 'cultural approach' in which the correspondence between social and technological features cannot be reduced to any particular factor or artefact. Turkle (1995: 264), for example, suggests that the correspondences between postmodernity and cybernetics are cultural 'deep assumptions' (here using a phrase from Hayles) which 'manifests itself in one place and then another, here as developmental psychology and there as a style of engineering, here as a description of our bodies and there as a template for corporate organization, here as a way to build a computer network and there as a manifesto of political ideals'.

Hess suggests that any one researcher might switch between the cultural and sociological approach, changing analytic tools as they see appropriate, but this makes the choice sound like merely one of personal preference or rhetorical strategy. In the discussion of relations between cybernetics and popular culture in the 1960s I was able to give a good sociological account of the particular people, events and artefacts (or in Latour's terms, the network actors) that created the linkage. But this was much less apparent in the 1970s and 1980s. I did not decide to switch explanatory methods; rather the nature of this particular relation between the technological and the social has undergone a historic change.

There are two possible explanations for such transformations. The first is that the technical–social coupling only existed as a strong force during the 1960s, and that this was like synchronizing two clocks – what appeared to be coupling in later decades was merely two independent dynamics with similar time constants. The second, which I find more believable, is that the kinds of explicit, overt gestures of political and technological allegiance that were appropriate in the 1960s would have been overbearing in the 1970s and 1980s. The coupling between popular culture and cybernetics was more subtle not because it was any less important, but because the subtlety was itself historically conditioned.

One of the fiercest battles of postmodernity has been the argument between the 'new left' of the 1960s and their postmodern counterparts. From the viewpoint of the 1960s activists, postmodernist analyses (i.e. poststructuralism) are

merely an excuse for navel-gazing (cf. Epstein, 1995). Postmodernists generally reply that the particular physical activity of massive street protests is not the only possible theatre for political movements, and that their political activism takes more subtle routes. One of these has been a shift to new forms of cultural representation, and it is here that we may find some of the mutual influences between cybernetics and popular culture. Rose (1994: 62–96) makes a detailed argument for the co-evolution of rap music and certain aspects of digital sound engineering, and also notes (p. 22) that many of the computer graphic effects that emerged in the later 1970s, such as morphing, were foreshadowed by the fluid transformations of graffiti and breakdancing from the early 1970s. 'In a simultaneous exchange, rap music has made its mark on advanced technology, and technology has profoundly changed the sound of Black music.'

Another example of this subtle exchange occurs in the CALAB software documentation created by white mathematician Rudy Rucker (1989). The controls for a specific group of the cellular automata parameters are recalled by analogy to rap artist names (pp. 35, 37). When I asked him about the reference, his reply was a striking mix of ethnic signifiers and science fiction – a far more subtle connection than the romantic organicism that characterized the 1960s:

> Well, I just remember thinking that it sounded like Black English, DB, DC, DD . . . de brothers. I got Run-DMC's record when I lived in Lynchburg, Virginia, about 1984. Even without the record, I was certainly aware of Black English. I tried to use some of it in my sci-fi novel *The Hollow Earth*, which has a Black character.

What stands out in this history is not any clever end-game, but rather the strategic status of oppositional moves. Norbert Weiner's brief attempt to apply cybernetic recursion to labour unions in the 1950s was a radical move, but in the 1980s worker 'self-management' was more about eliminating union activism. Rucker's use of rap signifiers in his seminal cellular automata lab of the late 1980s was only possible because of a politically unaccountable New Age-style ethnic collage, but in the context of the typically all-white signifiers of hacker technoculture (for example, the MUD as multi-user dungeon, the battle-ax as anti-virus icon and other signifiers of a playful Tolkenesque nordic mythology), it carries a cultural intervention that is not insignificant. Anti-hegemonic critique in cultural cybernetics works best when it does not depend on final answers, immovable grounds of truth, or ultimate formula. The only place to stand is to keep on moving.

Notes

1 In part, the use of '7' years was motivated by specific dates – 1967 as the 'summer of love', 1977 as the year of the first successful punk and rap hits.

But it also serves as an arbitrary 'cut' through the temporal changes, much like the way field biologists use a transect line for arbitrary sampling.

2 Varela's view of an inherent ethical advantage to analogue systems was contradicted by the authoritarian politics of Howard Odum's cybernetic theory (Taylor, 1988), as he made clear in a later essay (Varela, 1979).

3 African-American youth subculture was, of course, a foundational force in the counter-hegemonic aspects of the 1960s, but the alienation due to primitivist romanticism in hippy subculture resulted in a distinct distancing from the McLuhan-style organicist cybernetics, as implied by Boggs (1968). This alienation is reversed, however, in the comparison of hip-hop subculture to transitional postmodern cybernetics, as we will see in the following section.

4 The Turing machine is a mathematical abstraction which encapsulates all computations that would be possible with any digital device.

5 In fact the equivalence of deterministic and non-deterministic automata for the finite case (that is, finite state automata) was proved by M.O. Rabin and D. Scott in 1959.

6 This reversal of bias in the two cybernetic dimensions was also apparent in many locations throughout the 'military-industrial establishment' of this transitional postmodern era. One of the first explicit attempts to move towards military applications from within the tradition of holistic cybernetics was that of James Miller, whose *Living Systems* (1979) drew on Wiener, von Bertalanffy and others. The title of his essay, 'Potential applications of a general theory of living systems to the study of military tactical command and control' – a title that might be rephrased 'Applications of life to death' – is an oxymoron that underscores the tensions of transitional postmodernism's trope of reversal. A similar statement was made in a later military holism manifesto by Dik Gregory (1986) of the US Army Research Institute. A previous collaborator of Gordon Pask, Gregory cites not only the cybernetic tradition of the 1960s (noting both the disregard for analogue representation and recursion), but also the zen physics of Capra and Zukav and the latest on self-organizing systems philosophy from Varela and Maturana. Gregory's goal is the development of self-organizing military technologies which can constitute 'a dynamic "living" system' – presumably resulting in static 'dying' people.

References

Barnsley, M. F. and Demko, S. (1985) 'Iterated function systems and the global construction of fractals', *Proceedings of the Royal Academy of London*, A399: 243–75.

Bateson, M. C. (1972) *Our Own Metaphor*, New York: Knopf.

—— (1984) *With a Daughter's Eye*, New York: Simon & Schuster.

Blum, L., Shub, M. and Smale, S. (1989) 'On a theory of computation and complexity over the real numbers', *Bull AMS*, 21(1): 1–46.

Bobrow, D. G. and Winograd, T. (1977) 'An overview of KRL', *Cognitive Science*, 1: 3–46.

Bogen, J. E. (1969) *Bulletin of the Los Angeles Neurological Societies*, 34(3): 135–62.

Boggs, J. (1968) 'The Negro in cybernation', in *The Evolving Society; The Proceedings of the First Annual Conference on the Cybercultural Revolution – Cybernetics and Automation*.

Callon, M., Law, J. and Rip, A. (1986) *Mapping the Dynamics of Science and Technology*, London: Macmillan.

Campbell, F. W. and Robinson, J. G. (1968) 'Applications of fourier analysis to the visibility of gratings', *Journal of Physiology*, 197: 551–66.

Capra, F. (1975) *The Tao of Physics*, Berkeley, CA: Shambhala.

Castleman, C. (1982) *Getting Up*, Cambridge, MA: MIT Press.

Chambers, I. (1985) *Urban Rhythms*, New York: St Martin's Press.

Daugman, J. D. (1984) 'Two-dimensional spectral analysis of cortical receptive field profiles', *Vision Res*, 20: 847–56.

De Lacoste-Utamsing, C. and Holloway, R. L. (1982) 'Sexual dimorphism in the corpus callosum', *Science*, 216: 1431–2.

Delany, S. (1988) 'Is cyberpunk a good thing or a bad thing?', *Mississippi Review*, 16: 28–35.

Dery, M. (1988) 'Rap: Taking it from the streets, *Keyboard*, November.

—— (1994) 'Black to the Future: interviews with Samuel Delany, Greg Tate and Tricia Rose', in Mark Dery (ed.) *Flame Wars*, Durham: Duke University Press.

De Valois, R. L., Albrecht, D. G. and Thorell, L. G. (1978) 'Cortical cells: bar detectors or spatial frequency filters?', in S. J. Cool and E. L. Smith (eds) *Frontiers in Visual Science*, Berlin: Springer.

Dewdney, A. K. (1985) 'Analogue gadgets', *Scientific American*, June: 18–29.

DiLorenzo, K. (1985) 'Breakdancing isn't new', *The Crisis*, April: 8–9, 45.

Eglash, R. (1993) 'Inferring representation type from the fractal dimension of biological communication waveforms', *Journal of Social and Evolutionary Systems*, 16(4): 375–99.

—— (1995) 'African influences in cybernetics', in C. Gray (ed.) *The Cyborg Handbook*, New Jersey: Routledge.

Eisler, R. (1987) *The Chalice and the Blade*, San Francisco, CA: Harper & Row.

Elcock, E. W., McGregor, J. J. and Murray, A. M. (1972) 'Data directed control and operating systems', *Computer Journal*, 15: 125–9.

Electronic Design (1989) 'Analog and analog-digital arrays blossom', 37(13): 49–56.

Epstein, B. (1995) 'Why poststructuralism is a dead end for progressive thought', *Socialist Review, 25*: 83–120, 95–2.

Ferguson, M. (1980) *The Aquarian Conspiracy*, New York: St Martin's Press.

Franks, J. (1989) 'Review of Gleick (1987)', *The Mathematical Intelligencer*, 11: 65–71.

Frisch, U. and Parisi, G. (1985) 'Multifractals', in *Turbulence and Predictability of Geophysical Flows and Climate Dynamics*, New York: North-Holland.

Gabor, D. (1946) 'Theory of communication', *J. IEE London*, 93: 429–57.

Gregory, D. (1986) 'Delimiting expert systems', *IEEE Syst Man Cyber*, 16(6): 834–43.

Hager, S. (1984) *The Illustrated History of Break Dancing, Rap Music, and Grafitti*, New York: St Martin's Press.

Hall, S. (1980) *Culture, Media, Language: Working Papers in Cultural Studies, 1972–79*, London: Hutchinson.

Haraway, D. (1997) *Modest Witness@Second Millennium: FemaleMan Meets OncoMouse*, New York: Routledge.

Hayles, K. (1990) *Chaos Bound*, Ithaca, NY: Cornell University Press.

Hebdige, D. (1979) *Subculture, The Meaning of Style*, London: Methuen.

—— (1988) *Hiding in the Light: On Images and Things*, London/New York: Routledge.

Heims, S.(1984) *John von Neumann and Norbert Wiener*, MA: MIT Press.

Hess, D. (1995) *Science and Technology in a Multicultural World*, New York: Columbia University Press.

Hewitt, C. E. (1977) 'Viewing control structures as patterns of passing messages', *Artificial Intelligence*, 8: 323–64.

Hopfield, J. (1982) 'Neutral networks and physical systems with emergent collective computational abilities', *Proceedings of the National Academy of Sciences USA*, 99, April: 2554–8.

Hubel, D. H. and Wiesel, T. N. (1965) 'Receptive fields, binocular interaction and functional architecture in the cat's visual center', *Journal of Physiology*, 28: 229–89.

Jameson, F. (1991) *Postmodernism: Or the Cultural Logic of Late Capitalism*, Durham: Duke University Press.

Kerman, C. E. (1974) *Creative Tension: The Life and Thought of Kenneth Boulding*, Ann Arbor: University of Michigan Press.

Kirkpatrick, S. C. D., Gelatt, J. and Vecchi, M. P. (1983) 'Optimization by simulated annealing', *Science*, 220(4598): 671–80.

Kolata, G. (1983) 'Math genius may have hormonal basis', *Science*, 222: 1312.

Kristeva, J. (1989) *Language: The Unknown*, New York: Columbia University Press.

Latour, B. (1987) *Science in Action*, Cambridge, MA: Harvard University Press.

Leary, T. (1968) *The Politics of Ecstasy*, New York: Putnam.

Levy, J. (1978) 'Lateral differences in the human brain in cognition and behavioral control', in P. Bruser and A. Rougeul-Buser (eds) *Cerebral Correlates of Conscious Experience*, New York: North-Holland.

Lilienfeld, R. (1978) *The Rise of Systems Theory*, New York: John Wiley.

Lyotard, J. F. (1984) *The Postmodern Condition: A Report on Knowledge*, Minneapolis: University of Minnesota Press.

MacKay, D. (1981) 'Strife over visual cortical function', *Nature*, 289: 117–18.

McLuhan, M. (1966) 'Cybernation and culture', in C. R. Dechert (ed.) *The Social Impact of Cybernetics*, London: Notre Dame.

McRobbie, A. (1994) *Postmodernism and Popular Culture*, London/New York: Routledge.

Mandelbrot, B. B. (1987) *The Fractal Geometry of Nature*, New York: W.H. Freeman and Co.

Maren, A. J. (1990) 'Multilayer cooperative/competitive networks', in Maren *et al.* (1990).

Maren, A. J., Harston, C. T. and Pap, R. M. (1990) *Handbook of Neural Computing*, New York: Academic Press.

Martin, E. (1994) *Flexible Bodies*, Boston, MA: Beacon Press.

Mercer, K. (1988) 'Black hair/style politics', *New Formations*, 5: 33–54.

Miller, G. (1956) 'The magical number seven, plus or minus two', *Psychological Review*, 63: 81–97.

Miller, J. G. (1979) 'Potential applications of a general theory of living systems to the study of military tactical command and control', in C. P. Tsokos and R. M. Thrall (eds) *Decision Information*, London: Academic Press.

Minsky, M. (1988) 'The view from 1988' – Epilogue from *Perceptrons*, expanded edn, Cambridge, MA: MIT Press.

Minsky, M. and Papert, S. (1969) *Perceptrons: Computational Geometry*, Cambridge, MA: MIT Press.

Omohundro, S. (1987) 'Efficient Algorithms with Neural Network Behavior.' Report no. UIUCDCS-R-87-1331, Dept of Computer Science, University of Illinois at Urbana, April.

Pagels, H. R. (1988) *The Dreams of Reason: The Computer and the Rise of the Sciences of Complexity*, New York: Simon & Schuster.

Pollack, J. (1989) 'No harm intended', *Journal of Mathematical Psychology*, 33: 358–65.

Poster, M. (1990) *The Mode of Information*, Oxford: Polity Press.

Pylyshyn, Z. W. (1981) 'Complexity and the study of artificial intelligence', in J. Haugeland (ed.) *Mind Design*, Cambridge, MA: MIT Press.

Rubel, L. A. (1989) 'Digital simulation of analog computation and church's thesis', *Journal of Symbolic Logic*, 34(3): 1011–17.

Rubinoff, M. (1953) 'Analogue and digital computers – a comparison', *Proceedings of the IRE*, October: 1254–62.

Rucker, R. (1989) *CA Lab*, Sausalito: Autodesk Inc.

Rose, T. (1994) *Black Noise*, Hanover: Wesleyan University Press.

Spretnak, C. (1984) 'A green party – it can happen here', *The Nation*, 21 April.

Star, S. L. (1979) 'The politics of left and right', in *Women Look at Biology Looking at Women*, New York: Crossing Press.

Stoddard, R. (1990) 'Washington focus – future in the making', *Defense Computing*, 3(1): 15.

Tate, G. (1992) *Flyboy in the Buttermilk: Essays on Contemporary America*, New York: Simon & Schuster.

Taylor, P. J. (1988) 'Technocratic optimism, H. T. Odum and the partial transformation of ecological metaphor after World War II', *Journal of the History of Biology*, 21(2): 213–44.

Toffler, A. (1980) *The Third Wave*, New York: Morrow.

Toop, D. (1984) *The Rap Attack: African Jive to New York Hip-Hop*, Boston, MA: South End Press.

Touretzky, D. S. (1986) 'BoltzCONS: reconciling connectionism with the recursive

nature of stacks and trees', *Proceedings of the 8th Annual Conference of the Cognitive Science Society*, pp. 522–30.

Turkle, S. (1995) *Life on the Screen*, New York: Simon & Schuster.

Varela, F. (1979) 'Reflections on the Chilean war', *Lindisfarne Letter*, Winter: 13–19.

—— (1987) 'Laying down a path to walking', in W. I. Thompson (ed.) *Gaia: a way of knowing*, Great Barrington, MA: Lindisfarne Press.

Vergis, A., Steiglitz, K. and Dickinson, B. (1985) 'The complexity of analog computation', technical report No. 337, Department of Electrical Engineering and Computer Science, Princeton University, February.

Von Foerster, H. (ed.) (1952) *Transactions of the Seventh Conference on Cybernetics*, Josiah Macy Foundation.

Von Foerster, H. *et al.* (eds) (1968) *American Society for Cybernetics Purposive Systems: Proceedings of the First Annual Symposium of the American Society for Cybernetics*, New York: Spartan Books.

Watts, A. (1961) *Psychotherapy East and West*, New York: Random House.

Zorpette, G. (1988) 'Fractals: not just another pretty picture', *IEEE Spectrum* October.

J. Macgregor Wise

INTELLIGENT AGENCY[1]

Abstract

We are facing a new technological assemblage, networks of communication and information technology which mediate our lives in new ways. Within the discourses surrounding these new networks, amidst promises of unlimited agency, power and control, sits the key figure of the intelligent agent. An intelligent agent is a software program that would act in one's place in cyberspace, as a digital butler of sorts. Drawing on the actor-network theory of Bruno Latour and others, and the philosophy of Gilles Deleuze and Félix Guattari, this article analyses the politics and possibilities of intelligent agents. It focuses on prominent themes in the discourse about intelligent agents, such as libertarianism, consumerism, trust, and the abandonment of the body into a digital realm. Ultimately, the article argues, we need to view technologies, and agency, as embodied and contextualized, and abandon the modernist separation of humans and technologies.

Keywords

technology; actor-network theory; intelligent agents; Deleuze and Guattari

TECHNOLOGY OFTEN eludes cultural analysis, or is often significant in its absence. Indeed, cultural studies' history of dealing with technologies – at least up until the late 1980s – has been patchy at best (with significant, though usually isolated exceptions, e.g. Williams, 1974). In general, research based in humanistic or social science traditions tends to put technology in a black box, a domain marked 'Here Be Monsters' and left to others (engineers, technologists, repair technicians) to deal with (Callon and Latour, 1981). Technologies are seen

to be outside of the disciplinary purview of either the humanities or the social sciences and can thus be ignored. With the discursive turn in cultural studies more work focused on the reading of texts, a practice to which technologies usually do not lend themselves except in more Barthesian moments of reading 'style' (cf. Hebdige (1988) on Italian motor scooters). Even when cultural studies does consider nondiscursive practices it tends to focus on human practices rather than those of machines. Mention is occasionally made (following Michel Foucault or Gilles Deleuze and Félix Guattari) of social machines or machines of power, but rarely specific machines. One reason for all this is that we (as humans) create technologies to literally take a task off our hands, to do something for us so we can be preoccupied elsewhere (or to do something that we cannot do but want to, such as fly). We *delegate* tasks to technologies (traffic lights take the place of police officers standing at intersections; automatic springs on doors close them behind us so that we don't have to, and so on). But as technologies take tasks off our hands, they also take them off our minds. Technologies perform not only so that we don't have to, but also so that we don't have to think about them (i.e. closing doors) any more. Technologist Langdon Winner (1977: 314–15) puts it this way:

> There is a sense in which all technical activity contains an inherent tendency toward forgetfulness. Is it not the point of all invention, technique, apparatus, and organization to have something and *have it over with?* . . . Technology, then, allows us to ignore our own works. It is *license to forget.*

Is it then surprising that technologies tend to disappear from cultural analyses, slipping into the realm of habit and the quotidian? It is perhaps when technologies are new, when their (and our) movements, habits and attitudes seem most awkward and therefore still at the forefront of our thoughts that they are easiest to analyse, to delineate. Afterwards they can be exceedingly hard to pry loose from everyday life (excepting in the catastrophic collapse of the quotidian in times of war, disaster, and so on).

Bruno Latour (1988, 1993) argues that not only do we delegate tasks to technologies, but they then impinge behaviours back on us. Technologies regulate our behaviours (for example, how we enter a room, or how we watch television). The task of delegation, taken alone, is often reduced to a social deterministic (or social constructionist) view of technology: technologies do what we tell them to; technologies are what we say they are. The second task, of the impinging of technology, taken alone, is often reduced to a technological determinist view: who we are depends on our technologies. Latour says that we cannot separate these two processes, and that by looking at both processes together we see technologies as social actors. Latour and Michel Callon define an actor as 'any element which bends space around itself, makes other elements dependent upon itself and translates their will into a language of its own' (Callon and Latour, 1981: 286).

Latour's (1988) example is that of an automatic door-closer which regulates *which* humans can enter a room (making it difficult for small children, the weak, the elderly or the physically challenged) and *how* they enter a room. In this way the door-closer manages space, movement through that space, and human behaviour in that space. Technologies, in Latour's terms, are our lieutenants. They stand in place of (in lieu of) our own actions. The automatic groom on a door, the traffic light on a street, stand in for human actions. We need to remember, though, that once a task has been delegated to a technology, that technology then impinges back on everyone who encounters it and not just on those who designed it. Those who delegate and those who are impinged upon can be (and often are) disparate sets of people (Star, 1991). In this way Latour argues that technologies are moralistic, they impose 'correct' behaviour and foster 'good' habits.

When analysing a social field (or space), then, we have to consider not just the human actors inhabiting and crossing that space but the technologies which regulate that space as well. By being social actors, technologies exhibit a type of agency, and by this I mean social effectivity (rather than seeing agency as individual will). But humans do not simply move through social space (thereby constituting it), they are in many ways constituted by it as well (Wise, 1997), as are all the actors involved. The border often delineated between human and technology is a problematic one, which I will return to below. When we ignore technologies because they disappear into the quotidian we are ignoring social actors which have effects on how we behave and the possibilities for our actions.

We are currently facing a swarm of new technological actors in the form of information and communication technologies and the interconnections between them. Most prominently, much attention has been paid to the creation of the Internet, its economic policy form as the National Information Infrastructure, and its popular form as the Information Superhighway and, more broadly, cyberspace. However, this is not the introduction of just one type of actor: we are facing a whole array of technologies which bear a formal resonance to one another (not only interactive entertainment technologies brought to us via cable or direct broadcast satellite television, but ATMs, pay-at-the-pump petrol, voicemail, videogames, World Wide Web interfaces, and so on). What we are facing is a new technological assemblage, aspects of which are inserting themselves in many ways between us and the world. Our lives are becoming increasingly mediated by these technologies. This is not to say that our lives were somehow unmediated and authentic before these technologies came along. Humans have always been mediated by tools and language. What these new technologies do is shift the nature of that mediation; we are now mediated in a different (if not new) way. The question to ask would be: What is the nature of this mediation, what tasks are being delegated to these new technologies, and what do they impinge back on us? This article focuses on one particular set of these new technologies that illustrates the process of delegation and the reciprocal regulation of human action: intelligent agents. Agents seem to be the current screen on which

fantasies of unlimited human action and possibility are projected; the latest in a long line of utopian technological fixes. A lot of the current work on agents comes from the Artificial Intelligence community and robotics research. However, the figure of the agent has entered the popular imaginary over the past few years and it is this body of work which I will focus on here.

<div align="right">I</div>

Computers are infiltrating our cars, houses, businesses, banks, toasters and social interactions, and, as MIT's Nicholas Negroponte would have it, 'Intelligent Agents are the unequivocal future of computing' (1995a: 172). Agents therefore have the potential to impact many aspects of our daily lives. But what are intelligent agents?

> The buzzword *agent* has been used recently to describe everything from a word processor's Help system to mobile code that can roam networks to do our bidding.
>
> <div align="right">(Wayner and Joch, 1995: 95)</div>

Pattie Maes, an assistant professor at MIT currently exploring the development of agents, writes that 'Agent programs differ from regular software mainly by what can best be described as a sense of themselves as independent identities. An ideal agent knows what its goal is and will strive to achieve it' (1995: 85). Peter Wayner, a contributing editor to *Byte* magazine, defines an agent as 'a software program which can roam a network, interact with its host, gather information, and come home' (1995a: 12). Wooldridge and Jennings, in their Introduction to the published proceedings of an international conference on intelligent agents, write that an agent is computer hardware or software that exhibits autonomy, 'social ability' (the ability to communicate with others), reactivity to its environment, and proactiveness (1995: 2; see also Steels, 1995). Agent research takes two forms: the development of autonomous robots which can learn, develop and pass on information to others (humans and other agents), and software agents which exist solely as programs in a computer, or on the Internet. It is the latter which has been focused on more in the popular press and will be the subject of this article; so when I refer to agents, I mean software agents.

Basically, an intelligent agent is a software program tailored to an individual's needs and personality. There are generally two types of these agents.[2] One is called an interface agent and is an intelligent, adaptable interface to a program or system. Like a teller at your local bank branch or a server at a café that you frequent, such agents come to know you and your expectations, anticipating your business and even suggesting new services or products. Pattie Maes writes that 'computers are as ubiquitous as automobiles and toasters, but exploiting their

capabilities still seems to require the training of a supersonic test pilot. VCR displays blinking a constant 12 noon around the world testify to this conundrum' (1995: 84). She goes on to argue that all the new technology coming up will make the gap between users and technology that much greater. 'Some accommodation must be found between limited human attention spans and increasingly complex collections of software and data' (p. 84). Agents are that accommodation. Just as graphical user interfaces such as the Macintosh desktop look and that of Windows and Windows 95 made computers friendlier and easier to use (and therefore allowed more people to take advantage of what they had to offer), agents are an adaptive, proactive, partially independent interface.

The second type of agent is more of a personal assistant. This agent would act in the individual's place in cyberspace: buying concert tickets, negotiating meetings, database searching, and so on, all while the individual was occupied with other matters. Rather than being merely the interface between a person and the computer, the agent would be able to venture out on to the Internet independently to carry out the person's wishes or anticipate his or her demands. For example, my agent might alert me that not only have tickets for a local concert of my favourite rock band gone on sale (an announcement that I may have missed if I rely on my occasional listening to the radio or reading of the newspaper), but also that the agent has already purchased tickets in my favourite seats in that venue. Agents would also be able to communicate and share information with other agents (i.e. asking for directions) and even negotiate with them (have your agent call my agent). As computer programs which independently venture out over the Internet to perform tasks, agents bear a strong resemblance to computer viruses. Indeed, Peter Wayner refers to them as 'a good virus' and as 'controlled versions of viruses' (1995a: 9), though the best agents are supposed to work *without* our control (i.e. independence is part of the definition of a true agent). Anxieties about remaining in control of our agents will be dealt with below.

Intelligent agents are also referred to as virtual agents, agent software, messaging agents, or anything ending in the suffix -bot (knobots, infobots, softbots, etc.).[3] Microsoft's 'Bob' interface for Windows is said to be agent software and products like the Apple Newton (a handheld computer also called a personal digital assistant) have agent capabilities because they adapt to the individual user. The figure of the intelligent agent seems to be the next big thing in cyberspace and has appeared with increasing frequency in popular, academic and corporate discourses.

In a 1994 issue of *Newsweek*, Barbara Kantrowitz describes agents as digital butlers, our computer becoming an electronic version of *Upstairs, Downstairs*. Her article focuses on virtual shopping in electronic malls; once an agent knows your preferences you don't even have to accompany it as it shops and so you can avoid crowded malls. Again in *Newsweek*, a year later, Katie Hafner describes a broader range of agents dealing with managing information flow: e-mail filter programs

which sort, flag or delete incoming mail; personalized newspapers which are electronic clipping services providing news to you based on your interests, and so on. *Business Week* (Brandt, 1994) describes agents as a form of artificial life, programs which 'evolve', combine, split apart and pass on programming information to the next generation of agents in an electronic survival of the fittest. The computer magazine *Byte* devoted extensive coverage to the technical side of agents in a 1995 cover story (Indermaur, 1995; Wayner, 1995b; Wayner and Joch, 1995; see also Halfhill, 1996). And *Communications of the ACM* has a germinal special issue on the topic (July, 1994) that considers social and philosophical issues surrounding agents as well as technical ones. The issue calls for a 'scientific approach' to agents and not just a marketing approach. Agents have been used to help market communication and information technology companies by being featured prominently in promotional videos from AT&T, Apple Computers, Hewlett Packard, Digital, and so on. For example, in AT&T's *Connections* video (1993) a mother and daughter shop for wedding dresses together; their agents not only take care of business while they shop (negotiating deals, and so on), they also bring the dresses to them and model them. Also in the video, agents (who appear on computer screens like television news anchors directly addressing the user) arrange meetings and negotiate with other agents.

Agents seem especially important in what might be termed the 'Wired school' centred on *Wired* magazine (see Wise, 1997). *Wired* has run an interview with Pattie Maes (Berkun, 1995) and *HotWired*, the World Wide Web version of the magazine, has had Maes debating with Jaron Lanier, a pioneer in virtual reality systems, over the viability and desirability of agents (http://www. hotwired.com/braintennis/96/29/btOa.html). HardWired, *Wired's* book publishing arm, published *Bots: The Origin of New Species* in 1997 (Leonard, 1997).

I use the term 'Wired school' not just to refer to the magazine, web site and related publications, but also to the collection of writers connected with the magazine (either directly or more philosophically) such as Nicholas Negroponte, Kevin Kelly, John Perry Barlow, and so on, and organizations such as the Electronic Frontier Foundation (EFF) which lobbies in Washington, DC regarding civil liberties in cyberspace. What is common to this at times diverse group is an underlying libertarian view of cyberspace. The libertarian position takes technology to be the extension of rational individuals (Marshall McLuhan is often invoked here as a progenitor of this position; indeed, *Wired* lists him as their 'patron saint'). The figure of the agent fits in well with this position in that it is seen as an (autonomous) extension of one's self, a symbol of the increased agency available from cyberspace. Cyberspace is seen as a free and open space, a frontier where one can 'surf the new edge' (in cyberzine *Mondo 2000's* phrase). However, historian Richard Slotkin has argued that the myth of the frontier in American society functions 'as rationalizer of the processes of capitalist development in America' (1985: 34). Indeed, the wired brand of libertarianism appeals all too well to free market and corporate sensibilities.

Current rudimentary agent programs and those we can expect in the near future exhibit what Arjun Appadurai (discussing the global flow of images and markets) has termed the fetishism of the consumer: 'These images of agency are increasingly distortions of a world of merchandising so subtle that the consumer is consistently helped to believe that he or she is an actor, where in fact he or she is at best a chooser' (1996: 42). On this subject, Jesse Drew (1995: 75) has written:

> Mass-circulation magazines like *Newsweek* and *Time* have run cover stories about the coming 'revolution' that are little more than industry PR. Lifestyle magazines like *Wired* and *Mondo 2000* stimulate consumer demand for new gadgets and informed acquiescence to governmental and corporate policies – in the name of spurious 'liberation' and 'empowerment'.

For example, is it coincidence that Thinking Machines Corporation, a prominent maker of super-computers, is testing algorithm programs similar to those which will be the basis of autonomous agents (the type exhibiting artificial life) to predict how credit cards will be used on a broad scale (Brandt, 1994: 68)? It seems clear that consumer marketing demographics is driving much of the new technology (especially when electronic shopping is being touted as the key feature of agents). In a further example, Greg Elmer (1997) has explained how the earliest of agent programs (called 'spiders') have been used to map the sprawl of the World Wide Web and even autonomously repair broken links between sites. But such spiders are also capable of tracking user activity on the Web and 'enhancing demographic and psychographic profiles'.

> Moreover, as just one more step towards instituting strategies of advertising, marketing and consumer surveillance – which for decades now have targeted particular demographic and psychographic groups with a range of products and services (through the mail, at the supermarket, on the telephone, etc.) – the advent of spiders has also facilitated the technological construction of user profiles solicited through a language of freedom, interactivity, efficiency, and choice.
>
> (Elmer, 1997: 185–6)

If the current structures of the Web and the Internet can record one's passing for marketing purposes, how will this be different when it is an agent passing through? Might not it gather (willingly or not) handfuls of electronic brochures and bumper stickers to show you as it travels on your business? On a deeper level, it should be expected that future commercially distributed agent programs will always exhibit some form of normative action, either searching only prominent commercial sites (i.e. searching only Ticketmaster for concert tickets rather than independent dealers, or searching Microsoft sites first before others), or using

one's usage-profile (which adapts the agent to your needs) to alert marketers (privacy becomes a major issue with autonomous agents; see Norman, 1994). As the Web and Internet become more active (literally pushing information at us rather than waiting for the user to actively seek it out; see *Wired*'s cover story, March, 1997), agent-type programs will become an increasingly important mediary in our wired lives, both as a means of protection from unsolicited information and a source of it.

II

The notion that technology is the extension of (a liberal, humanist) self generally arises in two ways in the popular discourse on cyberspace. One is the cyberpunk literature, which I do not follow here (but see Bukatman, 1993; Dery, 1996). The second is the intriguing notion that we will *become digital*, once we delegate to electronic avatars and our actions are carried out by digital servants. So say the fervent believers of this vision of cyberspace such as Nicholas Negroponte. Negroponte and fellow MIT professor William Mitchell lead the way in abandoning the physical world of atoms to play in the City of Bits. Negroponte (1995b) explains, for example, how much easier life will be once we stop shipping around atoms and start sending bits (once we 'become digital'). He discusses the freedom, the very lightness of being, of living in a digital world and at the speed of light. In such a realm one has much more power to construct one's surroundings and control one's interactions with the world (via agents and intelligent newspapers). Mitchell (1995) explores the ways in which currently solid institutional and architectural spaces (such as museums, schools, hospitals and theatres) may be greatly transformed by the new technologies (or even vanish into thin air). Other proponents of similar views spin out scenarios where the body itself will be abandoned, our consciousnesses let free to roam the universe.[4] These discourses are often set in evolutionist or social Darwinist terms, making such changes seem positive and inevitable (on this, see Berland, 1997).[5]

The agent focuses and personifies a popular conception of individual agency in the new technological world. McLuhan and libertarianism come together: the individual is now in complete control of its extended self. But in control of what? A quote from Pattie Maes is revealing: 'we think it's important to keep the users in control, or at least always give them the impression they are in control' (quoted in Berkun, 1995: 117).

Between hyperbolic descriptions of freedom and agency we can note anxieties over this issue of control throughout discourses on agents and cyberspace generally.[6] Apple Fellow Donald Norman (1994: 69) puts it this way:

It's bad enough when people are intimidated by their home appliances, but what will happen when automatic systems select the articles they should

read, determine the importance and priority of their daily mail, and auto-
matically answer mail, send messages, and schedule appointments?

Will we become timid in the presence of our own agents and machines? Will
they begin to control us? Trust becomes a central factor in dealing with and
designing agents (Indermaur, 1995).[7] For example, William J. Mitchell (1995:
146) writes,

> Even if our agents turn out to be very smart, and always perform impecca-
> bly, will we ever fully trust them? And how will we deal with the old paradox
> of the slave? We will want our agents to be as smart as possible in order to
> do our bidding most effectively, but the more intelligent they are, the more
> we will have to worry about losing control and the agents taking over.

Andrew Leonard worries: 'what happens when our helpers finally throw off their
chains and sever their cyborg links?' (1997: 187). And Marvin Minsky, co-
founder of the Artificial Intelligence laboratory at MIT, writes:

> There's the old paradox of having a very smart slave. If you keep the slave
> from learning too much, you are limiting its usefulness. But, if you help it
> to become smarter than you are, then you may not be able to trust it not
> to make better plans for itself than it does for you.
>
> (quoted in Riecken, 1994: 25)

The worry that we will become enslaved to our machines (or that they will rise
up against us once the intelligent agents realize that we humans are slow and
boring) is not unique to intelligent agents, and is far from new. Indeed, it can be
traced back through a long line of writings on what Langdon Winner (1977) has
termed 'autonomous technology'. The dilemma at the heart of such fears sur-
rounding modern technology, Winner argues, is that of the master and the slave
described by Hegel. In this dilemma, the master not only becomes lazy and
dependent on the slave's work, but the slave becomes enlightened through
working with the land and tools and (in Marx's reading of this dilemma at least)
rises up against the master. This dilemma lies at the heart of the modern (for a
more extensive treatment of this see Wise (1997), following in part from Gross-
berg, 1993). The question is one of control, control of the other, and the
differentiation between self and other (Cartesian dualism, the Kantian
noumena–phenomena split). Thus we have seemingly constant debates over
whether we control our technologies/slaves (social determinism) or whether
they control us because we have become radically dependent on them (techno-
logical determinism).

 Perhaps the issue with intelligent agents, though, is not so much that agents
might take over the world, but more subtly that we may begin to defer too much

to machines. This is the argument of Jaron Lanier, a computer scientist and pioneer in virtual reality systems who argues that 'the idea of "intelligent agents" is both wrong and evil' (1996: 1). His main point is that 'Agents make people redefine themselves into lesser beings. . . . You change yourself in order to make the agent look smart. Specifically, you make yourself dumb.' If an agent is said to be intelligent (or expert) we tend to defer more towards that program. We tend also to limit ourselves only to the categories and procedures that the program offers. Thus the proliferation of intelligent agents and expert systems may actually increase normativity and obedience to technocrats and systems builders rather than freeing the individual from their control. The question to ask, then, is: What are we actually accomplishing when we use an intelligent agent? Are we just following its orders and protocols or are we exhibiting our own agency?

Theorizing resistance, Michel de Certeau contrasts 'style' with 'use' (1984: 100). *Style* refers to the singular processing of symbols or practice. In this case, style would be the ability to shape most if not all of an agent's protocols, proclivities and behaviour, and to be creative in one's use of agents. *Use* is normative and refers to socially structured codes. In this case agents would be primarily pre-programmed or come with a standard set of options. Indeed, it is a worry of the few critics of the intelligent agent (such as Lanier) that users won't exert the amount of style that they could (or, alternatively, they will not be able to, given the particular design of the agent, only certain functions can be performed, and so on).

Agents do (or will) exhibit a certain amount of agency, but of what type? To what extent do agents always at some level exhibit the normativity of their programmers and the structures of cyberspace into which they are released? Normativity and structure are not necessarily bad in and of themselves, but become much more of a concern the further apart the programmer and user are socially, economically and culturally from each other. Agents are always double agents. On the one hand, agents are nothing if not our lieutenants (in Latour's term), our butlers[8] (Kantrowitz, 1994), our familiars (in the demonic sense, as sorcerer's apprentices; Dery, 1996: 60), our delegates in cyberspace, carrying out our tasks so that our minds can be occupied elsewhere. But on the other hand, these agents are not just *our* delegates because we did not create them. The program and the logic (i.e. search protocols) of the agent limit and guide their progress and capabilities. This is what I mean when I say that all agents are double agents: they work for you, but they also work for (e.g.) Microsoft. Maes has written that 'it may prove hard for people to trust an agent instructed by someone else' (1995: 85). This will be less true as we develop agents which are not preprogrammed but learn everything from experience and from sharing information with pre-existing agents (ibid.: 86). This is when agents exhibit what is called 'artificial life' (Steels and Brooks, 1995).

Artificial life is a field of study that attempts to understand and reproduce the processes of life (Langton, 1996: 40; see also Kelly, 1995); in particular it

takes the knowledge and production of self-organizing entities as its central focus (Boden, 1996: 3). More than simply mimicking life (like the animatronic figures in a Disneyland ride), artificial life would be autonomous and emergent, it would change and evolve depending on its circumstances. 'Artificial life involves attempts to (1) synthesize the process of evolution (2) in computers, and (3) will be interested in whatever emerges from the process, even if the results have no analogues in the "natural" world' (Langton, 1996: 40). The artificial life approach to agents, then, would be to create rudimentary agent programs and then let them loose, allow them to explore, interact and adapt. The assumption behind this approach is a progressivist, survival-of-the-fittest view of evolution (cf. Berland, 1997). Better, more efficient agents will evolve if we simply let nature take its course. Nature, in this case, takes place in 'a complete electronic eco-system'; 'over time, these digital life-forms will fill different ecological niches' (Maes, 1995: 86). The artificiality of such a 'natural' ecosystem is betrayed by the fact that, coincidentally, the predicted fruits of electronic evolution happen to be agents which fill historically and socially specific human needs (i.e. database searching).

The drive to produce agents which are truly autonomous (living out their lives in the electronic jungle) is actually a drive to cover over or ignore the historical, social, cultural (and so on) conditions of creation, maintenance and development of such technologies. 'Programmers seek to remove traces of their presence in order to give the program the greatest possible autonomy' (Bolter and Grusin, 1996/7: 322). The contradiction between the historical specificity of agents and their universal evolutionary a-historicism is the same tension as that between the idea that agents become better the freer (more autonomous) they are (libertarianism returns here) and the need for control (and lack of trust) of agents, which is the dilemma of the master and the slave. In terms of human agency it is the tension between whether agent programs allow an amount of freedom (style) – i.e. agents should be able to be controlled by users – or whether users simply respond to autonomous programs. What contributes to this contradiction (and to the seemingly eternal debates between technological determinism and social determinism) is a conflation of two types of agency, what could be called 'technological agency' and 'linguistic agency'; each type presents a different way of achieving effects.[9]

III

Consider the strata in a rock formation. Strata of different composition are folded together. Imagine if one of these strata consisted of technology, thought broadly as corporeal agency – the ability to achieve effects through physical means, body on body, the direct manipulation of reality (Deleuze and Guattari, 1987). A

second strata, folded on to the first, we will call language, thought of as discursive agency, the ability to achieve effects incorporeally. For example, if a judge declares an accused 'guilty', that act has definite effects (the prisoner's status, his or her ability to move freely or conduct social interactions, is restricted), but those effects were carried out without physical force. Though incorporeal, the effects are still real. The combination, the articulation, of these strata together constitutes human social space. Human agency, the ability of humans to achieve effects in a society, is always both technological and linguistic. What changes from society to society, and across time, is the relative consistency and arrangement of each strata (technologies change, languages change) *and the relation between the two strata*. But we should also remember that in any social situation we are dealing with not only human actors (what Donna Haraway refers to as 'language-bearing actors' (1991: 3)) but also non-human, non-language-bearing actors as well.

Western, industrialized humans tend to place a lot of faith in the notion of a type of linguistic agency; indeed, this is the constitutive aspect of the public sphere and democracy (one can bring about changes in government and society through language alone, by voting and declaring). It is also through linguistic agency that we can control our machines since they have far surpassed our physical control. We command machines to do our bidding (cf. the current push to perfect voice-recognition systems).

With the Internet, digitalization and the rapid expansion of communication and information technologies, it would seem that linguistic agency would be even further expanded (hence the discussions of how the Internet will usher in true democracy and everyone will have more of a voice in public affairs). The reduction of the human to this stratum alone underlies the technolibertarian fantasies so prevalent around cyberspace. Negroponte's (1995b) digital being rides a swirl of information (seen as signs and language, and seen to be effective only through its representational – linguistic – functions), leaving the world of atoms far behind. Mitchell (1995) likewise focuses on the 'incorporeal' realm of cyberspace. And a similar reduction occurs when agents are not viewed contextually, as embodied, and when the task of creating and working with agents becomes that of refining programming language alone (see e.g. Varela, 1995, on embodied agents).

To assume this reduction, to claim, as Derrick de Kerckhove, chair of the Marshall McLuhan Program in Culture and Technology at the University of Toronto's St Michael's College has, that 'the Web is a new guise of language' (in Kelly, 1996: 149), is to virtually ignore the technological mediation that is occurring. Ironically, it is the mediating technologies themselves that allow this erasure. The problem with intelligent agents is a problem with all the technologies which increasingly insert themselves between us and the world; it is a characteristic of the *interface*. 'The transparent interface is one more manifestation of the desire to deny the mediated character of digital technology altogether' (Bolter and Grusin, 1996/7: 318). As Paul Virilio (1991: 52) has written,

We can now see more clearly the theoretical and practical importance of the notion of interface, that drastically new surface that annuls the classical separation of position, of instant or object, as well as the traditional partitioning of space into physical dimensions, in favor of an almost instantaneous configuration in which the observer and observed are roughly linked, confused, and chained by an encoded language.

The interface allows us to ignore all of the social actors (including all of the non-language-bearing actors) that must be taken into account in any activity in cyberspace. With the spread of cyberspace comes the increased insertion of technological actors into the public sphere: expert programs and artificial intelligence systems take control of situations out of human hands (this is especially true in military contexts, which reveal contemporary agents' relation to smart weapons systems (Gray, 1989; de Landa, 1991)); and we are now to have our own personal agents, and so on.

What are seemingly left behind in these cyberscenarios are both the technological actors making these changes possible and the bodies of those involved. Feminist cyborg theory made the body a political battleground (Balsamo, 1996; Haraway, 1991), but the discourses we have been examining in this article abandon the body in favour of a digital, linguistic, ephemeral agent. However, given the present proliferation of both technological actors and the increasing involvement of the body in new technological systems (both positively in terms of prosthetics and new possibilities for choice regarding one's body, and negatively in terms of repetitive strain injury, chemical and radiation poisoning, and so on), perhaps the question to ask is whether the predominant agency in social space is more technological than linguistic. In other words, that the focus on decorporealization masks important changes in the corporeal realm. Let me clarify here that I am not arguing that the body is real while the digital realm is false. Both are real, both have very real effectivity. What I *am* arguing is that both realms are inseparable. We cannot abandon one in favour of the other. Therefore discourses which attempt to do so are necessarily ignoring or masking other effects.

For example, abandoning the material realm to an electronic one helps one avoid discussing the very real problems that these electronic technologies are causing both industrially and globally (i.e. in the realm of atoms). Such ontological legerdemain ignores displaced, underemployed, temporary workforces that are exploited (and expanded) by the new information economy with its flexible, just-in-time management. As James Brook and Iain Boal have written in the Preface to their edited collection, *Resisting the Virtual Life* (1995: ix):

> The wish to leave body, time, and place behind in search of electronic emulation of community does not accidentally intensify at a time when the space and time of everyday life have become so uncertain, unpleasant, and

> dangerous for so many. . . . [T]he flight into cyberspace is motivated by some of the same fears and longings as the flight to the suburbs: it is another 'white flight'.

This new technology poses the risk of the further balkanization of the cyber-classes, a move which parallels the increase in elite gated communities in cities such as Los Angeles (Davis, 1990). For example, Negroponte (1995b: 153) discusses intelligent newspapers which feed us according to our special interests.

> Imagine a future in which your interface agent can read every newswire and newspaper and catch every TV and radio broadcast on the planet, and then construct a personalized summary. This kind of newspaper is printed in an edition of one.

And Mitchell writes: 'as networks and information appliances deliver expanding ranges of services, there will be fewer occasions to go out' (1995: 100). As this technology further distances users from the realities and politics of the body, and from the unwired transient workforce, it also displaces that workforce. The intelligent agent can be viewed as a labour-saving device. As such it necessarily displaces labour by performing the expertise and skills of labour.[10] The first victims of search engines, spiders and agents seem to be librarians. Fifteen library schools have closed since 1976 and the number of graduate degrees in library science have dropped by half in that time (Caulfield, 1997: 64). Librarians are being retrained from being public service-oriented archivists to being more corporate-inclined managers of information and databases. Agents are also poised to replace sectors of the service economy by automating features in banking (ATMs), shopping, and so on. But in addition, as with most of such devices, agents cause more labour by increasing normative expectations.[11] More can be accomplished with its help, so more *must* be accomplished. Within today's new technological assemblage we are busier than ever, and personally responsible for more information than at any other time in history. Agents become both a solution and a symptom of our information-glutted, hyperspeed world. But as agents become more efficient and fade into the woodwork, we will lose the opportunity to interrogate some of the social actors making the greatest impact on our lives.

In order for cultural studies to adequately describe and critique social and cultural life in the new wired world (a world which is geographically and economically specific despite global and universal claims), it needs to recognize and understand the changing mediation of technological agency and, more importantly, the shifting relations between technology and language, artefacts and discourse. Indeed, it is the stratification of technology and language that makes humans human (Deleuze and Guattari, 1987: 260; Wise, 1997). Technology and discourse, mediation and agency, are not somehow external to some essentialized

human identity, but rather constitute it. The question we should ask shouldn't be of the human *and* technology, but of the human *as* technology.

Rather than simply focusing on a stand-off between a person and a machine (and trying to determine on which side lies the central point of agency, the fulcrum of power on which the social rocks), perhaps we need to view the situation as the creation and functioning of an assemblage, a user–interface–machine assemblage (finger–screen–chip; face–headmount–processor) where the interface doesn't stand absolutely between the user and computer but is simply one element in the assemblage. This assemblage is articulated to other assemblages (at the ATM we have a person–car assemblage on one end and an ATM–phone network-bank assemblage on the other). These assemblages are stratified with (articulated to) assemblages of language which link discourses of freedom, agency, efficiency and consumerism.

In terms of agents, perhaps what we need to do is to re-embody the disembodied agent. Indeed, some have argued that seeing agents as embodied, as acting (and thinking) in response to a particular context, is the best way to continue to develop agents (see Steels and Brooks, 1995, and esp. Varela, 1995). Seeing cognition as embodied gets us out of the modern dichotomy described by Descartes that posits a unified thinking self and separates it from the world (Varela, 1995). By *embodied*, Francisco Varela (1995: 15) means:

> (a) that cognition depends on the kinds of experience that come from having a body with various sensorimotor capacities; and (b) that these individual sensorimotor capacities are themselves embodied in a more encompassing biological and cultural *context*.

This is a lesson not just for agent research and cognitive science but for cultural theory as well. Cultural studies is said to be marked by a radical contextualism (Grossberg, 1993), but we need to recognize that such contextualism implies embodiment, and the bodies that constitute the stuff of social space are technological as well as human. Further, to recognize this embodiment means to recognize that culture, power, values and ideology can be carried by material structures and technologies, and not just in the meanings we attribute to them or discourses about them, but in the ways that they bend our space and behaviour. Resistance, likewise, can reside in the negotiated style of our habits and movements in space.

Notes

1 An earlier version of this article was presented at the Society for Literature and Science Conference in Atlanta, GA, October 1996. I would like to thank Anne Balsamo for her comments on that draft and suggestions for revision.

2 I want to thank Phoebe Sengers for clarifying this distinction for me. Peter

Wayner (1995a) lists some of the more popular roles that have been attributed to agents: a good virus, a time saver, a personal shopper, a butler, a little person, a prodigy, a power librarian, an actor and a dancing mailman (pp. 10–11). Wooldridge and Jennings (1995) list four applications of agent technology: cooperative problem solving and distributed artificial intelligence, interface agents, information agents and cooperative information systems, and believable agents (which provide the illusion of life) (pp. 21–2).

3 Agents are also referred to as 'avatars', especially following science fiction author Neal Stephenson's book *Snow Crash*. However, one's avatar in cyberspace is usually directly controlled by the user and is therefore not a true agent in the sense developed in this article (see Halfhill, 1996).

4 See Mark Dery's (1996) survey of such discourses.

5 Andrew Leonard's (1997) book, *Bots: The Origin of New Species*, is (obviously, from its subtitle) grounded in Darwinian discourse, though he sees less inherent progression than others, that survival of the fittest doesn't necessarily make things better (p. 186).

6 A related concern often brought up briefly in discussions about agents is the question of responsibility: Who is responsible for an agent's actions? For example, what if I didn't want the tickets that my agent just purchased; do I still have to pay for them? What if my agent damaged or compromised someone else's computer? Is it my fault or the agent's fault? Though these questions are raised frequently (often, it seems, to show that the essay writer is somewhat conscious of the social implications of technology), they are never answered or dealt with at any length. One attempt to do so is Krogh's (1996) discussion of agents as legal entities.

7 Anthony Giddens has argued that trust in large-scale institutions and technologies is a hallmark of the modern (1990).

8 The gendering of the term 'butler' is deliberate as most representations of intelligent agents are male. However, Sandy Stone (1995) discusses the creation of an agent at the Atari Lab that was deliberately gendered male to avoid the stereotypes of secretaries as always female.

9 I deal with technological and linguistic agency much more extensively in Wise, 1997.

10 Cf. David Noble (1986), who explores the displacement of labour on the factory floor with the introduction of numerically controlled machine tools, that is, industrial robots.

11 For a historical perspective on the paradoxes of labour-saving technology in the home, see Ruth Cowan, 1983.

References

Appadurai, A. (1996) *Modernity at Large: Cultural Dimensions of Globalization*, Minneapolis: University of Minnesota Press.

AT&T (1993) *Connections* (promotional video).

Balsamo, A. (1996) *Technologies of the Gendered Body: Reading Cyborg Women*, Durham, NC: Duke University Press.

Berkun, S. (1995) 'Agent of change' (Interview with Pattie Maes). *Wired*, April: 116–17.

Berland, J. (1997) 'Cultural technologies and the "evolution" of technological cultures', Paper presented at the International Communication Association Conference, Montreal, May.

Boden, M. (1996) 'Introduction', in M. Boden (ed.) *The Philosophy of Artificial Life*, New York: Oxford University Press: 1–35.

Bolter, J. D. and Grusin, R. (1996/published 1997) 'Remediation', *Configurations*, 4(3): 311–58.

Brandt, R. (1994) 'Agents & artificial life', *Business Week*: 64–5.

Brook, J. and Boal, I. (eds) (1995) *Resisting the Virtual Life: The Culture and Politics of Information*, San Francisco, CA: City Lights.

Bukatman, S. (1993) *Terminal Identity: The Virtual Subject in Postmodern Science Fiction*, Durham, NC: Duke University Press.

Callon, M. and Latour, B. (1981) 'Unscrewing the big Leviathan: how actors macro-structure reality and how sociologists help them do so', in K. Knorr-Cetina and A. Cicourel (eds) *Advances in Social Theory and Methodology: Toward an Integration of Micro- and Macro-sociologies*, Boston, London and Henley: Routledge & Kegan Paul: 277–303.

Caulfield, B. (1997) 'Morphing the librarians: fighting off extinction in the information age', *Wired*, August: 64.

Cowan, R. S. (1983) *More Work for Mother: The Ironies of Household Technology From the Open Hearth to the Microwave*, New York: Basic Books.

Davis, M. (1990) *City of Quartz: Excavating the Future in Los Angeles*, New York: Verso.

de Certeau, M. (1984) *The Practice of Everyday Life*, trans. S. Randall, Berkeley: University of California Press.

de Landa, M. (1991) *War in the Age of Intelligent Machines*, New York: Zone.

Deleuze, G. and Guattari, F. (1987) *A Thousand Plateaus: Capitalism and Schizophrenia*, trans. B. Massumi, Minneapolis: University of Minnesota Press.

Dery, M. (1996) *Escape Velocity: Cyberculture at the End of the Century*, New York: Grove Press.

Drew, J. (1995) 'Media activism and radical democracy', in J. Brook and I. Boal (eds) *Resisting the Virtual Life: The Culture and Politics of Information*, San Francisco, CA: City Lights: 71–83.

Elmer, G. (1997) 'Spaces of surveillance: indexicality and solicitation on the Internet', *Critical Studies in Mass Communication*, 14(2): 182–91.

Giddens, A. (1990) *The Consequence of Modernity*, Stanford, CA: Stanford University Press.

Gray, C. H. (1989) 'The cyborg soldier: the U.S. military and the post-modern warrior', in L. Levidow and K. Robins (eds) *Cyborg Worlds: The Military Information Society*, London: Free Association Books: 43–71.

Grossberg, L. (1993) 'Cultural studies and/in new worlds', *Critical Studies in Mass Communication*, 10(1): 1–22.

Hafner, K. (1995) 'Have your agent call my agent', *Newsweek*, 27 February: 76–7.

Halfhill, T. (1996) 'Agents and avatars', *Byte*, February: 69–72.

Haraway, D. (1991) *Simians, Cyborgs, and Women: The Reinvention of Nature*, New York: Routledge.

Hebdige, D. (1988) *Hiding in the Light: On Images and Things*, New York: Routledge.

Indermaur, K. (1995) 'Baby steps', *Byte*, March: 97–104.

Kantrowitz, B. (1994) 'The butlers of the digital age will be just a keystroke away', *Newsweek*, 17 January: 58.

Kelly, K. (1995) *Out of Control: The New Biology of Machines, Social Systems and the Economic World*, New York: Addison-Wesley.

—— (1996) 'What would McLuhan say?' (Interview with Derrick de Kerckhove), *Wired*, October: 148–9.

Krogh, C. (1996) 'The rights of agents', in M. Wooldridge, J. P. Müller and M. Tambe (eds) *Intelligent Agents II: Agent Theories, Architectures, and Languages: IJCAI'95 Workshop (ATAL), Montreal, Canada, 19–20 August 1995: Proceedings*, New York: Springer Verlag: 1–16.

Langton, C. G. (1996) 'Artificial life', in M. Boden (ed.) *The Philosophy of Artificial Life*, New York: Oxford University Press: 39–94.

Lanier, J. (1996) 'Agents of alienation', Http://www.voyagerco.com/misc/jaron.html

Latour, B. (1988) 'Mixing humans and nonhumans together: the sociology of a door closer', *Social Problems*, 35: 298–310.

—— (1993) *We Have Never Been Modern*, trans. C. Porter, Cambridge, MA: Harvard University Press.

Leonard, A. (1997) *Bots: The Origins of New Species*, San Francisco, CA: HardWired.

Maes, P. (1995) 'Intelligent software', *Scientific American*, September: 84–6.

—— (1996) 'Intelligent agents = stupid humans, post 2', *Hotwired: Braintennis*, 16 July, Http://www.hotwired.com/ braintennis/96/29/index1a.html

Mitchell, W. (1995) *City of Bits*, Cambridge, MA: MIT Press.

Negroponte, N. (1995a) '000 000 111 – Double agents', *Wired*, March: 172.

—— (1995b) *Being Digital*, New York: Knopf.

Noble, D. (1986) *Forces of Production: A Social History of Industrial Automation*, New York: Oxford University Press.

Norman, D. (1994) 'How might people interact with agents', *Communications of the ACM*, 37(7): 68–71.

Riecken. D. (1994) 'A conversation with Marvin Minsky about agents', *Communications of the ACM*, 37(7): 23–9.

Slotkin, R. (1985) *The Fatal Environment: The Myth of the Frontier in the Age of Industrialization, 1800–1890*, New York: Atheneum.

Star, S. L. (1991) 'Power, technology, and the phenomenology of conventions: on being allergic to onions', in J. Law (ed.) *A Sociology of Monsters? Power, Technology, and the Modern World*, Oxford: Blackwell: 27–57.

Steels, L. (1995) 'Building agents out of autonomous behavior systems', in L. Steels and R. Brooks (eds) *The Artificial Life Route to Artificial Intelligence: Building Embodied, Situated Agents*, Hillsdale, NJ: Lawrence Erlbaum Associates: 83–121.

Steels, L. and Brooks, R. (eds)(1995) *The Artificial Life Route to Artificial Intelligence: Building Embodied, Situated Agents*, Hillsdale, NJ: Lawrence Erlbaum Associates.

Stone, A. R. (1995) *The War of Desire and Technology at the Close of the Mechanical Age*, Cambridge, MA: MIT Press.

Varela, F. (1995) 'The re-enchantment of the concrete: some biological ingredients for a nouvelle cognitive science', in L. Steels and R. Brooks (eds) *The Artificial Life Route to Artificial Intelligence: Building Embodied, Situated Agents*, Hillsdale, NJ: Lawrence Erlbaum Associates: 11–22.

Virilio, P. (1991) *The Lost Dimension*, trans. D. Moshenberg, New York: Semiotext(e).

Wayner, P. (1995a) *Agents Unleashed: A Public Domain Look at Agent Technology*, New York: AP Professional.

—— (1995b) 'Free agents', *Byte*, March: 105–14.

Wayner, P. and Joch, A. (1995) 'Agents of change', *Byte*, March: 94–5.

Williams, R. (1974) *Television: Technology and Cultural Form*, New York: Schocken.

Winner, L. (1977) *Autonomous Technology: Technics-out-of-control as a Theme in Political Thought*, Cambridge, MA: MIT Press.

Wise, J. M. (1997) *Exploring Technology and Social Space*, Thousand Oaks, CA: Sage.

Wooldridge, M. and Jennings, N. (1995) 'Agent theories, architectures, and languages: a survey', in M. Wooldridge and N. Jennings (eds) *Intelligent Agents: ECAI–94 Workshop on Agent Theories, Architectures, and Languages, Amsterdam, Netherlands, 8–9 August 1994: Proceedings*, New York: Springer Verlag: 1-39.

Charles R. Acland

IMAX TECHNOLOGY AND THE TOURIST GAZE

Abstract

IMAX grew out of the large and multiple screen film experiments produced for Expo '67 in Montréal. Since then, it has become the most successful large format cinema technology. IMAX is a multiple articulation of technological system, corporate entity and cinema practice. This article shows how IMAX is reintroducing a technologically mediated form of 'tourist gaze', as elaborated by John Urry, into the context of the institutions of museums and theme parks. IMAX is seen as a powerful exemplar of the changing role of cinema-going in contemporary post-Fordist culture, revealing new configurations of older cultural forms and practices. In particular, the growth of this brand of commercial cinema runs parallel to a blurring of the realms of social and cultural activity, referred to as a process of 'dedifferentiation'. This article gives special attention to the espistemological dimensions of IMAX's conditions of spectatorship.

Keywords

cinema; epistemology; postmodernism; technology; tourism; spectatorship

Technologies and institutional locations of IMAX

ONE OF THE first things you notice at the start of an IMAX film, after the suspenseful atmosphere created by the muffled acoustics of the theatre, and after you sink into one of the steeply sloped seats and become aware of the immense screen so close to you, is the clarity of the image. As cinema-goers, we are accustomed to celluloid scratches, to dirty or dim projections, and to oddly ubiquitous focus problems. The IMAX image astonishes with its vibrant colours and fine details. Much in the fashion that film realism always dreamed of its

possibilities, it is easy to mistake the IMAX screen for a wonderful, varying window on to real and imagined worlds. *The Living Sea* (Greg MacGillvary, 1994), an IMAX documentary about the majesty and fragility of the world's oceans, is notable less for its eco-friendly message than for the schools of multicoloured fish, edited and composed in constrasting fashion so that their fluid movements are like watching a firework display. Other images compete for the educational theme of *The Living Sea*, especially IMAX's stock point of view travelling camera shots, here used to fly over ocean islands, to swim through underwater seascapes, and to participate in a coastguard practice rescue mission. This is not to suggest that these powerful images are incompatible with Meryl Streep's gentle narration about the interconnectedness of oceanic life; rather, through the size and clarity of the image emerges a kind of postcard environmentalism, in which grand vistas of landscapes and animal life appear to be literally brought before you. As the audience learns about 'the living sea', they also experience the pleasure of spectatorial centrality, finding that the power of the IMAX gaze is a mastery over the film subject.

Paul Virilio (1990) describes IMAX as a form of 'cataract surgery' that essentially grafts its screen upon the eyes of spectators. In his view, IMAX's total encompassing of the field of vision collapses human sight into both filmic and architectural space; the theatre and the images merge with the audience's senses such that the only point of orientation left is that provided by the film. Virilio indicates that this brings IMAX back in time to the origins of motion pictures, back to the fairgrounds of the late nineteenth and early twentieth centuries. The stunning films of IMAX and the special viewing situation reignite the early experience of filmic realism – the shock of movement and the sensation of 'being there'. But this return, a full century after the Lumière Brothers and through the hegemony of Hollywood realist conventions, has some striking differences. What does IMAX restructure, and what does it offer as a practised space? What then of its form and economy? This article shows how IMAX is reintroducing a technologically mediated form of tourist gaze into the context of the institutions of museums and theme parks. While focusing upon those two institutions of both public education and touristic activity, IMAX is also a powerful exemplar of the changing role of cinema-going in contemporary post-Fordist culture. In this respect, the case of IMAX reveals new configurations of older cultural forms and practices, and how the conditions of spectatorship are woven into the new arrangement.

IMAX Corporation grew out of the large format and multiple screen films produced for Expo '67 in Montréal. Graeme Ferguson, Robert Kerr and Roman Kroiter, encouraged by the success of their experiments, formed a private corporation to explore the possibilities of large format cinema further. Their strong ties to the National Film Board of Canada meant that there would be a history of appropriating personnel, and with them, thematic and aesthetic concerns; this would be substantial enough for IMAX to be reasonably considered an unofficial

spawn of the NFB. Fuji commissioned the first IMAX film, *Tiger Child* (Donald Brittain, 1970), for its pavilion at Expo '70 in Osaka. The first permanent IMAX theatre, Ontario Place's Cinesphere in Toronto, opened in 1971. Two years later, IMAX opened its first IMAX DOME, or OMNIMAX at the Reuben H. Fleet Space Center in San Diego, with its larger, curved screen and a projector that sits in the middle of the theatre. As of March 1994, there were 121 permanent IMAX theatres in twenty countries, and a backlog of thirty-five new theatres awaiting completion. While remaining based in Toronto, a US investment group, WGIM Acquisition Corporation, purchased IMAX in 1994.

The IMAX experience is an amalgam of a number of cinematic innovations. With the standard IMAX film, the image is eight storeys high and thirty metres wide, making it approximately ten times that of a 35mm film. This is achieved by taking 70mm film stock, turning it on its side, and using fifteen perforations (the sprocket holes on the side of the celluloid) to designate each frame. The physical dimensions of the film necessitated not only the construction of specific cameras and cinemas, but also new ways to project the image. The film itself is so heavy that it could not move smoothly through a projector in a vertical position. Instead, the film lies horizontally, on a flat-bed, with the IMAX patented 'rolling loop' – a wave-like action – moving each frame through the projector. This atypical cinema experience effectively imprints the corporate logo upon every frame; unlike conventional cinema, it is impossible to forget you are watching IMAX technology.

The IMAX experiment is incomplete. It is not a stable set of technological structures in which a form of monumental documentary resides. Instead, IMAX must be seen as a multiple articulation of technological system, corporate entity and cinema practice invested in the notion of expanded cinema, or what Andre Bazin (1967) called the myth of total cinema. Bazin's claim was that an idea about reducing the distictions between the screen world and the real world fuels film's drive towards realism. Because the ultimate confusion between the mediated and the unmediated is still a long way off, he concluded that the cinema has not yet been invented, but instead is a symptom of that tendency. IMAX, however, takes us another step towards Bazin's objective. Barring the various critiques of Bazin, and of realism as the 'essence' of motion pictures, IMAX is unambiguously a film technology and form designed to create the experience of being there, or getting there, for spectators. Its goal is one of simulation, of hyper-realism, of producing images so real that they offer an illusion of material presence, and of creating the sensation of movement for its spectators. This leads IMAX to continue technological development to improve upon the illusion. The conventions of film realism, cinema vérité and continuity editing are never part of the IMAX promotional material; instead, it refers to the technological innovations in screen size, film stock, film speed, screen curvature, 3-D and architecture. In the end, this becomes its own best argument for investment in its technology; only IMAX film systems can create IMAX film realism.[1]

The corporation's revenues come from four main sources: long-term theatre system leasing, maintenance agreements for the systems, film production, and film distribution. Until 1988, most of the IMAX theatre systems were sold, with IMAX owning and operating but a handful. IMAX, however, found selling the systems outright left them with no control over the quality of the theatre environment, which occasionally deteriorated substantially. The possibility of greater revenue through leasing arrangements, coupled with the desire to maintain a particular 'family-oriented' image for the company, led to a shift away from the sale of their systems. Currently, leasing and maintenance agreements are the key source of revenue for IMAX, accounting for over 50 per cent. Put differently, IMAX is largely in the business of leasing its patented technology for film projection. There are over a hundred films in the IMAX film library, though the company has distribution rights to only thirty-nine (in 1994) of them. To date, the most successful film has been *The Dream is Alive* (Graeme Ferguson, 1985), filmed on a space shuttle, which has grossed over $US 100 million. IMAX also generates revenue from the commissions it receives to produce films, for clients including Lockheed Corporation, the Smithsonian Institute, and the Government of Canada. The rental of IMAX cameras and expertise to other filmmakers is another aspect of their operations.

IMAX's tight vertical intergration means that it is involved in production, or in benefiting from production through equipment rental, receiving commissions to produce films, distributing films, renting and maintaining the theatre systems, and even collecting admissions receipts at the theatres it owns. In this light, the films feed the core of the business, which is leasing and maintaining the technological infrastructure itself. Or, to use the current language of the film business, the software of film feeds the hardware of distribution and technological structures. With this focus upon the technological system (indeed, until 1990, the corporation was called IMAX Systems), it is not surprising to see the IMAX cameras so frequently in the films themselves; technological self-reflexivity relates to the very heart of its business.

In as much as the system's renters represent the principal clients for IMAX, as opposed to IMAX-goers or film financiers, the renters' conceptions of what kinds of films are appropriate play a significant role in IMAX film production. It follows that the location of the theatres, and their association with other investments, activities and practices, is a key determining feature for the films IMAX makes and for the role IMAX plays in contemporary culture. The majority of IMAX theatres are situated at institutional sites; the content of the films reflects this historical relation. In 1994, museum sites accounted for 59 per cent of all IMAX theatres, theme parks accounted for 18 per cent, 3 per cent were zoos and aquaria, and the remaining 20 per cent were commerical sites and 'destination complexes', which refers to high-concept shopping malls. For the theatres scheduled to open over the next two years, the biggest jump is in the final category, which accounts for 29 per cent of the current backlog. Examples of

prominent locations include the Kennedy Space Center in Florida, the Museum of Science and Industry in Chicago, the Smithsonian's National Air and Space Museum in Washington, DC, the Canadian Museum of Civilization in Hull, the Grand Canyon National Park, four theatres at the Futuroscope complex in Poitiers, France, The Science Museum in Osaka, the Singapore Science Center, the Swedish Museum of Natural History in Stockholm, and the National Museum of Natural Science in Taichung, Taiwan.[2]

Given IMAX's historical association with museums, it is not surprising to see documentary and educational films predominate the IMAX film library. A deal with Capital Cities/ABC to make education films assures that this direction will continue (Noble, 1994). Recent moves towards fiction film, however, coupled with IMAX's attempts to bring its business closer to Hollywood, has developed a strained relationship with the more traditional institutional locations. Some museums, including the Natural History Museum in New York and the Air and Space Museum in Washington, refused to show the popular IMAX concert film *Rolling Stones: 'At the Max'* (Julian Temple, 1991) because it was seen as inappropriate to the museum's mandate. A more ambitious move into narrative film, and 3-D, is *Wings of Courage* (Jean-Jacques Annaud, 1995), about Antoine de St Exupery and other pilots in 1930s Argentina, starring Val Kilmer, Tom Hulce and Elizabeth McGovern. Other similar developments include a deal with Sega Enterprises to build two motion simulators, or 'ride-films' (Enchin, 1995c) and with Sony to construct two new IMAX 3-D theatres at Sony's movie theatre entertainment complexes in San Francisco and Berlin (IMAX Corporation, 1995). This follows Sony's success with IMAX 3-D at its Lincoln Square theatre complex in New York. As these corporate arrangements show, the shift from a strictly educational emphasis to a mixed educational and entertainment format occurs not with the production of films alone, but with the construction of new theatres situated in different institutional locations. Consequently, this represents not only a new aesthetic and market concern, but also an articulation with cultural practices other than those of museum-going. In effect, the experience of IMAX is becoming more generalized in the culture, and less associated with education and the museum specifically.

Epistemology of the panoramic view

In his pre-history to the 'society of the spectacle', Jonathan Crary argues that vision becomes a kind of work, subject to a certain discipline, during the onset of modernity (1990: 18). The problem of the observer, a term that connotes 'to comply with' better than the related term 'spectator', 'is the field on which vision in history can be said to materialize, to become itself visible. Vision and its effects are always inseparable from the possibilities of an observing subject who is both the historical product *and* the site of certain practices, techniques, institutions,

and procedures of subjectification' (Crary, 1990: 5). Anne Friedberg (1993) has commented specifically on motion pictures' association with zones of cultural and commercial practice, linking the visual experience of cinema with that of window shopping. The result, she argues, has been the formation of a 'mobile virtual gaze', where the browsing of shopping and the varying gaze of cinema engender similar social relations. It is suggested by both Crary and Friedberg, among others, that modes of visuality provide a certain access to the world not only through what is seen, but how it is seen in the context of specific technologies and institutions. Technologies of visualization are a structured relation between the human senses and knowledge production, fashioned by and operating within systems of social and institutional relations; they make discursive powers themselves visible, and in this way provide access to historiographic claims about what it meant to look with modern eyes.[3]

Wolfgang Shivelbusch (1979) describes the reconstruction of city and country space with the introduction of rail travel in the mid-nineteenth century. He argues that rail travel as a new form of mass mobility also presented a panoramic perspective upon the modernizing world. The view from the train was one of both access to changing vistas, and a movement through them, as well as a detached and distant spectatorial relation. The train offers views of 'an evanescent landscape whose rapid motion makes it possible to grasp the whole, to get an *overview*' (Shivelbusch, 1979: 63). Shivelbusch sees the view from the train as a new European perspective that is found in other popular forms. For instance, 'What the opening of major railroads provides in reality – the easy accessibility of distant places – was attempted in illusion, in the decades immediately preceding that opening, by the "panoramic" and "dioramic" shows and gadgets' (1979: 64). Though the relation characterized by Shivelbusch is said to typify the modern, it also seems to capture the conventional postmodern quality of a collapse between actual travel and the illusion. In this way, Baudrillard's (1988) comment that the panoramic experience of highway driving is in fact cinematic is better understood as a continuation of long-standing similar relations between travel and representation.

Drawing upon the particularities of nineteenth-century bourgeois perception, IMAX continues to insist upon spectatorial primacy as a form of knowledge. It is to our age what the Panorama and Diarama were to their time.[4] The orchestration of the all-engulfing image places viewers in a central location as a source for the unfolding of a known and organized world; the panoramic overview is equally an educational technique to present that vision of the world to an as-yet uninitiated audience or public. The characteristics of this form of bourgeois perception, then, involve the extention and reproduction of that worldview. For this reason, the image of spectatorial centrality is ideologically linked to the reinstatement of certain forms of epistemological power.

Historically, the museum has been one institution built around particular dominant epistemological structures and their arrangement for mass audiences.

As Tony Bennett (1990) has discussed, the core discursive element of the museum has been the democratization of knowledge and a desire to maintain a fix on the forms of knowledge presented. The modern museum matched, and often mismatched, a general Enlightenment principle of human universality with a highly regulated and policed civic space. Codes of public behaviour, including their surveillance and discipline, defined the museum as much as discourses of openness and accessibility. This has frequently taken the form of developing and enforcing a set of practices which guide the encounter between museum visitors and displays, hence between patrons and the museum's tacit classificatory framework. As Bennett (1990: 44–5) puts it,

> The purpose, here, is not to know the populace but to allow the people, addressed as subjects of knowledge rather than as objects of administration, to know; not to render the populace visible to power but to render power visible to the people and, at the same time, to represent to them that power as their own.

Museums are very different institutions today, though traces of their earlier nineteenth-century formation are amply evident, and IMAX is consonant with the museum's new relations between entertainment and education. On this shifting stake, Robert Lumley observes that one of the central dilemmas of the modern museum is to determine whether or not 'museums are to have a cultural role as distinct from that of the theme park', and if so, how (1988: 18). The panoramic view of IMAX is part of the new populism of museum sites, in their slide towards the amusement park as a model and in the development of expectations about museum visits. It is part of the museum's shifting stake in the idea of guiding people towards a systematic understanding of the world; it maintains similar forces of subjectification, yet it erodes traditional ideas about education with its powerful brand of sensory pleasure. In other words, IMAX is more than a bit of flashy bait to get people into a dying institution; it promotes a discursive relation, and a specifically technological one, between a public and its education. And the very nature of its panoramic realism, which encourages a collapse of the referent and the reference, reasserts a modern, disciplined, visual relation and code of civic behaviour. To adopt the IMAX gaze is to find oneself firmly interpellated into an epistemological purview that covers both the museum and new entertainment technologies.

IMAX films soar. Especially through the simulation of motion, they encourage a momentary joy in being placed in a space shuttle, on a scuba dive, or on the wing of a fighter jet. For IMAX, 'being there' is most often thought of in terms of a sensation of movement; ironically, it is the induced sensation of travel, rather than arrival at a location, that prompts the claims of hyper-presence. The most conventional ways to construct this relation in IMAX are through point of view camerawork, rapid travelling movements and the use of dizzying heights.

The shots remain steady, for even the slightest tilt or jiggle can be felt in the stomach. Canted camera shots appear only to create the sensation of turning, at which point the audience invariably tilts as well. It is no surprise that flight is a key subject for IMAX; they have explored a remarkable variety of the educational aspects of flight, from its history to the space shuttle and into fiction with *Wings of Courage*. IMAX also habitually presents aerial photography as a way to survey other subjects, especially landscapes. The centrality of flight has been built into one of IMAX's cinemas in Poitiers. The innovation here is that the cinema has a transparent floor through which the audience can look at a second screen below their feet, running in sync with the vertical one in front. They have called this the IMAX MAGIC CARPET.

What happens as the films soar over their subject? Where the thrill(!) of air-sickness is an indication of a successful mediation between the viewer and the filmic material, what has IMAX's panoramic overview accomplished? First, it provides a survey, which includes an attempt to visually apprehend the whole world. Benedict Anderson (1991) has remarked upon the relationship between census-taking and the formation of nationhood, where the collection of population data is not just a form of surveillance but also an exercise in asserting the legitimate power to construct images of a citizenry by centralized, and centralizing, institutions. Similarly, IMAX's massive screen and travelling camera construct an idea of totality, leading to the question, 'What more could there be?' This visual and physical exhaustion has correspondences to what Foucault (1970) has pointed out as the modern epistemological project of 'ordering things' through 'les mots et les choses'.

Second, the panoramic survey has the result of arranging and squeezing diverse terrains and distant locations into a central place in the film, in the IMAX theatre. Unlike Shivelbusch's description of rail travel, IMAX offers movement without moving, tourism without travel, and effects a brand of geographical transformation akin to that of map-making. The sequence of images puts forward an argument of geographic centrality to the spectator; the order, and the sensory experience of that order, releases a foundational myth of tourism and museums alike – that of the encounter with distant lives and places, but always through a set of ordering and structuring principles. In the end, IMAX similarly writes a geographical relation in which distance does not matter and in which the organiz-ation of sites is always possible in and through its technological system. This geo-graphical transformation through representation is inextricably linked to the museum's collapse into theme park markets and strategies. I suggest, as will be developed in what follows, that the discursive matrix of IMAX represents a new generalizability to the tourist gaze and its associated cultural practices.

IMAX and touristic anticipation

The Grand Canyon Tourist Center boasts an IMAX theatre which presents *Grand Canyon: The Hidden Secrets* (Keith Merrill, 1984) thirteen times a day in the summer, and nine times a day in the winter. The promotional brochure explains that the seventy-foot high screen and the six-track sound allow visitors to 'discover in only 34 minutes a Grand Canyon that would take a lifetime to experience'. The two photographs on the brochure provide an interesting contrast. One is an image of the tourist information centre and its parking lot. The other is a still from the IMAX film, denoted by the sprocket holes added along the top and bottom of the image, with a photograph of rapids literally spilling out of the frame. Nothing designates the location of the tourist centre in the image; it is generic and could be at virtually any tourist attraction. By contrast, the brochure presents the Grand Canyon as it exists on IMAX. The film begins with Anasazi culture, then moves on to conquistador De Cardena's 1540 impressions, and finally to John Wesley Powell's 1869 explorations. This simple narrativization of historical events is familiar to the IMAX screen; beyond the breathtaking images of the natural wonder in the documentary is a colonialist and orientalist story of discovery and first encounters with strange, native cultures. And to round out the introduction to the famous national park, the visitors' centre offers 'native americans in traditional dress on staff' and a Taco Bell restaurant.

IMAX is multiply positioned in discourses of tourism. First, as an unusual cinema experience, it is itself a tourist attraction, one that often requires a certain amount of travel and 'departure' to encounter. For instance, as of March 1994 there was only one IMAX cinema in the UK, one in Indonesia, three in Australia, and none in Canada east of Montréal. Unlike the relative proximity of conventional cinema-going, IMAX remains an extraordinary form associated with a special trip. Second, as noted above, the cinemas are often found at what could be broadly described as tourist sites such as museums and amusement parks. In this respect, IMAX is part of an overall tourist outing, playing a role in the journey as one element in a day's activities, as opposed to the destination *per se*. One does not plan a vacation around the Grand Canyon IMAX; one goes to the Grand Canyon, where the IMAX is one of the many tourist-related experiences available to sample. Third, IMAX typically offers views to other locations and attractions. Its cinema of 'transportation' promises a form of virtual tourism, and invites an understanding of distant locations. For instance, IMAX strategically placed at a tourist attraction might use thematically appropriate films, as is the case with the Grand Canyon IMAX offering year-round screenings of IMAX's *Grand Canyon*. Indeed, as a potential first stop for the visitor, the film presents an ideal encounter with the natural wonder. The swooping cameras, the high perspective surveying the vastness of the canyon, the clear and powerful musical score, create an awe-inspiring sensation that may contribute to and compete with the site itself. Of course, the film's drama of discovery and colonization lives with

the tourist as a way of narrativizing the visit and one's impressions. As John Urry points out, a key aspect of tourism is the construction of anticipation of the experience, and further, 'Photographic images organize our anticipation or day-dreaming about the places we might gaze upon' (1990: 140). Here, IMAX's mode of representation helps form the potential encounter, in effect establishing or priming what Urry calls the systematized and socially constructed gaze of the tourist. In short, IMAX's stake in the tourist gaze is that it constructs a tourist attraction as a view to tourism itself.

Turning to Daniel Boorstein (1964), and even Jean Baudrillard (1983), one would conclude that sites like the Grand Canyon IMAX are typical pseudo-events – or, in this case, what might be called pseudo-visits – which feed a need for safe inauthenticity. In effect, in this view, IMAX helps to insulate tourists from the (un)realities of their world. Instead, I would suggest that IMAX coincides with what Urry (1990) elaborates as the 'post-tourist' who revels in and seeks out the inauthenticity of such pseudo-visits, contrary to what Boorstein characterizes as a retreat. Even more compelling is Dean MacCannell (1976), who emphasizes the touristic occasion as a form of quest for authenticity, in which reified social relations are enacted and reinforced. In this view, the 'real' of IMAX as a tourist site is not the filmic material, not the images of the Grand Canyon, but the rapid tour 'backstage' after the film to see the mechanics of projection and, most impressively, the absence of more than an attendant or two to operate the auto-mated system.

It is my view, however, that the Grand Canyon IMAX is not about the fake or the inauthentic, but that, like the nineteenth-century train, it is one touristic activity that mediates and structures the entire visit. Trips to the Grand Canyon are still made, but they are made with the assistance of other institutions that guide the encounter. For this reason, IMAX is best understood as an example of what Urry (1990) describes as a shift towards post-Fordist forms of tourist prac-tices and economies. This develops in the context of forms of flexible special-ization, of international finance, and of new economic relations among national markets. The tourist industry has been democratized in certain ways throughout the twentieth century; its emphasis upon service products, its construction of the 'flight' from the work week and its privileged encounter with otherness, with the exotic, make it a key player in the postindustrial economy. Further, tourism's current tendency to expand into virtually any realm of social life, through an alchemic process by which every place and event has the potential, with the right development, promotion and merchandizing, to be transformed into a cash cow tourist attraction, only heightens its pervasiveness.

The tourist gaze marks an access point to the formation of knowledge about otherness. It 'presupposes a system of social activities and signs which locate the particular tourist practices, not in terms of some intrinsic characteristics, but through the contrasts implied with non-tourist social practices, particularly those based within the home and paid work' (Urry, 1990: 2). Tourism refers to a form

of visitation and encounter with the unfamiliar; it is a departure from the every-day, in terms of both space (physical movement to other locations) and time (designated travel or tourist times like weekends, annual vacations and holidays). The 'tour' suggests a circuit which both guides one away, instructs about the journey, and leads one back.

What then of tourism in the context of changing relations of distance, space and time? What of tourism without travel, as offered by IMAX? In other words, if the very notion of 'departure' no longer refers to the same set of practices and experiences, then we must think about the very concepts of tourism. David Harvey (1990), like other postmodern critics, reminds us that the experience of geography is primarily a form of simulacrum in which the world can figure in its entirety. Potential tourists can anticipate virtually anywhere, which suggests that the postmodern condition is not only one of geographic collapse that provides a sense of proximity to the globe, but that there is a relation of access to it, either through images or actual visitation. While some imply that the distinction between travel and images of travel is being eroded as post-tourism becomes the norm, the existence of each remains, given an unequal distribution of who has the resources to move between the realm of a mediated representational encounter to actual travel, from the pseudo-visit to the visit. Janet Wolff (1985) and Meaghan Morris (1988) have both addressed the especially masculinist access to travel, as well as theory's romantic privileging of nomadic life over domestic space, which once again constructs a crude negatively valued feminine sphere against the 'freedom' of male wanderings. To extend this argument, the power to move throughout the globe, as structured by the materiality of class, race and gender, additionally appears in and is constructed by representational forms. A simple point, perhaps, but one worth emphasizing: while there are material structures guiding touristic practices, those structures are also embricated in dis-courses of tourism. One essential element that both virtual and actual touristic forms share is that they are irreducibly lodged in the tourist gaze, one that through its imagined apprehension of the globe pertains to both the construc-tion of anticipation (i.e. knowledge) and availability (i.e. domination).

IMAX echoes other touristic pleasures and representational forms which, broadly defined, could range from roller-coasters to virtual reality. Hence, sight-seeing, travel writing (Burke, 1978; Said, 1978) and even localized resorts, such as Blackpool (see Bennett, 1983; Thompson, 1983), are all important precursors to the cultural forms that are currently developing around the mediation of IMAX's travel cinema. In the history of sightseeing, Judith Adler suggests that the conventions of travel writing were part of a project to 'survey all of creation' (1989: 24). IMAX coincides with that articulation of the grand epistemological project of the Enlightenment, and its related colonialist impulse, in the context of collapsing spheres of tourism, museums and theme parks.

Urry concludes that 'contemporary societies are developing less on the basis of surveillance and the normalisation of individuals, and more on the basis of the

democratisation of the tourist gaze and the spectacle-isation of place' (1990: 156). It is difficult to rank the two, and certainly Urry seems to underemphasize the saturation of surveillance in contemporary life. But he is right to remind us that the tourist gaze is no longer a specialized relation; rather, that it is a model for cultural relations for a broad spectrum of social activity. As the industries of the global movement of bodies and images expand, some continue to celebrate a democratization of tourism; I want to emphasize instead a distribution and reinvestment of the forces of orientalism and colonization.

Transnational culture and the destination complex

IMAX is one historical extension of Canadian cinema, bringing together the strong documentary and experimental film traditions, emerging from a mix of public and private cultural funding, and continuing a tradition of national cinema which has its sights set on international markets.[5] Arguably the most successful Canadian cinema practice, and certainly the most ambitious in its development of specifically designed elements for every stage of production, distribution and exhibition, IMAX also took the next logical step, one that makes it an even better exemplar of the state of national cinemas in the context of international cinema markets: it was bought by a consortium of US investors. What at one time may have been a paradox is no more; today, it is axiomatic that the forces which elevate a culture industry will tend towards its increasing distance from the national domain. Success invariably refers to the dispersal of a corporation into the ether of international finance. In its place are the supposedly obvious proposals of corporate location, as in IMAX's 'Toronto-based' operations. This takes for granted a culture industry logic that the maintenance of local jobs is all that is at stake in questions of national culture. Ultimately, there is no long-term reason for a business to be in any one location, which means that all those forces promoting the international competitiveness of Canadian culture industries may in fact finally succeed in making them so mobile that they depart from the scene altogether. In this context, transnational ownership tries to present itself as a phantom itch – you feel it but it's not really there, supposedly. Few are fooled by this, which is one reason why a city or province's ability to attract international business has become a contemporary political obsession in Canada.

This is not to say that I think IMAX headquarters will leave Toronto at any time in the near future, and in this way sever the last of its historical ties to Canadian cinema practice. However, in a world of the increasing mobility of capital, the very possibility of departure plays to a grander necessity for city, provincial and federal governments to make their home a comfortable one for potentially transient business endeavours. As the many theorists of postindustrial capitalism point out, the relationship between local investment and transnational flow of capital lead to an ever tenuous expectation about the future economic strength

of a region. When this involves a culture industry, the very texture of community life, whether at a city or national level, is worn away, sending ripples of deterioration far beyond those of employees and investors; it sends them on into the heart of civic and intellectual existence.

But even with the ever more abstracted nature of industry, cultural life still touches ground and materializes in particular locations. For IMAX, it is the theatre itself. As a budding transnational cultural player, IMAX is equally an emblem of a certain tendency in US film. In the context of the decreasing irrelevance of domestic box-office receipts as a measure of the success of a Hollywood film, the industry as a whole has been reshaping itself to deal with new forms of distribution and new entertainment tie-ins. Consequently, new cultural practices are developing around motion pictures, particularly through its connections to other activities and sites, thus transforming cinema-going.

In 1994, a US investor group, WGIM Acquisition Corporation, purchased IMAX.[6] This move also involved a merger with Trumbull Company Incorporated (TCI), founded by Hollywood director and special effects wizard Douglas Trumbull. Already famous for work on films such as *2001: A Space Odyssey* (Stanley Kubrick, 1968) and *Blade Runner* (Ridley Scott, 1982), he participated in earlier IMAX projects, most significantly *Back to the Future . . . The Ride* in 1990 at Universal Studios, Florida. As a wholly owned subsidiary of IMAX, TCI became IMAX RIDEFILM, with Trumbull remaining as Chair and CEO, as well as occupying a more central position as a Vice-Chair of IMAX.

Some of the salient attributes of IMAX for investors and for corporate strategy include: a backlog of theatres to be built over the next few years (thirty-five in 1995), whose systems leasing is the prime revenue generator; films with a long-term running potential, hence an extremely valuable film library (of which IMAX has distribution rights to about 40 per cent); short films, meaning more shows per day, and therefore a high audience turnover rate; and the uniqueness of the IMAX experience, allowing admission prices to be set above those for traditional cinema (considering the shorter length of the films). According to investors' logic, changes in consumer activity provide contextual details which support IMAX's potential. These include: a stabilization in attendance at traditional cinemas that has coincided with an increase in theme park attendance; the growth of in-home entertainment technologies (VCRs, satellite delivery, cable services, etc.) that have led consumers to look for a variety of out-of-home products that provide a distinct experience; and an overall increase in the amount spent on leisure activities.

The IMAX 'flight' experience, and its merging of both amusement parks and museums, complements rather than competes with in-home entertainment spending. Further, the emphasis upon developing new technological forms (e.g. 3-D) will continue to ensure that IMAX remains in a market with few competitors. This suggests that the overall incentive is to provide short ride-film experiences, which generates revenue (1) by introducing a new audience every ten

minutes or so, (2) by charging a relatively high admission price (say US$5) for each ride, (3) by being able to offer a longer day (more showings in the morning and through the evening) than traditional theatrical exhibition, and (4) through the longevity of the individual ride-film. On this last point, the Universal Studios' *Back to the Future . . . The Ride* IMAX is already eight years old and shows no sign of slowing down as an audience draw. IMAX has already opened a motion simulator in Lincolnshire, and plans to install others in multiplex cinemas in the US, in addition to its Sega deal (Enchin, 1995a).

Always key to IMAX is the location of the theatre and its integration with other activities and practices, especially tourism and the museum and now, more recently, shopping. The sharp jump in the installation of screens at commercial sites includes a contract to build five theatres with Hammons Entertainment, the biggest single deal in the corporation's history (Enchin, 1995b), and the Sony Theatre in New York, a twelve-screen site with an IMAX 3-D theatre, described as a theatrical exhibition 'theme-plex' (Evans, 1994).

De-differentiation is a convenient term to describe the blurring of realms of social and cultural activity. What may have been more conventionally delimited spaces of public and private life are less identifiable. Urry refers to the postmodern collapse of the high/low culture dichotomy and of spheres of social activity including 'tourism, art, education, photography, television, music, sport, shopping and architecture' (1990: 82). In the present context, the distinctions between the museum and the amusement park, between institutions of public education and public entertainment, between shopping and tourism, and their associated modes of presentation, are increasingly muddied.

The last collapse is evident in the creation and growth of 'destination complexes' which on the surface appear to be upscale, high-concept shopping malls. Even an article on the front page of the *New York Times* announced, 'America's hot tourist spot: the mall outlet' (McDowell, 1996). As sites for public life akin to the marketplace and the town square, these are locations for the exchange of ideas as well as money. Destination complexes have also been involved in attempts to revitalize urban spaces previously devoid of economic activity. A destination complex is where people go to experience something beyond the chores of shopping. It is a shopping theme park; an environment that offers a unique or special shopping experience is offered, and a place that presents an idea of exclusivity to an everyday activity. In this way, destination complexes are the antithesis of warehouse-style shopping, where the attraction is built around an idea of the stripped down functional form of buying as much as possible for as little as possible. And the presence of an IMAX theatre, with its related assemblage of educational, entertainment and touristic discourses, ensures the formation of a mall into a destination complex. Though the tourist gaze is dependent upon its 'departure' from the everyday, de-differentiation, especially at the site of the destination complex, subsumes this gaze into this reconfiguration of 'ordinary' social activity.

These observations matching IMAX's operations with sociocultural trends suggest that IMAX is being seen as one image of future cinema-going; more specifically, the implications point to an agreed-upon notion of 'upscale' cinemas and its relation to special commercial sites. While there are many other interpretations of these shifts, it is important to take seriously what is salient to those in a position to put their assumptions into effect. With an agreed upon future for both cinema and IMAX operating in investment circles, one can reasonably expect it will have direct consequences in corporate decision making, thus affecting the organization of the sites for leisure. And sure enough, the ride-film and the development at commercial sites are becoming a focus for IMAX's place in the changing environment of cinema-going. In short, IMAX is one symptom of a general shift in leisure as well as a more specific reconstitution of the cultural practice of cinema-going.

The conservative horror often expressed about de-differentiation betrays an elitist notion of guarding the best of culture as well as a general disdain for popular pleasure. None the less, it is worth considering what is being lost as well as what is being enabled by the shifts in cultural forms and practices I have identified here. The sliding tourist gaze is one form of popular interpellation, hence of subjectivity, which is becoming increasingly pervasive. By naturalizing coinciding shifts in technological and social relations. IMAX is a complex manifestation of late capitalist forms of perception and knowledge.

Notes

1 For additional discussion of IMAX technology and film realism, see Wollen (1993). Belton (1992) offers a broader analysis of the history of projection context.

2 With museum sites as the mainstay of IMAX's market, it is worth noting the extent to which these institutional locations are frequently central to their various national contexts, suggesting that there is something about IMAX's mammoth representational form that fits neatly with mandates to promote a centralized national discourse. While it was initially prominent in Canadian technological nationalism, the IMAX system is remarkably mobile and can easily fit with other, or any, national endeavour or location. For example, at Expo '92 in Seville, Spain, IMAX was the centrepiece of the Canadian, Japanese and French pavilions.

3 Charney and Schwartz (1995) offer several investigations that expand on the relationship between cinema and modernity.

4 For example, the Cyclorama in Ste-Anne-de Beaupré, Québec, established in the late nineteenth century, still offers a circular tour of the Crucifixion of Christ. In its day, it was the largest single canvas painting in the world.

5 My articles (Acland, 1995, 1997) elaborate on these observations.

6 Two investment analysis reports prepared for the new IMAX Corporation, by Donaldson, Lufkin and Jenrette (1994) and by Goldman Sachs (1994) are the sources for much of the information concerning IMAX's future economic development that follows.

References

Acland, Charles R. (1995) 'Shadows on the landscape: notes toward an anatomy of IMAX', *Point of View*, 27: 8 ff.

—— (1997) 'IMAX in Canadian cinema: geographic transformation and discourses of nationhood', *Studies in Cultures, Organizations and Societies*, 3: 289–305.

Adler, Judith (1989) 'Origins of sightseeing', *Annals of Tourism Research*, 16: 7–29.

Anderson, Benedict (1991) *Imagined Communities* (revised edn), New York: Verso.

Baudrillard, Jean (1983) *Simulations*, trans. Paul Foss, Paul Patton and Philip Beitchman, New York: Semiotext(e).

—— (1988) *America*, trans. Chris Turner, New York: Verso.

Bazin, Andre (1967) *What is Cinema?* trans. Hugh Gray, Berkeley: University of California.

Belton, John (1992) *Widescreen Cinema*, Cambridge, MA: Harvard University Press.

Bennett, Tony (1983) 'A thousand and one troubles: Blackpool Pleasure Beach', in *Formations of Pleasure*, Boston, MA: Routledge: 138–155.

—— (1990) 'The political rationality of the museum', *Continuum*, 3(1): 35–55.

Boorstein, Daniel (1964) *The Image: A Guide to Pseudo-Events in America*, New York: Harper.

Burke, Peter (1978) *Popular Culture in Early Modern Europe*, New York: Harper & Row.

Charney, Leo and Schwartz, Vanessa R. (eds) (1995) *Cinema and the Invention of Modern Life*, Berkeley: University of California Press.

Crary, Jonathan (1990) *Techniques of the Observer: On Vision and Modernity in the Nineteenth Century*, Cambridge, MA: MIT Press.

Donaldson, Lufkin and Jenrette (1994) 'IMAX Corporation: company analysis', unpublished manuscript, New York.

Enchin, Harvey (1995a) 'IMAX says ABC deal will survive', *Globe and Mail*, 2 August: B8.

—— (1995b) 'IMAX lands U.S. order for five giant-screen theatres', *Globe and Mail*, 7 July: B2.

—— (1995c) 'IMAX, Sega to team up at two Japanese theme parks', *Globe and Mail*, 16 February: B7.

Evans, Greg (1994) 'Sony's N.Y. "theme-plex" stirs exhibs' interest', *Variety*, 12–18 December: 9ff.

Foucault, Michel (1970) *The Order of Things: An Archaeology of the Human Sciences*, New York: Random House.

Friedberg, Anne (1993) *Window Shopping: Cinema and the Postmodern*, Berkeley: University of California Press.

Goldman Sachs (1994) 'IMAX Corporation', Unpublished manuscript, New York.

Harvey, David (1990) *the Condition of Postmodernity*, Cambridge, MA: Blackwell.

IMAX Corporation (1995) 'Sony and IMAX expand relationship', Press release, 6 March.

Lumley, Robert (1988) *The Museum Time Machine*, New York: Routledge.

MacCannell, Dean (1976) *The Tourist: A New Theory of the Leisure Class*, New York: Schocken.

McDowell, Edwin (1996) 'America's hot tourist spot: the outlet mall', *The New York Times*, 26 May: 1 ff.

Morris, Meaghan (1988) 'At Henry Parkes Motel', *Cultural Studies*, 2(1): 1–47.

Noble, Kimberley (1994) 'IMAX teams up with giant', *Globe and Mail*, 1 November: B19.

Said, Edward (1978) *Orientalism*, New York: Vintage.

Schivelbusch, Wolfgang (1979) *The Railway Journey: Trains and Travel in the 19th Century*, trans. Anselm Hollo, New York: Urizen.

Thompson, Grahame (1983) 'Carnival and the calculable: consumption and play at Blackpool', in *Formations of Pleasure*, Boston, MA: Routledge: 124–37.

Urry, John (1990) *The Tourist Gaze: Leisure and Travel in Contemporary Societies*, Newbury Park, CA: Sage.

Virilio, Paul (1990) 'Cataract surgery: cinema in the year 2000', trans. Annie Fatet and Annette Kuhn, in Annette Kuhn (ed.) *Alien Zone: Cultural Theory and Contemporary Science Fiction Cinema*, New York: Verso: 169–74.

Wolff, Janet (1985) 'The invisible *Flaneuse*: women and the literature of modernity', *Theory, Culture and Society*, 2(3): 37–46.

Wollen, Tana (1993) 'The bigger the better: from cinemascope to IMAX', in Philip Hayward and Tana Wollen (eds) *Future Visions: New Technologies of the Screen*, London: British Film Institute Publishing: 10–30.

Notes on Contributors

Charles R. Acland is an assistant professor in the graduate programme of communication studies at the University of Calgary. He is author of *Youth, Murder, Spectacle: The Cultural Politics of 'Youth in Crisis'* (Boulder, CO: Westview Press, 1995), and is currently writing about cinema-going in the context of global film culture.

Ron Eglash received his BS in cybernetics and MS in systems engineering, and worked at National Semiconductor as a human factors engineer. He returned to the University of California for a doctorate on the cultural analysis of science and technology from the Board of Studies in History of Consciousness, and after graduating received a Fulbright scholarship for research in ethnomathematics at the University of Dakar in Senegal. He is currently a senior lecturer in Comparative Studies at Ohio State University.

Richard Grusin is Chair of the School of Literature, Communication, and Culture at Georgia Institute of Technology. He is the author of *Transcendentalist Hermeneutics: Institutional Authority and the Higher Criticism of the Bible*, and (with Jay David Bolter) *Remediation: Understanding New Media*. He is currently completing a book entitled *The Reproduction of Nature: Cultural Origins of the National Parks*.

Kavita Philip is an assistant professor in the School of Literature, Communication, and Culture at Georgia Institute of Technology. She received her Ph.D. (1996) in science and technology studies from Cornell University. She works on the cultural politics of colonial science, and the global political economy of science in the new world order, with a focus on South Asia.

Susan Squier is Brill Professor of English and women's studies at the Pennsylvania State University. She is the author, most recently, of *Babies in Bottles: Twentieth Century Visions of Reproductive Technology*.

J. Macgregor Wise teaches courses in mass media and theory in the Speech and Communication Studies Department of Clemson University, South Carolina. His book, *Exploring Technology and Social Space*, was published by Sage Publications in 1997.

Notes for Contributors

Submission

Authors should submit **three** complete copies of their paper, including any original illustrations. Send articles to the Editors:

Professors Lawrence Grossberg and Della Pollock
Editors, *Cultural Studies*
Department of Communication Studies
CB#3285, 115 Bingham Hall
University of North Carolina at Chapel Hill
Chapel Hill, NC 27599-3285
USA
Email address: cs-journ@email.unc.edu

It will be assumed that the author has retained a copy of his or her paper. Submission of a paper to *Cultural Studies* will be taken to imply that it presents original, unpublished work not under consideration for publication elsewhere. In submitting a manuscript the authors agree that the exclusive rights to reproduce and distribute the article have been given to the Publishers. This includes reprints, photographic reproductions, microfilm, or any other reproduction of similar nature and translations, though copyright is retained by the author.

Manuscript Format

All submissions should be in English, typed or computer printed in double spacing on one side of the paper only, preferably $8\frac{1}{2}$" \times 11". Please include an abstract of up to 300 words (including 6 keywords) for purposes of review. For both articles and reviews, the author's name should not appear anywhere on the manuscript except on a detachable cover page along with an address, short biographical note, and the title of the piece. E-mail addresses are appreciated.

Photographs, tables and figures

Photographs should be high contrast black and white glossy prints. Tables and figures need not be rendered professionally but should be neatly drawn in black ink.

Copyright-protected material

Written permission to reproduce photographs, tables, figures, song lyrics, or any other copyright-protected material *must* be obtained by authors from the copyright-holders *before submission*.

Citation style

Manuscripts must conform to the Harvard reference style. The Harvard system uses the name of the author and the date of publication as a key to the full bibliographic details, which are set out in a reference list at the end of the article. When the author's name is mentioned in the text itself, the date alone is inserted in parentheses immediately after the name, as in 'Smith (1970).' When a less direct reference is made to one or more authors, name and date are given together, with different references separated by a semicolon, as in, 'several authors have noted this trend (Smith, 1970; Mbene, 1984; Sánchez, 1991).'

When the reference is to a work of dual or multiple authorship, use only the surnames or the abbreviated form: 'Smith and McLeod (1982)' or 'Smith et al (1982).'

If two authors cited have the same surname, include their initials in the reference to distinguish them: 'Zukovic, C. (1993) and Zukovic, R. L. (1991).'

If two or more works by the same author are cited, add lower case letters after the date to distinguish them: 'Parenti (1973a, 1973b).'

The date of publication used is the date of the source to which you have referred. However, when using a republished book, a translation, or a modern edition of an older book, give the date of original publication as well: 'Lacan (1966/77).' When using a reprinted article, cite the date of the original publication only. (See 'Reference list' below for proper reference list formats.)

Page numbers in citations are indicated by inserting the relevant numbers after the date, separated from the date by a colon: 'Hani (1980: 56) or Leibowitz and Mohammed (1993: 23–4).'

When referring to mass media materials, include relevant information within parentheses: '(*Women's Weekly*, 16 July 1983: 32).'

Treat recorded music as a book: the musician or group is considered the author, the title is underlined, and the distributor is listed as publisher. Treat television serials (as opposed to episodes) and films similarly. Treat television episodes, poems, songs and short stories (i.e. works that are usually not published separately) as articles, placing the title in single quotation marks.

Reference list

Submissions should include a reference list conforming to the style shown in the following examples. Note: elements of information in each reference are separated by a period or full stop; lines after the first line in the reference are indented; authors' names are given in full; page numbers are required for articles published in readers, journals, or magazines; where relevant, translator, date of first publication of a book, and original date of a reprinted article are noted; when referring to a revised or second edition, cite only the edition used. Examples:

Book

Leach, Edmund (1976) *Culture and Communication*. Cambridge: Cambridge University Press.

Two or more references to same author
Leach, Edmund (1976) *Culture and communication*. Cambridge: Cambridge University Press.
—— (1974) Levi-Strauss. London, Fontana.

Multiple authors
Ogden, C. G. and Richards, I. A. (1949) *The Meaning of Meaning* (2nd edn.). London: Routledge & Kegan Paul.

Two references published in same year; translated text; two places of publication
Lacan, Jacques (1977a) *Ecrits: A Selection*. Trans. Alan Sheridan. New York and London: Norton. (Originally published 1966).

Article in reader not already cited; multi-volume work; article in book by same author
Leavis, F. R. (1945) ' "Thought" and Emotional Quality'. In his (ed.) (1968) *A Selection from Scrutiny* (vol. 1). Cambridge: Cambridge University Press, 211–30.

Article in journal
Macherey, Pierre and Balibar, Etienne (1978) 'Literature as an ideological form: Some Marxist propositions'. *Oxford Literary Review*, 3(1) 4–12.

Article in magazine or newspaper
Burstall, Tim (1977) 'Triumph and disaster for Australian films'. *The Bulletin*, 24 September 1977: 45–54.

Film or TV programme
The War Game (1966). Dir. Peter Watkins, BBC.

Proofs

Page proofs will be sent for correction to the author whose name appears first on the title page of the article unless otherwise requested. *The difficulty and expense involved in making amendments at the page-proof stage of publication make it essential for authors to prepare their typescripts carefully: any alteration to the original text is strongly discouraged.* Our aim is rapid and accurate publication. Authors can help us by providing good, clear copy, following the above instructions and examples, and returning their page proofs as quickly as possible.

25 offprints and a copy of the issue in which the article appears will be supplied free of charge to the author. There is no other remuneration for publication in *Cultural Studies*.

Guidelines for Book Reviews

Our goal is to provide information on and analysis of books of potential interest to the readership of *Cultural Studies*, which maintains an international readership. Because the field of cultural studies is/can be defined broadly and often draws on the work and literature of other fields, reviews should focus on the book's relevance to cultural studies. Our ideal book review is a 475–950 word, succinct and

incisively critical review. Longer reviews and essays will be the exception. Submissions for longer reviews and review essays will undergo the journal's blind review process and should only be submitted after consultation with a book review editor. Also, please contact a book review editor for details on reviewing films, conferences, and other events of significance to the readership of *Cultural Studies.*

All submissions should be in English, typed or computer printed in double spacing on one side of the paper only, preferably $8\frac{1}{2}$" × 11". The author's name should not appear anywhere on the manuscript except on a detachable cover page. E-mail addresses are appreciated.

All reviews should include the following:
Heading information:

1. Your name and title for the book review (short, preferably 5–6 words maximum)
2. Title and author of the book reviewed
3. Publication information: city, publisher, date, page length, ISBN number and price for cloth/Hbk, ISBN number and price for paper.

Body of review:

1. Brief description or explanation of contents of book
2. Consideration of its relevance to cultural studies
3. A critical engagement with the contents of the book

Ending Information (on attached, separate page):

1. Word count
2. Brief biographical note of the author of the review (2–3 lines)
3. Address of book review author

Book reviews should be submitted to one of our book review editors:

Tim O'Sullivan, School of Arts & Humanities, De Montfort University, The Gateway, Leicester LE1 9BH UK

Jennifer Daryl Slack, College of Arts & Sciences, Department of Humanities, Michigan Technological Univ., 1400 Townsend Drive, Houghton, MI 49931-1295 USA

Graeme Turner, Department of English, University of Queensland, Brisbane, Qld 4072 Australia.

Citizen 2000: A Special Issue of Cultural Studies
Call for Essays and Abstracts

The closing decades of century have witnessed the vulnerability, and even collapse, or power models of political agency. The incapacity of left and liberal models to dominate conservatism or to cope with reaction sometimes leaves left, liberals and rightists locked in a symbiotic embrace. Neither can quite release the old structure on nation and state. But new politics wear themselves out as quickly as they emerge: as soon as 'identity' had carved out new terrain, it was undermined and assaulted from within. Hot on the heels of the decline in Identity Politics theorists LaClau and Mouffe proposed a new theory of 'radical democracy,' but this, too, was not triumphant. Critics stress the disabling effects of radical democracy's neglect of political norms and its sacrifice, in the name of "local politics," of total critiques of the world state and the state of the world.

In response to the fragility of old concepts and new, recent theoretical and practical inquiry has reinvoked the concept of citizenship. Can attention to the idea and the ideal of 'the citizen' open up novel ways to comprehend, reformulate and remodel political agency? What definition and what status in the worlds of theory and practice shall we accord to millenarian citizens?

Citizen 2000 will ask if a new focus on citizenship, or new theories of it, might correct and revitalize traditional political models. Or, can identity or anti-identity movements find in 'the citizen' radical options that have so far gone unutilized? Is citizenship a key to the vital future of political models, or a fossil whose antiquation is merely being mystified?

Papers are invited from any discipline and any theoretical persuasion, but we are especially interested in work that brings novel methods, theories, texts, locations, or subjects into the current debates about citizenship.

This special issue will be edited jointly by Cindy Patton of Emory University and Robert Caserio of Temple University.

Please send inquiries via email to: cpatton@emory.edu

Complete manuscripts must be submitted by *October 30, 1998*

Cindy Patton
Graduate Institute of the Liberal Arts
Callaway Center
Emory University
Atlanta GA 30322

CRITICAL ARTS: A JOURNAL FOR CULTURAL STUDIES

Volume 11, Numbers 1–2, 1997 (DOUBLE ISSUE – late December)

POPULAR CULTURE AND IDENTITY

Theme editors: Dr Ruth Teer-Tomaselli and Dorothy Roome

Articles

Introduction
Ruth Teer-Tomaselli (1)

Random thoughts provoked by the conference 'Identities, Democracy,
Culture and Communication in Southern Africa'
Stuart Hall (Open University) (2)

South Africa in the global neighbourhood: towards a method of cultural
analysis
Michael Chapman (University of Natal) (3)

Television, political culture and the identity of citizenship
Michael Bruun Andersen (University of Oslo) (4)

The transition to democracy and the production of a new national
identity in Mozambique
Yonah Seleti (University of Natal) (5)

Witch baby coloured girl (cartoon)
Ngaire Blankenberg (6)

Transformation and reconciliation: 'Simunye', a flexible model
Dorothy Roome (University of Natal) (7)

Identification and interpretation: the bold and the beautiful and the
urban black viewer in KwaZulu-Natal
Michele Tager (University of Natal) (8)

Middle-class matters, or, how to keep whites whiter, colours brighter,
and blacks beautiful
Sonja Laden (University of Tel Aviv) (9)

Re-remembering protest theatre in South Africa – a gendered review
of the historical and cultural production of knowledge around two plays;
the hungry earth and you strike the woman, you strike the rock
Lliane Loots (University of Natal) (10)

An academic milling around 'the Mall': (de)constructing cultural knowledge
Sally-Ann Murray (University of Natal) (11)

Book Review

Intercultural Communication
R. K. Singh (India)

PURCHASE / SUBSCRIPTION INFORMATION

Single copies at $US35 or R30 can be obtained from:

* Centre for Cultural and Media Studies, University of Natal,
 Durban 4041, South Africa
 Fax: (31) 260–1519
 E-mail: Govends@mtb.und.ac.za
* European sales from Intervention Press, Castenschioldsvej 7,
 DK 8270 Hojbjerg, Denmark. Fax: 86 275133
 E-mail: peter ian.crawford@intervention.dk400.dk
* Australian sales from CRCC, Murdoch University, Perth.

Subscriptions: $US70 per volume or R60 (institutional).
 $US45 or R50 (individual).
European rates can be obtained from Intervention Press.

http://www.und.ac.za/und/ccms/intro.html

CRITICAL ARTS: A JOURNAL FOR CULTURAL STUDIES

now has a Web page

http://www.und.ac.za/und/ccms/intro.html

Editor-in-Chief: Keyan G Tomaselli
Managing Editor: Dorothy Roome
Associate Editors: Tom O'Regan,
Joe Muller and Ruth Teer-Tomaselli

Centre for Cultural and Media Studies (CCMS)
University of Natal
Durban 4041, South Africa

govends@mtb.und.ac.za
Fax: 27-31-260-1519
Phone: 27-31-250-2505

CCMS Web Page: http://www.und.ac.za/und/ccms/intro.html

Antithesis Vol.9 'Everyday Evasions: Cultural Practices and Cultural Politics' July 1998

Critical Articles

John Frow *A Note on the Everyday*
Ian Buchanan *The Everyday is an Other*
Greg Seigworth *Houses in Motion*
Pia Ednie-Brown *Getting things out of perspective*
Sarah Squire *On Flirtation*
Lucia Saks *Discover the Nation and Eat it*
Ilinca Stroe *Popular Culture Revisited*
Tara Forrest *Distraction and Action*
Paul Lobban *Little Freedoms*
Emma Williamson *The View From the Road*

Short Responses re 'the Everyday' by Stephen Muecke, Ross Gibson, Greg Wise, Dean Kiley, Margaret Morse, Stuart Koop, Innes Park.

Photography

Photographs by Lyndal Walker with Lara Travis' *Vanitas*

Interview

The Art of Conversation in a Media-Soaked Planet of Noise Daniel Palmer interviews McKenzie Wark

Fiction

Fran Martin introduces and translates two stories by Taiwanese writer Davy Chi *The Scent of HIV* and *I'm Not Stupid*
Catherine Padmore *Venus Rising*
Hélène Frichot *Unprecented*

Poetry

Chris Womersley *The Final Days of Share House No. 8*
Bernhard Frank *All Over*

Order/subscription information:

-For one year (one issue per year)
Australian subscriptions: $15 individuals, $25 institutional
Overseas: US$15 individuals, US$25 institutional

Send cheque or money order to:
Antithesis
Department of English with Cultural Studies
University of Melbourne, Parkville, VIC 3052
Australia

Tel: 61 3 9344 5501/5506
Fax: 61 3 9344 5494
e-mail: antithesis@english.unimelb.edu.au

Credit card sales via Reading Books and Records:
http://www.readings.com.au

SPECIAL ISSUE: BECOMING 'HONG KONG' IN POSTCOLONIAL TIMES

As a 'global city' within the Chinese nation-state, Hong Kong today is a curious historical construct. This special issue will interrogate the reconstruction of Hong Kong as a 'postcolonial' cultural space that interfaces with transnational and global culture. It hopes to address these and other relevant questions:

- How is 'postcoloniality' in Hong Kong being defined at the intersection of local and international discourses?
- How is it manifested in cultural terms through popular culture, arts, literary works, urban planning, education, economic discourses and so on?
- What implications are there for the performance of cultural identity and belonging in HKSAR (Hong Kong Special Administrative Region) around gender, sexuality, capital, ethnicity and other political and social realities?
- How can a critical consideration of 'becoming Hong Kong' serve to rearticulate cultural studies as a transnationalist practice located within Asia?
- How can this consideration facilitate an understanding of the various formations of the diasporic communities of Hong Kong Chinese in different parts of the world?

We seek scholars, writers, artists, and/or activists, especially those from Hong Kong or other Asian locales (although not exclusively so), to contribute essays or artworks from a wide range of perspectives and disciplines.
Please send works and inquiries to:
John Nguyet Erni, Special Issue Editor,
Department of Communication, University of New Hampshire, Horton SSC, 20 College Road,
Durham, NH 03824–3586, USA.
Tel: 603–862–3709; Fax: 603–862–1913; email: jne@cisunix.unh.edu

DEADLINE FOR SUBMISSIONS: September 1999.

Printed in the United States
by Baker & Taylor Publisher Services